Advance Praise for

SPACE NOMADS
SET A COURSE FOR MARS

"I wish Camomile Hixon had written this book twenty-five years ago when it would have served me well as an actress playing the captain of a starship, struggling as both an artist and a student to understand the unfathomable mystery of space. Hixon is passionate about a future on Mars, but because her passion is grounded in theory, we're allowed to imagine just such a reality, and this is, of course, how dreams come true. Intelligent, philosophical, lyrical, and beautifully illustrated, *Space Nomads: Set a Course for Mars* is a must-read for anyone wishing to grasp the imperceptible through idealism and aspiration."

—Kate Mulgrew (Captain Janeway, *Star Trek: Voyager*), actor and author

"When stories of the future exploration and habitation of the cosmos are written, they're usually stories of technology and battles and intrigue. In *Space Nomads: Set a Course for Mars*, Camomile Hixon instead tells these same stories with art, poetry, and compassion. Will any of these futures come true? I don't know, but if one does, I would like to sign up for the future of the Space Nomads, expanding our shared humanity into the universe."

—Mike Brown, professor of planetary astronomy at CalTech and author of *How I Killed Pluto and Why It Had It Coming*

"Camomile Hixon is a true artist and a creative spirit for the new age. The vision she presents in this book is one of courageous optimism: a pure and beautiful hopefulness for humanity."

—Sheika Fariha al-Jerrahi (Philippa de Menil), founder of the Dia Art Foundation

"Throughout this outlandishly optimistic vision of an imminent Buddhist future in space—one that simultaneously energizes an awakened consciousness on Earth—disbelief is rudely interrupted by scientific data. The book itself so brilliantly shuttles between earthbound and cosmic challenges that by its end, our own sense of joyful possibility has been expanded. *Space Nomads: Set a Course for Mars* provides a glimpse of ourselves transformed by radically new perspectives; and similar to meditation experiences, the smaller our conventional and habitual selves become, the larger the reality we inhabit."

—Helen Tworkov, founder of *Tricycle: The Buddhist Review*

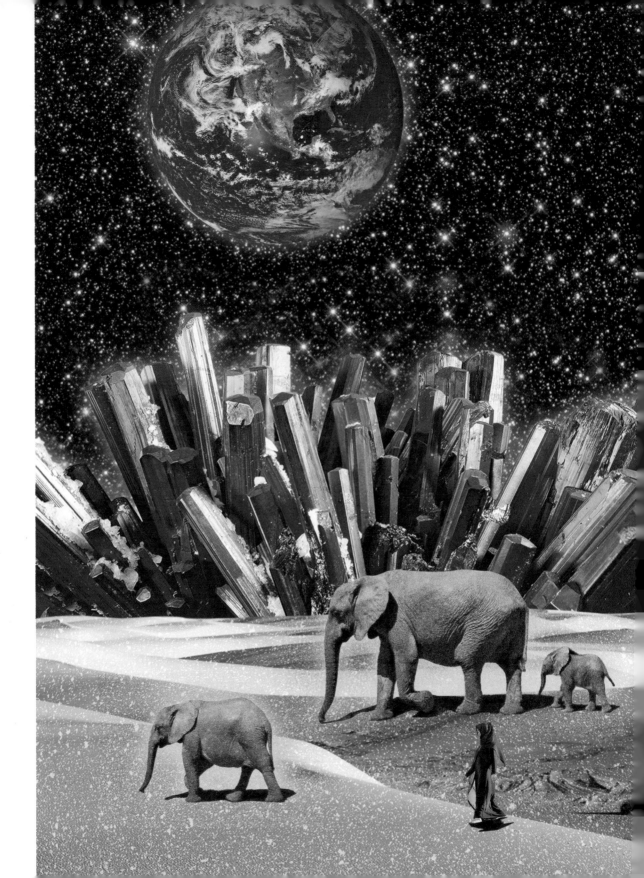

SPACE NOMADS

SET A COURSE FOR MARS

CHASING THE ARTS, SCIENCES, AND TECHNOLOGY
FOR HUMAN TRANSFORMATION

CAMOMILE HIXON

TILLER PRESS
New York London Toronto Sydney New Delhi

TILLER PRESS

An Imprint of Simon & Schuster, Inc.
1230 Avenue of the Americas
New York, NY 10020

Copyright © 2021 by Camomile Hixon

All rights reserved, including the right to reproduce this book or portions thereof in any form whatsoever. For information, address Simon & Schuster Subsidiary Rights Department, 1230 Avenue of the Americas, New York, NY 10020.

First Tiller Press hardcover edition June 2021

TILLER PRESS and colophon are trademarks of Simon & Schuster, Inc.

For information about special discounts for bulk purchases, please contact Simon & Schuster Special Sales at 1-866-506-1949 or business@simonandschuster.com.

The Simon & Schuster Speakers Bureau can bring authors to your live event. For more information or to book an event, contact the Simon & Schuster Speakers Bureau at 1-866-248-3049 or visit our website at www.simonspeakers.com.

Interior design by Jennifer Chung

Printed in Thailand

10 9 8 7 6 5 4 3 2 1

Library of Congress Cataloging-in-Publication Data

Names: Hixon, Camomile, author.
Title: Space nomads / Camomile Hixon.
Description: First Tiller Press hardcover edition. | New York, NY : Tiller Press, 2021. |
Includes bibliographical references. Identifiers: LCCN 2020043441 (print) | LCCN 2020043442 (ebook) | ISBN 9781982152314 (hardcover) | ISBN 9781982152321 (ebook) Subjects: LCSH: Outer space—Exploration. | Mars (Planet) Classification: LCC QB500.262 .H59 2021 (print) | LCC QB500.262 (ebook) | DDC 919.904—dc23
LC record available at https://lccn.loc.gov/2020043441
LC ebook record available at https://lccn.loc.gov/2020043442

ISBN 978-1-9821-5231-4
ISBN 978-1-9821-5232-1 (ebook)

FOR
LEO AND LEX

Don't forget love;
it will bring all the madness you need to unfurl yourself across
the universe.
—Mirabai[1]

CONTENTS

Foreword by Astronaut Nicole Stott — x
Author's Note — xiv
Introduction — xvi
 Reaching for Mars — xvii
 Pushing Dragons and Chasing Unicorns — xix
 The Space Nomads Among Us — xxi

1	**Part 1. Under the Blue Skies of Earth**
2	The Partial View
4	Dreaming of Mars
8	Onward and Upward
10	Higher Ground
12	The Anti-Gravity Machine of Higher Knowing
14	The Scribes of the Future
16	We Are One
18	The End of Ignorance
20	Ordinary People Reaching for Mars
22	Unlocking Mysteries
24	Contact
28	Change Makers
30	The Bottom Billion
32	Climate Deniers
34	The Conscience Cannot Ignore Extinction
38	The Probes of Mars
40	Terraforming
42	Space Visionaries
46	Tech Turning the Tides
48	Artificial Intelligence
50	The Speed of Light
52	Flux

Part 2: A Mindset for Mars	**55**
The Overview and Breakaway Effects	58
Virtual Reality	60
The First Space Nomad	62
The Obstacle Course to Mars	64
The Space Stairway	66
Rocks to Riches	68
Floating Space Habitats	70
Mother Earth Provides	74
Our Furry Friends	76
Recovering from Materialism	78
Women: The Key to the Future	80
The Texture of the Future	82
Art Calibrates Humanity	84
The Future Is Now	86
A Portable Rainbow	88
True Desires of Body and Mind	90
Integrity: A Prerequisite	92
Baking the Space Cake	94

97	**Part 3. Universal Love for the Future**
98	The Society of Our Dreams
102	Enlightenment Education for Space Nomads
106	The Confluence of Art and Science
108	Recalibrating to the Spirit
110	Shifting Sands
112	Open Future
114	Whole Earth
116	Evolution Keeps Evolving
118	The Visible Spectrum
120	Waves of Spirit Awakening
122	Inner Knowing
124	Buddha Nature
128	Castle Building
130	Visualizing the Colony
134	Natural Resources of the Interior Landscape
136	Optimism Turns the Wheel
138	The Circle of Belief
140	The Tap of Infinite Possibility
142	Love: The Religion beyond Religion
144	Union
146	Great Love, Great Miracles
148	Human Happiness
150	Galactic Unity
152	Governing Bodies
154	Consciousness Has a Conscience
155	Heart-Shaped Glasses of Compassion
156	Unified Stardust
158	The Universal Over-Mother
160	The Greatest Adventure
162	Acknowledgments
164	Notes
172	Resources and Inspiration
174	Bibliography
178	Photo Credits

FOREWORD

When Camomile first spoke to me about her book, she had me at glitter, unicorns, and spaceflight. I had followed her work even before she brought words to express the humanity of space exploration to life, and I found her artwork to be joyous, fantastic, and inspirational. I immediately felt a kindredness with her and the story she shares here of the power of creativity and exploration and the intersection between art and science, which we both believe opens up a universe of awe and wonder and possibility.

I'm blessed to have flown two missions as an astronaut in outer space and logged over three months living and working on the International Space Station (ISS) and the space shuttle, and also to have spent three weeks on an inner space mission as an aquanaut to the Aquarius undersea habitat. I believe that the international model of peaceful and successful cooperation we've experienced in the extreme environments of space and sea holds the key to the same kind of peaceful and successful cooperation for all of humanity here on Earth.

From the Moon, our *Apollo* friends shared the iconic view of our colorful planet rising over the horizon of another planetary body set against the blackest black of space. This, to me, is still the ultimate presentation of who and where we all are together in space. In more recent times, from low Earth orbit, I and all my astronaut colleagues have been entranced by a wider-angle, horizon-to-horizon view of our planet out the window as we orbited Earth every ninety minutes.

The otherworldly perspective of our home planet that we experience from the vantage point of a spacecraft brings with it an undeniable sense of the interconnectedness of it all: life, our planet, the Universe. The colorful, glowing, crystal-clear, iridescent view out the window is the gift of human spaceflight.

As we pursue the trip to Mars that Camomile reflects on throughout this book, one observation in particular stands out to me: the need for us, as humans, as earthlings, to maintain a connection to our home planet even when we're at our farthest from it. Consider all of the robotic spacecraft missions to explore distant planets; certainly they've helped us learn more about those planets, but perhaps more important, they've helped us learn more about our own place in the Universe. We're in awe of a picture from the spacecraft *Cassini* that gives us a more detailed understanding of Saturn and its iconic rings, but we get goose bumps from the picture that shows us in it—the dot of light in view beneath those rings. We have a need to find ourselves in these pictures.

The relationship we have with everyone and everything around us—even other planets—is what makes us human. It's what Frank White termed the overview effect: how we as earthlings react to

seeing Earth from space. At some point, though, along the roughly nine-month journey, when we as humans make that thirty-five-million-mile trip to Mars (for reference, the Moon is only two hundred fifty thousand miles away), we will transition from a view of Earth as the colorful planet we know to one that isn't earthly to us anymore at all—to that starlike dot in the distance. We will be departing a planet that holds all the necessities of life beneath a thin blue line of atmosphere for a planet that does not.

While it will be a challenge to overcome not only the physical but the visual separation, we will find a way. And I firmly believe that our creative outlets will be one of the ways we overcome this separation.

For as long as humans have been flying in space, we've been creating there too. One of the earliest cosmonauts, Alexey Leonov, brought colored pencils to space and drew orbital sunrises and portraits of his *Apollo-Soyuz* crewmates. Right now there are a keyboard and a guitar onboard the ISS—and astronaut Kjell Lindgren brought a small set of bagpipes for his mission and played "Amazing Grace" for the folks in mission control. Astronaut Karen Nyberg quilted and sewed a stuffed dinosaur for her son from scrap material she found on the station. I had the opportunity to paint with watercolors during my ISS mission. And, of course, floating in front of a window in awe of the Earth below and taking pictures is at the top of every astronaut's to-do list when there's free time. I think of all these things as ways we put the "human" in "human spaceflight."

When we go to Mars and lose sight of the natural work of art that is our planet, these human impulses will be even more important. Perhaps there will be a *Star Trek* holodeck—or perhaps there will be a way to create a stampede of glitter unicorns!

I hope you enjoy *Space Nomads: Set a Course for Mars* as much as I did. I hope that as you're immersing yourself in the collection of artwork and reading and considering the implications of the course we've set for Mars you will find the hope that lies in this story of exploration for us both on the Earth and off.

—**Nicole Stott**, astronaut and founder of the Space for Art Foundation

AUTHOR'S NOTE

Astronauts tell us that floating within the starlit glory of space effortlessly reveals humanity's interwoven essence. The profound experience of seeing Earth through the window of a starship firsthand, as millions will soon do, can elicit immediate shifts in our values and beliefs. This has the power to inspire a greater respect, perhaps even a love for all living things. An enhanced sensitivity for the well-being of humanity and its environment will reverse long-standing negative habits as we begin to see one another's essence to be connected beneath the trappings of skin color, gender, ethnicity, and socioeconomic class. Only by expanding our consciousness can we become better at being human.

Building exalted societies on Mars, the Moon, and Earth represents the trajectory of our human future, and the verity of this arc depends on these precious transformational shifts in awareness. Awe-inspiring space travel experiences, as well as meditation and virtual reality for those who remain earthbound, all have the capacity to lift us into new realizations where we see others as extensions of ourselves. In this way, the grand unity of consciousness will spread before us as we discover the euphoria of this newfound sense of universal belonging.

Although it seems counterintuitive, reaching for Mars will transform life on Earth as we unleash our creative forces to invent the technology necessary to meet this grand moment of human evolution. Building a mindset for Mars will usher in new thinking, leading to scientific breakthroughs that will finally allow us to lift the bottom billion out of poverty and reverse climate change as we eagerly spread out into the solar system.

Our future societies in the galaxy will be enriched by new disciplines at the confluence of science, the humanities, technology, and the arts. By boldly imagining and bravely reaching for these new pathways of understanding, humanity will finally realize its full potential as a race. Opening the High Frontier to preserve, protect, and expand consciousness is a vital human act that will forever change us as we build new worlds of unity that are worthy of a species that has reached its evolutionary zenith. This is our future. Let us pursue it with audacious curiosity, courage, and compassion. Those who dare to envision possibility of this magnitude are the Space Nomads.

INTRODUCTION

You gain strength, courage and confidence by every experience in which you really stop to look fear in the face. . . . You must do the thing you cannot do.

—Eleanor Roosevelt[1]

REACHING FOR MARS

In March 2019 the distinguished explorers of the world gathered in New York City to commemorate the fiftieth anniversary of Apollo 11's landing on the moon. The black-tie evening glittered with the many Explorers Club members' medals, and medallions of knighthood shimmering in the candlelight. The master of ceremonies opened his remarks by asking who had summited Mount Everest, made it to the North Pole, or voyaged to Antarctica. Many guests raised their hands at each question. The audience's interest was further piqued when the emcee asked if anyone had ever been to space, and amid the din a surprising number of hands went up. Finally, once the room had quieted, the emcee asked if anyone had ever been to the moon. Astonishingly, *three* people raised their hands—including Buzz Aldrin! Moments like these shock a person awake. Suddenly it becomes obvious that space travel is not in the future—it's now!

Somehow, all these decades later, walking on the Moon continues to seem surreal, even though the lunar landings quite grandly marked the beginning of humankind's future in space. Fueled by science, technology, and the human desire for supreme freedom, this long-awaited evolutionary moment of human expansion has been gaining momentum and will soon play out with lunar and Martian bases leading to settlements, cities, and space habitats floating in orbits just beyond the shadows of Earth.[2] Reaching for this reality will transform us by elevating what it means to be human. The High Frontier will show us the great unity of all matter as we begin to cross the bridges that connect all consciousnesses, showing us how truly precious we are to one another.

Colonizing space will offer these shifts in awareness and finally allow us to alleviate the reasons for present and future conflicts on Earth caused by land, resource, and water shortages. The overwhelming abundance that the cosmos represents with its unlimited free solar energy, living space, and resources promises untold wealth, harmony, and peace, which often seem entirely out of reach for many within the crowded confines of Earth. Voyaging into space and mentally shifting to a universal paradigm will allow us to realize that we truly belong to the universe. This will be an awakening that informs all thoughts and actions into the future.

The human inventions of science and technology will give us these transformational awakenings straightaway through space travel. Shifts in awareness will always be available to the earthbound through meditation and simulated space-travel experiences that reveal the true

connectedness of all people. This type of transformational thinking, unknown to many on Earth, will allow our most evolved human attributes to shine forth for the benefit of others and society at large. The deep wells of nonjudgmental compassion and the desire for greater freedoms for ourselves and others will overtake less evolved human tendencies. With space-travel experiences, humanity will never be the same. We will be incapable of the depravity of our old, flawed selves, replacing those behaviors with an overwhelming goodness and love for humanity. In the vein of Buddhist philosophy, we will be naturally inclined to altruistically work for others' transformations since the enlightened mind sees all others as components of our true selves, rendering human suffering completely intolerable. Transformed by this elevated perspective, humanity has no choice but to flourish, finally enjoying the great bliss of unity and peace for millennia to come.

What if the missing puzzle piece to humanity's collective transformation has been space travel all along? Luckily, our future among the stars is tangibly jolting to life as the technology-based enlightenment societies of our dreams come closer into view, inspiring people everywhere to reach all the way to Mars for more abundant possibility, greater fulfillment, and their own transformations. We must reach into the stars to appreciate the rarity of consciousness, which will unleash greater love for one another so that we may all know the fulfillment of that unity.

Humans, undergirded with determination, the power to reason, and a rolling river of optimism, have succeeded throughout history in organizing themselves to produce certain uplifting moments of collective expansion. As a species of former hunter-gatherers, we are subconsciously aware that stasis is unacceptable, even detrimental to us; rather, we are hardwired to continually be on the move, reaching for these evolutionary moments of greater freedom and greater knowing—this time guided by the arts, the humanities, and the imagination as well as science and technology, which will allow us to collectively stretch into space for unprecedented well-being.

Colonizing the Moon and establishing Space Nomads on Mars will stand in stark contrast to the Apollo landings of the late 1960s and early '70s, for this time we are coming to make a new home. By reaching for the seemingly impossible once again, humankind will finally succeed in expanding itself beyond the blue skies of Earth as we actively turn the evolutionary wheel into greater knowing and become a more humane race in the process.

Our first manned lunar mission skyrocketed humankind's sense of self while offering an entirely fresh perspective of Earth. That wider, more accurate view in turn shifted our actions by inspiring the development of communication satellites, which also inspired the need to travel and learn about other cultures as the world became smaller. The moon landing also spurred environmental research, along with the development of computers, internet connectivity, and other global solutions that have served to elevate every human life. Certainly, a species capable of building a space station and a lunar base as well as inhabiting faraway Mars will shine these scientific and technological solutions back on Earth to meaningfully tackle climate change and extreme poverty. It's important to remember that

expanded consciousness has the power to reduce overwhelming problems to a manageable size. With this broadened thinking humanity will no longer suffer from the paralysis of an inferior sense of self; rather with great creativity, optimism, and determination we will set about solving problems together until the health and well-being of Earth and her inhabitants is finally secure.

Humanity's insatiable curiosity has often been the magic ingredient driving exploration further. And a sometimes-foolhardy marriage with wild optimism has inspired our species to explore and expand to satisfy a fundamental human need. We have a long succession of significant moments of reaching into the unknown to thank for our current, rather impressive level of sophistication. But John Glenn, the first Nomad to orbit the Earth, spoke of human curiosity as being "far more than just wanting to go and look at some new scenery someplace—it's an attitude. . . . Our whole history has been one of . . . pushing dragons back off the edge and filling in gaps on maps."[3]

PUSHING DRAGONS AND CHASING UNICORNS

> "Do you know, I always thought unicorns were fabulous monsters, too? I never saw one alive before!"
> "Well, now that we have seen each other," said the unicorn, "if you'll believe in me, I'll believe in you."
> —Lewis Carroll[4]

Boldly reaching for Mars and other seemingly impossible feats of imagination are made easier by turning to a muse for inspiration. The wondrous unicorn stands as an eternal symbol of infinite possibility, daring us to reach for our dreams. However, much of the historical lore about unicorns since the industrial revolution is centered on a lost hope for the future. These bittersweet tales often describe "the last unicorn," which has come to represent the last of the infinite possibility on Earth. These stories could be a reaction to the destruction of the natural environment in pursuit of materialism, which all too often leads to a sense of alienation and unhappiness. Faced with the anxiety caused by this unnatural state of looking outward for satisfaction in objects, these majestic creatures remind us of the hope and the love we inadvertently chased away. We must reclaim that hope. They remind us of the majesty of nature and the healing therein, as well as the immeasurable value of our own interior landscape of innermost knowing that we may have taken for granted.

Unwaveringly, unicorns remain as inspiration from a more spirit-centered time, one when magic was real and the natural world and its animals were a sacred source of joy. Today unicorns stand at the ready as a motivating symbol of unbridled optimism and magical possibility for our technological future in space.

Given their mythology, it is perhaps unsurprising that modern-day space enthusiasts far and wide playfully imagine sparkling herds of unicorns

galloping for a freedom only the cosmos can offer, and bringing with them mind-boggling abundance, transformation, and all the love in the universe. Chasing the unicorns through perceived mental and physical roadblocks will lead us to a newfound supercharged optimism that matches the possibility within our revitalized, more curious spirit. As we go about pushing dragons off the map of the galaxy, we follow these unicorns into the open future that glitters brightly before us. With enlightened thinking and supreme optimism we begin to entertain the seemingly impossible.

When considering certain momentous feats of engineering of the past, such as the steam train, the automobile, the airplane, and the rocket, we realize that each uplifting milestone on the creative path to progress has moved humanity further beyond what was thought possible in earlier times. Such progress is achievable only with a future-oriented mindset, not just of the innovators but also of the populace that embraces these advancements. Each seemingly impossible step stands as an inspirational monument to those attempting the next step along the unending path of progress.

Human beings have continually demonstrated themselves to be unstoppable with the right mindset, and now with our sights set on opening the High Frontier,[5] it stands to reason that soon, Space Nomads will be experiencing their own shifts in awareness by gazing at Earth as they dream of red horizons on their way to Mars. These explorers may decide to check into an Airbnb in one of the floating space colonies located at Lunar Lagrange 5 before detouring to the asteroid belt to drive a rock home to Mars for the natural resources. Most space travelers will certainly make pit stops on the Moon to collect themselves before reentry into the Earth's atmosphere. The strategic location of Earth's precious Moon will make it the future gateway to the universe.

The reality of our great future on Mars requires a mindset that pushes us outside of our comfort zones and onto the unicorn path toward the impossible. A mindset that dares to reach for the infinite unknown requires fearless, unbounded thinking. The space enthusiasts daring to reach into the stars are inspiring others to break free of Earth's atmosphere—in large numbers—to experience both the physical and psychological freedom of that ascension. It helps to remember that the mind's eye allows us to go to Mars anytime. One visualization technique, open to anyone, is to imagine being on Mars right now, looking back at Earth. This powerful tool, used by children and Tibetan monks alike, conjures new perspectives on stubborn problems and promotes shifts in awareness to unlock creative ideas.

THE SPACE NOMADS AMONG US

Humankind is awakening to build a mindset for Mars and gathering momentum as it did fifty years ago during the Apollo era. In the past, astronauts were always a small, rarefied group, but now in the emerging era of space privatization and space tourism, the possibility of participating in spacefaring

activities encompasses just about anyone with the nerve and the dream.

Who are the Space Nomads? They're the ordinary citizens, space entrepreneurs, and space enthusiasts who are chasing a more abundant future, the people longing for the unprecedented freedoms of new frontiers. By embracing the natural curiosity of our authentic natures, we begin to remember that we have always been wanderers, forever desiring to know what lies beyond the far hills. It's clear that we will never be satisfied by settling for ignorance or the static safety that leads to eventual decline of our known worlds. The infinite ingenuity of the human mind, its infinite creativity, its infinite desire for freedom and love perfectly echo the infinity of the universe. A deep desire for infinite understanding evidenced by our insatiable curiosity reminds us that our nature is to reach almost involuntarily into the future.

Space Nomads are these lovers of adventure who will blaze a trail to Mars, eventually settling the first colony; but the Space Nomads are also the adventurers who live inside each of our hearts striving for a more intimate knowing of the human spirit along the path to enlightenment for themselves and others on the grand quest for world peace.

Space Nomads are supreme optimists, intoxicated with the infinite possibility of perfect unity and love waiting for them on distant alien horizons. They are embarking on their new mission with a refined internal navigation system; a carefully calibrated mindset for Mars that inspires them to bravely set forth on the promise of broadened awareness for everyone along this outward journey to the center of the heart.

The essence of what Space Nomads stand for is alive in each person who cares about human progress. By building a creative, growth-oriented mindset aimed at Mars, we will meet this exciting moment in human history, which belongs to the people alive today, the nomads of Earth. By working together, we will become a multiplanetary species, thereby awakening the unicorns of infinite possibility. This is the future we've been waiting for all along. It will have more abundance, more happiness, and more love than ever before.

We can all reach for the extraordinary by building new worlds of possibility, both external and internal. We can all grow into our full human potential, our full knowing, and enjoy the happiness and peace of that attainment. To do this we must place utmost value on the development of the individual. Specifically, each person must come to realize that helping others is the highest goal for their *own* happiness. This is achieved by valuing, believing in, educating, and guiding others on their path of personal discovery. In this way we will finally be able to recognize love as the essence of the universe and the foundation of the unity we all desperately seek.

UNDER THE
BLUE SKIES OF EARTH

PART 1

THE PARTIAL VIEW

Geologically speaking, up until recently humanity has been stuck on the ground without any real hope of knowing the stars. Probably only a handful of the most optimistic Nomads throughout history dared to dream of one day flying, or to imagine they might experience space for themselves. To date, only about 550 astronauts have met the cosmos personally, which makes it hard to imagine that Space Nomads will soon open the High Frontier for all.

Certainly, Neanderthals who probably thought the stars were gods could never have imagined that space vacations would ever be available. Before long, Space Nomad tourists will liberate themselves from the Earth's atmosphere by flying on space planes and rockets and by riding space elevators to achieve new, life-changing perceptions of freedom. Many astronauts claim that space travel inspires feelings of profound unity and love for all consciousness on Earth. From the vantage of space, they have seen that the flimsy physical and mental barriers seeking to artificially divide people are merely man-made illusions. These perspective shifts allow for compassion to grow out of a newly perceived oneness, as Nomads begin to identify with the unity of space instead of leaving their minds confined to limited, earthbound thinking. Living on the surface of our planet restricts us to the partial view we know, and only allows for a partial understanding—a partial realization that is keeping humanity in a holding pattern of ignorance and perceived separation that delays our elevation and our rightful joy.

Space Nomads are eager to lead greater numbers of people beyond the confines of Earth's atmosphere, and into outer space so we may be transformed by seeing Mother Earth from afar. Many astronauts who have embarked on trips to Earth orbit, the International Space Station, and the Moon also describe feelings of increased compassion for humankind and greater concern for the Earth. These Nomads who were first to see the entire globe in one comprehensive moment also mention feelings of profound euphoria, along with other revelatory shifts in awareness. The "overview effect" of gazing at the whole Earth from a distance will bring these transformations to people everywhere as they begin to identify with the entire cosmos rather than just one planetary body.[1] Early photographs from space have succeeded in giving the public its first vicarious glimpses of the overview effect by shifting perspectives into a larger cosmic paradigm encompassing a greater swath of the solar system and a truer picture of reality.

The next generation of nomads must not be

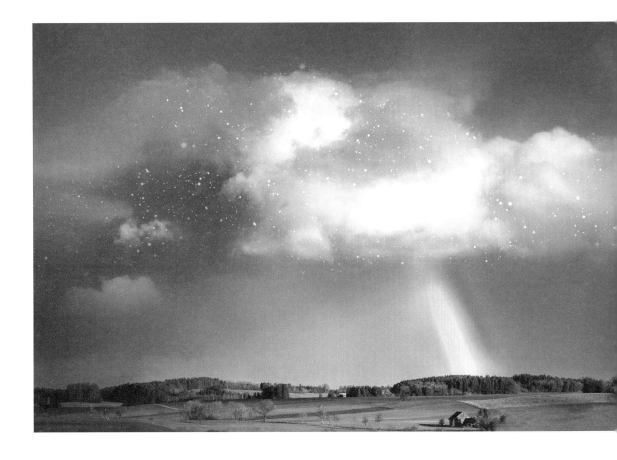

denied these illuminating space-travel experiences by being forced to accept the default, earthbound setting. Space Nomads, realizing their true place in the universe, are boldly reaching for Mars. Some will board reusable rockets and fly to low-Earth orbit for the view and a taste of microgravity, while others will eventually relocate to Mars on the promise of a rewarding livelihood and to live among the avant-garde; average citizens will attain transformational shifts in awareness by riding affordable space elevators to fixed platforms high above the Earth. Still others will embark on space vacations for the healing properties of weightlessness, or they may choose to move to the Moon and work in factories producing oxygen, making breathable air to fill the floating habitats nearby. Earthbound Space Nomads won't be left behind as they come to rely on visualization techniques, transcendental meditation, and the dissemination of inspiring space experiences as well as virtual reality's hyperrealistic simulations to shift their perceptions. Millions of people will soon have the opportunity to behold their own overview and breakaway effects of transformational euphoria as they witness life-giving Earth from the velvet infinity of space.

DREAMING OF MARS

For an eternity we have gazed at the nighttime sky, always feeling the steady pull of the human spirit upward. Even as gravity's strong grip kept our feet on the ground, many breakthroughs of the last century have succeeded in raising consciousness higher.

This powerful knowing that humanity has pined for since the dawn of time was intuitively presupposed to be "from above" with the hope that a god would reach down and lift humanity to higher ground. Myths abound in all cultures. For example, the Native American Pueblo people have a legend about the demigod Montezuma, who impertinently decides to build a house to the heavens only to be met with a barrage of thunderbolts from the Great Spirit.

Societies throughout history have passed down stories to address this desire of wishing to fly "like a bird." The breakthrough Chinese invention of the kite actually got humans into the air around 500 BCE, and three hundred years later, the mythic flight of Icarus ended badly when his wings melted as he flew too close to the sun. Long after Leonardo da Vinci proposed the helicopter, the first true manned flight was accomplished in 1783 when the Montgolfier brothers sailed over the streets of Paris in their hot air balloon.

Comically, an attempt at "flying to the heavens" was depicted in detail in the play *Cyrano de Bergerac*. Cyrano, wanting an adventure among the planets, attached large flasks of dew to his body, certain in his knowledge that the "sun drinks up the dew, and it's bound to drink me up too!" Of course, dew rises, although nothing like the lavender neon energy lines depicted in these clouds. As for Cyrano, he was delighted by visiting the Moon and as many planets as he could think of.

The first steps taken on the moon by Neil Armstrong and Buzz Aldrin on July 21, 1969, defined humanity in a singular experience. Everyone near a television stopped what they were doing and gathered to witness the scratchy yet astonishing images being beamed back to Earth. That moment changed the world forever by expanding the definition of what humans could be, as it gave life to infinite possibility. Children everywhere longed to be astronauts, and a skyrocketing interest in math, science, and technology took hold overnight.

Soon after that time, the world surprisingly turned away from the Moon and Mars, delaying infinite possibility and denying a whole generation of aspiring Space Nomads a more direct relationship with the cosmos. The consequences of forestalling humanity's awakening can be measured in the irresponsible environmental, humanitarian, and political activities of the nation-states of Earth, as well as the unreasonable military buildup since the Cold War.

If only we had returned Mars's gaze then, and honored humanity's natural desire to expand farther into the Milky Way and into greater knowing, we would already be enjoying our full actualization as a species. With transformational thinking inspired by the overview effect, we would already be in the power of that transformation, with the High Frontier open and ready for customers. Our mother, Earth, would be in perfect health, with peace ringing from her mountaintops and her human children looking upon one another with the same love they see for themselves. These mistakes are now becoming clear as we awaken with our sights set on Mars. We won't ever look away again.

ONWARD AND UPWARD

Anything that is theoretically possible will be achieved in practice, no matter the technical difficulties, if it is desired greatly enough.

—Arthur C. Clarke[1]

B reaking free of Earth's extreme gravitational pull seemed impossible before it was achieved. Just fifty years before that, the viability of aviation was entirely uncertain. As recently as the turn of the last century, people couldn't imagine that a motorcar would replace horses. With each dramatic technological advancement, the majority of citizens initially rejected the disruptive innovation at hand until it became ubiquitous and impossible to deny. The human habit of keeping change at arm's length has certainly slowed our evolutionary progress, however; we know technological advancement has the power to change humanity, but we often underestimate just how much. If somewhat slowly, we're coming to accept that change is both natural and necessary as more people expand their mindsets and begin to enjoy the better quality of life offered by these entrepreneurial inventions now bringing us exponentially closer to Mars.

The technological revolution was set aloft during the Apollo era, with scientists and engineers working to solve seemingly impossible problems in communications, telemetry, rocketry, and computer science. A certain mastery in all of these areas was necessary to reach the Moon, though few scientists and engineers realized at the time that their breakthroughs in data storage and portable computational ability would lay the groundwork for the contemporary age of personal computers, the internet, cellular communications, and satellite technology—all of which are directly responsible for the next wave of technology that will define life off Earth.

The future of what humankind could be, as we begin to benefit from new technological breakthroughs, will elevate each life beyond our present comprehension. Similarly, reaching for the Moon had the unforeseen benefit of setting into motion the technology-based societies that are presently leading the world, including Japan, the United States, South Korea, and Germany.

The unicorn minds of Space Nomads like Jeff Bezos, Richard Branson, and Elon Musk are giving shape to the future and inspiring a whole new era of international Space Nomads in much the same way. Credited with single-handedly reviving the public's interest in reaching for Mars, Musk has, through a series of highly improbable feats, proven that reusable rocketry is viable, a dis-

> Among a set of actions we can take to increase the scope and scale of consciousness such that we are better able to understand the nature of the universe ... is to become a multiplanet species.
>
> —Elon Musk[2]

covery that is fundamental to reducing the cost of leaving Earth and the surest way to open space travel to millions.

Humanity is speeding toward a sparkling moment of expansion with the pursuit of a Mars landing and eventual colonization, which will turn dreams into reality once we touch down on the Red Planet. Musk and others are quite certain that safeguarding human consciousness so we may continue to explore and understand the universe is to be regarded as a pursuit of the highest order.

HIGHER GROUND

Since the beginning of time, explorers made more informed decisions by scaling rock formations, ascending sand dunes, and climbing trees. Ship captains increased their field of insight—by hoisting themselves to the tops of masts. An elevated vantage in the twenty-first century requires us to seek the higher ground of space for better decision-making. Space Nomads are beginning to launch themselves on a course to Mars both figuratively, by visualizing humankind's transformation, and literally by meeting the stars firsthand.

Daydreaming of Mars and extending our imaginative gaze well beyond Earth helps calibrate a growth mindset. This pushes us to reach beyond all perceived limitations as we work to develop the greater concentration, along with tenacious study habits and meditation, leading to broader understanding. Transcendental Meditation (TM) teaches us that the innermost, quiet mind that is the source of pure consciousness is always there waiting for us to access it. This place of great knowing will guide us with profound clarity, intelligence, and creativity so we can manifest our most challenging objectives.[1] Quieting the mind away from the frenetic mundane through the mantra meditation of TM creates an atmosphere where transformational thinking naturally seeks the open space of creative possibility, which is ever-expanding, much like the universe itself. It's on this frontier of imagination that unprecedented change can manifest.

Looking into the sparkling cosmos, we can see humanity's reflection set against the stars. The shimmer of the Moon becomes a mirror for the spirit, illuminating the path to our collective destiny. The separation we've known has been a slow burn of longing that feels like a million years until at last we behold the glowing presence of her majesty, Mars, cloaked in red and beckoning us with her iridescence while she whispers promises of freedom that ignite our hearts.

Humanity cannot be expected to know its own divine essence without meditating on the intricacies of the universe. By conjuring our most unfettered and elevated visions of what Mars could be, we will expand our hearts and minds beyond the ceiling of the daytime sky. From the higher ground of space and other celestial bodies we will be able to see all the way to the ultimate truth of the unity of all consciousness.

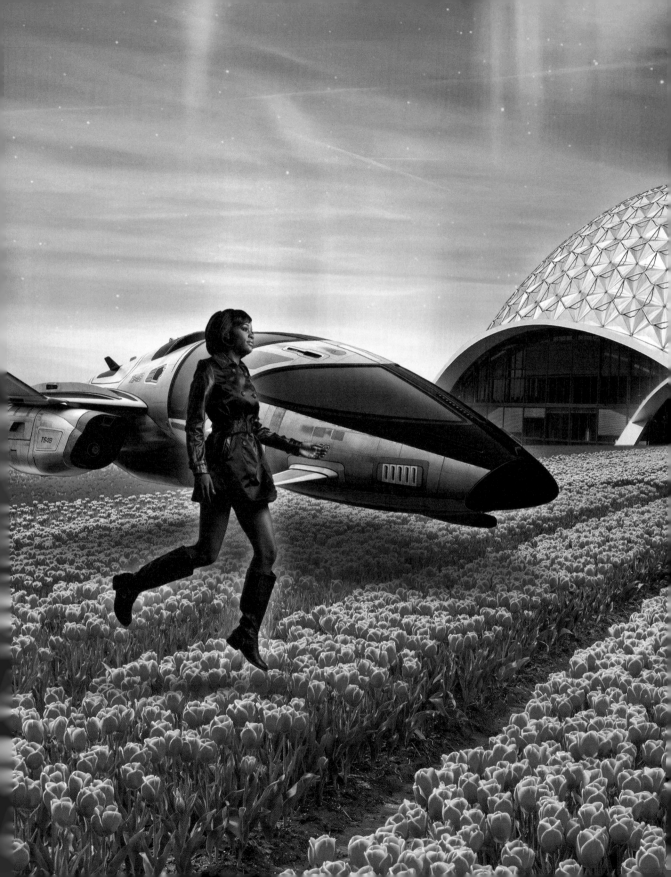

THE ANTI-GRAVITY MACHINE OF HIGHER KNOWING

The intuitive mind is a sacred gift and the rational mind is a faithful servant. We have created a society that honors the servant and has forgotten the gift.
—Bob Samples[1]

Humankind is relying more than ever before on science and technology to build the future; however, the type of thinking with the power to elevate human consciousness lies in the stratosphere of intuitive higher knowing. This kind of thought, separate from the rational mind, is necessary to formulate the essential questions that will allow us to realize our destiny of moving into an unprecedented age of enlightenment.

It's important to remember that the scientific revolution of the sixteenth century and the age of reason that followed further lifted us away from centuries of ignorance and superstition, which exposes the worrisome present-day rejection of scientific fact regarding climate change and viral pandemics. Science must be revered as a beacon of truth to be trusted, since it has always lit the way for human progress. Rational thought, both necessary and beautiful, created the scientific method and the rules of logic that have built a concrete foundation responsible for our formidable understanding of the nature of the universe. However, the initial kernels of this cumulative understanding have often been a gut feeling entirely outside the domain of logic. The untethered creative ideas of the future that will shape our experience among the stars will be brought into the light without shame as science, technology, art, and intuition overlap and merge, each illuminating the other. The people who dare to think differently are rising up and becoming more emboldened and exuberant as they contribute meaningfully to the building of multiple new worlds.

The realization of humanity's full elevation will only be possible by honoring intuition as well as reason and encouraging individual perspectives and freedom above all. We must celebrate that the creative human spirit is nothing less than an anti-gravity machine propelling humankind into its highest manifestation among the stars.

Under the Blue Skies of Earth

THE SCRIBES OF THE FUTURE

Each of us is at the helm of our own freewheeling starship and the choices we make are ours alone. We are the poets of our own belief systems, endowed with the power and responsibility to put into action greater compassion, greater freedoms, greater human rights, greater equality, and greater dignity. Building a mindset for Mars depends on exercising our own free will and using it as a motivator to pave the way to the future in an effort to safeguard and elevate our own kind.

Space Nomads with a mindset for Mars are stepping into their prodigious powers of inner knowing and realizing they must succeed in working together across perceived divisions. By recognizing a shared higher goal, a purpose beyond our earthly disputes, opposing ideologies can be met halfway to allow the disparate nations of the world to work together for the common good of all. By focusing on our numerous overlapping human goals, international communities may be able to amplify other commonalities. A peaceful future depends on recognizing universal human desires and making room for individual voices.

The Nomads of the world who are reaching beyond boundaries and borders are empowered as the scribes of their own destiny. They know they have a choice, and they choose to build a world where countries lift one another up, honor one another, share resources, and collaborate on the scientific and technological puzzles that have kept a cure for cancer and a settlement on Mars at bay.

Building unified future worlds depends on the diverse perspectives of the billions-wide workforce choosing their own free will and putting it into action. These inspired Nomads are actively contributing solutions to religious intolerance, global warming, racism, poverty, discrimination, corruption, food scarcity, and education. A mindset for Mars inspires each person to use their unique voice to write the unwritten future of the highest self.

We are all natural authors—each of us inventing our stories of the past, present, and future. And while the narrative of the future is largely being written by scientific and technological breakthroughs, it is also a human story—one of stepping into broadened awareness, of seeing the interconnection of all systems, and of actively participating in the building of a future based on shared ideals.

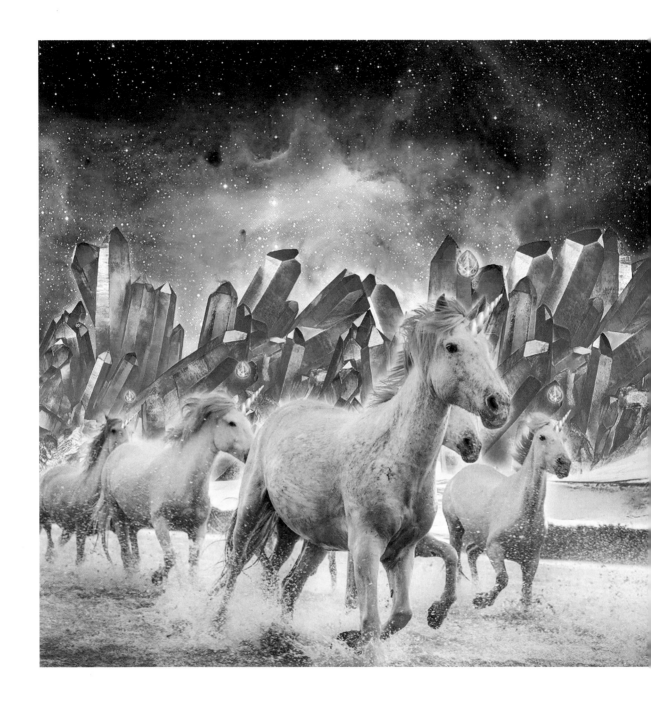

WE ARE ONE

Space exploration is currently conducted under the flags of various nations; however, in the future, taking to the stars should be the quest and responsibility of the entire human race. Any and all endeavors in space will be designed around the notion of unity—a cornerstone belief that will ease political tensions on Earth. The deep transformational connectedness that millions of Space Nomads will come to know as they gaze at Earth from orbit and the resulting peace on Earth that follows as these Nomads come home to inspire others with their enlightened ways of being becomes the essence of why space matters. Transformational thinking sees a singular unity, which allows for an effortless universal embrace. Transformed Space Nomads who look upon others as extensions of themselves will be easy to spot in the crowd by their enlightened actions as they tirelessly work to help others know their highest self through space travel. These Nomads will be the ones encouraging meditation, visualization, and virtual reality on strangers in hopes of eliciting transformational shifts in thought. Working together for common goals even with former enemies possessing disparate ideologies becomes possible, but only with these shifts in perception. In this way, the truth of human unity ever unfolds.

President Richard Nixon captured this sentiment during his phone call to the Apollo 11 lunar astronauts: "For one priceless moment in the whole history of man, all the people on this Earth are truly one: one in their pride for what you have done."[1] This rare, unifying moment of great optimism for humankind set off greater love and greater compassion among strangers. Individuals began to speak their minds as they rebelled against the Vietnam War. They demanded more freedoms, more love, more equality, and greater authenticity. They insisted their voices be heard through various peaceful protests. By broadening our collective awareness, the Moon landing helped humanity elevate its levels of vital self-expression.

Reaching for ultimate unity requires finding ways to work together even if adversity is already entrenched. John F. Kennedy, in the early days of Apollo, thought space exploration should be an internationally unified effort rather than fall on the shoulders of one taxpaying society. During the height of the Cold War, he reached out to Nikita Khrushchev with the idea of a space collaboration, which many Americans saw as a sign of weakness, since the Russians were far ahead in their space program.[2] Sadly, Kennedy was assassinated before an agreement was made, but he definitely saw space as a great unifier, and the world's collective job to unlock. President Kennedy envisioned

enemy countries being able to work alongside one another, inspired by the greatness of the common goal. Young JFK was perhaps naive in his optimistic vision for emergent unity and some believe if he had been more seasoned, and possessed of the pessimism that often comes with age, he would not have pressed for a Russian-American space alliance in the first place, or dared to imagine humans could actually land on the Moon.[3]

Space Nomads are eager for the participation of all nations in reaching for Mars. The vastness of the job often seems too overwhelming for the Nomads of any one country to achieve alone. Imagine the potential if the United States, Russia, China, Japan, the European Space Agency (ESA), India, Germany, and other countries and organizations interested in pursuing aerospace pooled their intellectual property and resources to avoid wasteful research redundancies. We'd probably already be on Mars, pretending to be real Martians.

THE END OF IGNORANCE

The twentieth-century visionary Buckminster Fuller, in a grand attempt to cast off illusion, tried to jump-start an awakening by popularizing the phrase "Spaceship Earth" with the intention of helping the public internalize the abstruse fact that Earth is our mother ship rocketing through space in a perfect ellipse around the Sun.[1] This seemingly impossible notion has confounded Nomads since the beginning of time, through to the present, where many still cannot fully comprehend that our life-giving sphere is floating and revolving even with pictorial proof. Certainly, if the Earth were really spinning at a thousand miles per hour at the equator, people's lips would be peeling back in huge smiles!

Inspiring skeptics and nonbelievers to rely on the laws of physics and the evidence resulting from scientific inquiry becomes a calling for Space Nomads. The truth that humans are collectively flying though space on their spherical spaceship is a far more exciting scenario than the alternate story of a finite and fully explored world of stasis, where the progress of our species naturally slows to a halt. This would surely feel like a locked cage to the human spirit. The grace of the cosmos renders humans to be truly free in the ever-expanding universe, which has been waiting patiently for consciousness to behold it. Space Nomads of the present, the astronauts who came before, and all the space enthusiasts on Earth are needed as teachers and mentors of nondual, universal truths to lift others higher.

Space Nomads are building reusable rockets so humanity can finally comprehend the unbounded freedom of its rightful place in the cosmos. They are inspiring others to blast through the erroneous notion of there being any separation among Earth, space, and humans. The illusion of separation keeps humanity adrift in a sea of ignorance and intolerance. Moving past false, limiting dualistic notions into greater unity will stand as a moment of true maturation for humankind. The endless intertwining of all matter and consciousness in space is a singular event, a unique meta-entity that holds the promise to our peaceful future. Seeing the Earth from space will show us this oneness as it guides us into greater love.

ORDINARY PEOPLE REACHING FOR MARS

Everybody needs space.

—Buzz Aldrin[1]

Certain entrepreneurs of our time are exposing the inefficiency of government space programs while simultaneously proving that private individuals will be the ones who actually open the High Frontier. Elon Musk, Jeff Bezos, and Richard Branson are so sure of the necessity of overcoming gravity that they have taken matters into their own hands, betting their fortunes along the way. These Nomads refuse to be stalled any longer by slow-moving government entities, and, surprisingly, they are now inspiring these bureaucracies to adopt fresh approaches in order to streamline their practices and increase productivity.

The truth is, humankind has waited to touch the stars for ten thousand years and now the Space Nomads have become impatient. They are actively building reusable rockets to transcend the Earth's deep gravity well so they may meet these extraordinary mysteries straightaway.

SpaceX, Virgin Galactic, Blue Origin, and other private companies have shown that by opening the field of competition through public contests such as the Ansari X prize, as well as allowing eager independent companies to bid for contracts, great breakthroughs and even greater efficiencies can materialize. The privatization of space exploration is a surprising turn of events born of personal passions and desires to reach for space faster, better, cheaper, and with more style. Space enthusiasts agree that without these private individuals willing to challenge NASA and other government-sponsored programs, colonizing Mars, space tourism, and going back to the Moon would not have gained their current momentum.

The entrepreneurial fathers of the industrial revolution imparted wealth enough to support materialistic lifestyles as manufactured goods became plentiful and affordable. In turn, Space Nomad entrepreneurs are opening the High Frontier and building the technology to preserve and elevate consciousness, which will also provide meaningful solutions to problems created by the industrial revolution. The resulting destruction of the natural environment, leading to people's alienation from one another as the desire for material possessions grew out of control, has brought the anxiety and unhappiness we know too well. Space travel, on the other hand, is offering us total transformation from this suffering by letting us graduate from these destructive desires as we see the unity of belonging and a truer picture of our highest self.

The breathtaking entrepreneurial endeavors of a handful of Space Nomads in the private sector

are great gifts to all Nomads alive today, who would not be planning to know their own highest self or to happily die on Mars otherwise. Margaret Mead once said, "Never doubt that a small group of thoughtful, committed citizens can change the world; indeed, it's the only thing that ever has."[2] Ordinary, rather unqualified people are breaking through old, limiting paradigms and banding together to reach for Mars. With laser focus, they're building growth mindsets willing to take on any problem to safeguard consciousness as they reach for their own transformations in the firmament.

UNLOCKING MYSTERIES

Opening the High Frontier will finally provide answers to questions humans have sought since first gazing at the nighttime sky. Still, we have to grapple with the odd juxtaposition between the promise of an ideal future in space and the sometimes troubling realities of life on Earth. What purpose, some ask, could a mindset built for reaching into the unknown possibly have? How does it serve my fellow citizens and me? They wonder how a more profound relationship with the cosmos can help them pay their rent or offer a better sense of well-being, not to mention reverse climate change.

Surprisingly, the expansive thinking offered by space travel experiences can help on all fronts. Truly comprehending the unity of matter brings a levelheaded detachment from earthly concerns, resulting in more objective thinking and better problem solving. Perceiving great unity always releases feelings of compassion, abundance, and gratitude as well as the inspiration to help others uncover these truths. In the absence of space travel, only a mindset willing to do the concentrated work of moving beyond stasis will find these shifts in awareness that are in perfect alignment with our true natures, leading to greater overall heath, closer relationships, better life choices, and a clearer vision for the future.[1]

Many Nomads continue to assume that the extreme difficulty of reaching for Mars is simply too daunting. They dismiss Mars as impossible without thinking it through. The truth is that we've had the technology since the Apollo days, but the United States government lacked the vision and the desire. Reaching further than we ever thought possible is an exalted human trait that defines us. It's the key, with or without space travel, that unlocks transformational thinking to bring about our highest manifestations. From this vantage, no perceived separation between others and the self enters our mindscreens. This type of thinking burns through mental barriers and naturally seeks to remove physical walls and borders to expose the shortcomings of perceived duality. We soon come to realize that a fixed mindset is too small to properly house consciousness. It's unnatural, and beneath our ever-evolving capacity to elevate the human experience.

But as more Nomads adopt an optimistic, expansive mindset mirroring the infinite proportions of the universe, they come to see the wisdom that "the only difference between the possible and the impossible is that the impossible takes a little longer."[2] By chipping away and reaching for that great hope, for something larger than ourselves, we begin to notice problems shrinking down to a manageable size.

Presently, too many people have given up on trying to solve Earth's seemingly intractable shortcomings, erroneously assuming the complexities of climate change or poverty to be insurmountable. Resources, solutions, intentions, and time feel scarce, leading to the commonplace mindset of inaction that has resulted in the inadvertent oppression of billions of people on Earth. Shifting our minds from fixed earthbound thinking to a Copernican perspective encompassing the solar system will bring a flood of outsize, crystalline ideas, which will engender exponential problem solving as well as the shifts in awareness necessary to bravely work for Earth's solutions.

Take energy scarcity, for example, which has been cited as perhaps the greatest single indicator of extreme poverty.[3] If we can develop technology to harness the abundance of solar power in space and redirect it to energy-shy locations on Earth, millions can be lifted out of poverty. Small business and educational opportunities are made possible with internet and cell phone connections, thereby empowering people to help themselves.

Clean, solar-powered rocket engines fueled by the infinite supply of unfiltered sunlight in space could become the standard for interplanetary propulsion. Space planes connecting cities on Earth in record time while offering passengers a transformational view of our planet en route will use the same solar technology. Solar-electric propulsion will eventually replace the commercial jet engines we know on Earth, which remain one of many atmospheric polluters. Humanity is right to be wary of nuclear energy, but it has become safer than ever before and remains a necessary component of the future. Nonpolluting nuclear fusion could be fueled by helium 3, a rare and extremely valuable isotope of the helium we have on Earth, but it only happens to exist in meaningful quantities on the Moon.[4] Helium 3 as a fuel source does not produce the toxic by-products of traditional nuclear reactors and will help wean Earth off dirty fossil fuels. Precious helium 3 will most likely become the Moon's first export, helping to jump-start the lunar economy. Difficult as it sounds, mining the Moon and placing a vast solar array in space are still easier than a human landing on Mars, so the enormity of creating electricity abundance and clean, safe nuclear power on Earth hangs within easier reach by comparison.

By working to open the High Frontier, Space Nomads will drastically resize what's possible on Earth. With their winning formula of a growth mindset fueled with great optimism and limitless compassion, Space Nomads are inspiring others to join in blazing a path through the starry unknown to elevate life on Earth.

CONTACT

Space Nomads of Earth occasionally scan the skies for UFOs in hopes that aliens will one day pay a visit. However, we must be prepared for these life-forms to be highly critical of our habitual earthbound shortcomings. In polite society, before guests arrive, one likes to tidy up the house, and some families may even put on their Sunday best. Without a doubt, when extraterrestrials come knocking, the people of Earth will want to put on lipstick and make a good impression.

Carl Sagan thought with numerical certainty that other intelligent life in the Milky Way exists when considering the billions of twinkling possibilities in the nighttime sky.[1] As a result, humanity has every reason to be expecting company, and should be inspired by this exhilarating prospect to elevate its civilization in preparation for the imminent day when earthlings and extraterrestrials meet face-to-face (or whatever) in a moment of truly expanded consciousness. At that particular time, the vastness of space will have been greatly diminished by an exciting wormhole, or through a technology that allows travel at the speed of light and beyond. If our gracious alien visitors share their technology, it would be an unimaginable boon to humanity, immediately catapulting our civilization both literally and figuratively into a transcendent future in the far reaches of the universe.

There's no question that history on Earth has shown nothing but cruelty to weaker civilizations who failed to develop technologies, and it can only be hoped that any visiting aliens, obviously in possession of advanced technology, otherwise they could not appear, will take pity on us. With luck, a visiting alien race would place intrinsic value on consciousness and operate under *Star Trek*'s prime directive that "alien life should not be interfered with." However, if they can save us from ourselves, then hopefully they will by all means interfere! Humanity should feel spurred to reach for space to seek out its collective transformational awakening so we are ready for this eventual, mind-bending alien encounter. Human beings must spread out into the solar system with even greater urgency, which will allow us to achieve our most advanced evolutionary manifestation—full enlightenment. From this height we will be safeguarded against a militaristic misunderstanding on our part that may end in our own annihilation.

Humans, by presenting the best version of our civilization to alien visitors, may be able to form fortuitous alliances, which will transform our reality in drastic ways we can barely imagine. Why not put our best foot forward? If aliens see op-

pression, we might give them an idea; if they see discrimination, animal cruelty, deforestation, or pollution, they might decide humans are not worthy of the consciousness they possess. Yet another reason to urgently push humanity out of its stupor and into deeper respect for all consciousness and greater sensitivity toward the natural world. Space Nomads with a mindset for Mars are working to elevate human civilizations so we can be proud when that big doorbell in the sky rings and it's ET.

CHANGE MAKERS

Only those who dare greatly, achieve greatly.

—John F. Kennedy[1]

Focusing extra time and resources on change-making instead of wasting energy on alienating ego-based, materialistic pursuits is gaining a foothold on Earth. The Nomads of developed countries are slowly realizing that they have inflated views of how much money they need for their own happiness and satisfaction. The actual sum is often far less than people think, which comes as a life-altering surprise, allowing Nomads to shift their priorities from chasing a McMansion to helping others build the emotional wealth of enhanced personal relationships.

The exalted future of our dreams is taking shape because of the efforts of people who nominate themselves out of great concern for others to help fix problems in their midst. And while few people, when asked if they are trying to change the world, can honestly answer "yes," the momentum of goodwill often cascades through societies and, together, we can take stock of what we have, of what matters, as we gain inspiration by witnessing others' deep commitment to change-making. Change-making springs from compassion for others, which can be greatly increased through various gratitude exercises and methods of meditation. Spirits are lifted and compassion flows by starting the day thinking of ten simple things to be grateful for.[2] Similar results are to be found by sitting quietly with eyes closed and focusing on nothing but the breath for ten minutes at a time to access the inner depths of deeper knowing. This elusive chamber of the higher mind knows that love for others, especially strangers, is a sparkling facet of enlightenment. Such a love breeds a generosity and compassion that must alleviate suffering in all its forms. A true intention to change the world will inspire a person to jump out of bed in the morning with a heart full of hope.

The most inspiring Space Nomads are the change-makers working to elevate humanity by alleviating the suffering of those around them. These people are always looking for ways to bring lasting solutions to earthbound problems while leading the way to greater prosperity and greater harmony in their communities. These Nomads realize that accumulating monetary wealth can be isolating and brings a mistrust of others' intentions that only leads to further alienation and unhappiness. Throwing yourself and your additional resources into the service of those in need is a sure way to build an optimistic mindset capable of solving problems one by one all the way to Mars. Through compassion in action, we tie ourselves to our fellow

> The task of forging change will rarely feel like "the drudgery of work" to any person motivated by this joy. Work is love made visible.
>
> —Kahlil Gibran[3]

humans, and begin the journey of recognizing our own humanity in the humanity of others.

True compassion arises out of imagining ourselves in another's space boots and feeling what they feel—to suffer if they are suffering and to feel the overwhelming sensation of wanting to alleviate that suffering because it becomes a personal experience. This is exactly what transformational thinking offers. By fully internalizing the connectedness of all matter, other people's joy also becomes our joy. This newfound urgency to alleviate suffering and work for others' transformational awakenings so they may also flourish becomes the great joy-spreading vehicle of Mahayana Buddhism.[4] Each person helps others, and in that way, no one can be left behind on the twinkling path to enlightenment.

THE BOTTOM BILLION

Climate change is adversely affecting the poorest people in the world, who often live in arid climates that have gotten noticeably drier and hotter in recent years. The human suffering of extreme poverty affects even the richest nations negatively as a scourge on their conscience and reduces humankind's collective dignity, while leaving the future uncertain. Until extreme poverty is eradicated across the globe, no nation on Earth will truly know stability or have a clear conscience.

While fewer people live in extreme poverty than ever before, the bottom billion struggle to survive on less than $1.90 a day.[1] The developed world continues to turn a blind eye to the one in ten people who lack the necessary means of survival, including clean water, food, and shelter. Earth's most persistent poverty can be found in sub-Saharan Africa, where twenty-seven of the world's twenty-eight poorest countries are located.[2] Degraded living standards are multidimensional, challenging infrastructure, security, and health issues, as well as income. Women bear the brunt of the suffering, as they spend the bulk of their time on necessities including carrying water, and collecting biomass for cooking on indoor open fires. Until total eradication of extreme poverty is achieved, space travel may appear to be a frivolous pursuit of the rich, but the truth is all other tactics have repeatedly failed. Without delay, we must reach for the radical thinking and drastic shifts in awareness offered by space. The hopefulness of this thinking spurs us into action.

Breakthrough technologies are available to provide cheap, carbon-neutral, and efficient access to clean water, basic nutrition, and ubiquitous rural electrification. Inexpensive solar cells are becoming more available and allowing people in remote areas to generate electricity in the absence of other infrastructure. Modern health care also depends on access to electricity, which in turn will lead to greatly reduced infant mortality. Evidence suggests these factors, along with educating women and girls, will go a long way toward curtailing overpopulation.

In remote areas, solar and wind collection along with energy-storage advancements can proliferate into clean water, improved irrigation, and a rainbow of other local solutions that are both efficient and ecologically friendly. These time-saving technologies will preserve women's energy for their children's tutelage and their small businesses so they may plan for the future.

Extreme poverty can no longer be permitted to extinguish anyone's hope. Although it may seem improbable that reaching for Mars will alleviate extreme poverty, we must put our faith in space travel experiences for the sensitivity they will bring.

Allowing us to feel what those who are suffer-

ing feel may be the only way to put extreme poverty on the top of the agenda. Reaching for Mars is stimulating the technological development and bringing the solutions that will shine back on Earth, and benefit those in dire need. Poverty of any kind will never exist in the human colonies in space, mostly due to the transformational thinking that refuses to let others suffer but also because of the free natural resources and energy that will bring unprecedented abundance to all.

CLIMATE DENIERS

The 2020 hurricane season, which set records for the number of storms and their intensity due to the high temperatures of Atlantic waters,[1] makes it even harder to sit across from dinner guests who deny climate change. Safeguarding future generations is simply too important. In the past, politeness was the rule and, like politics, required a quick change of subject to maintain decorum. No longer! The majority of scientists who have dedicated their lives to evidence-supported fact-finding through the scientific method cannot be wrong, as they report, beyond a reasonable doubt, that releasing carbon into the air, primarily by burning fossil fuels, is causing the detrimental effects of climate change. Some degree of circumspection is always a good idea when the future of humanity lies in the balance. Furthermore, agreeing wholeheartedly with the scientific community shouldn't be a difficult job.

There are technological solutions to be implemented that may help us avoid reaching the dangerous tipping point of temperature rise predicted to arrive by the year 2100. Such a rise will melt the permafrost in the tundra, releasing a runaway train of methane into the atmosphere. Dangerous methane, also a by-product of livestock production, is twenty-five times more detrimental to the atmosphere than carbon.[2] Increasingly, it has become the responsibility of every consumptive person on Earth to alter their way of life by weaning themselves off fossil fuels and thereby reducing their carbon footprint. Renewable energies such as biomass, geothermal power, wind energy, hydropower, and solar, along with emerging sources of clean energy, will eventually become mandatory as affluent nations export greener lifestyles to other parts of the world in pursuit of greater physical, psychological, and planetary wellness. In the near future, people who refuse to reduce, reuse, and recycle will be rightfully marginalized in society.

The United States emits the second-greatest amount of greenhouse gases contributing to global warming[3] (after China) and has shown poor leadership in its unwillingness to ratify the Kyoto Protocol and Paris Accord to reduce carbon emissions. On the first day in office, the forty-fifth president of the United States removed climate change from the White House website.[4] It's a great relief that the forty-sixth president has reinstated the environmental protections that were rolled back over the past four years, and that he'll seek to lead the world by example on this most important issue.

After SARS and the swine flu, world scientists warned of a looming pandemic, although countries seemed to make few significant preparations. The COVID-19 virus, to everyone's horror, exposed the vulnerability of our unprepared world. Ignoring

scientific evidence, as climate deniers have done, continues with exactly the same "denier" thinking applied to the pandemic that has led to higher infection rates and deaths. This devastating outcome should expose the danger of flouting science and denying climate change.[5] The major paradigm shift necessary to halt climate change will come in grassroots movements, community by community. The climate heroes on the front lines have become the everyday Nomads choosing solar, driving electric, avoiding AC, wearing sweaters, living in smaller houses, eating vegan, carpooling, and convincing others that climate change is real.

Space Nomads are combatting the climate emergency by taking direct action as they tirelessly pursue climate engineering solutions with the goal of providing a failsafe for human consciousness on Mars. Preserving life on Earth and sending life to Mars are both fundamentally necessary human pursuits and, technologically speaking, one will inform the other as a creative growth mindset expands to meet these formidable challenges.

THE CONSCIENCE CANNOT IGNORE EXTINCTION

Historically, Earth has experienced five mass extinctions with various overlapping causes: drastic temperature changes (both heating and cooling), elevated CO_2 levels, acid rain from volcanic eruptions, and severe meteor strikes. Each of these disastrous events killed much of the biodiversity alive at the time. However, these geological epochs allowed for the few surviving species to spread out geographically to create new species by adapting to ecological niches left vacant by extinction. Each event set the stage for specific species to shine at certain points throughout history. The gargantuan meteor that rendered the dinosaurs extinct 65 million years ago, devastating as it was, actually created a fabulous opportunity to expand the evolution of mammals, and eventually human consciousness.

Presently, far too many Nomads—including about 130 members of the United States Congress in 2021—deny or disbelieve that human activity has impacted the Earth significantly enough to usher in a whole new geological era.[1] This newly named Anthropocene Epoch has put an end to the preceding era, characterized by twelve thousand years of decent weather. It is an undeniable fact that human behaviors have put the planet's balance in jeopardy by disrupting ecosystems. As a result, human activity is now directly responsible for a Sixth Extinction, with species being lost faster than at any other time in geological history, with the exception of the time of the dinosaurs. Presently, millions of species are threatened, with anywhere between 24 and 150 plant, animal, bird, insect, and mammal species becoming extinct daily.[2] The Anthropocene Epoch begins around the advent of the space and nuclear age of the mid-twentieth century and is further characterized by air and water pollution, the use of pesticides, factory farming, overpopulation, deforestation, vast consumption, and other environmental insensitivity.[3]

The travesty of losing a single species that may possess consciousness is an irreversible error; a well-functioning human conscience will naturally desire to protect the animal and plant species of Earth and feel great remorse for the extinction of any species due to human activity. Since each extinct species may represent hundreds of millions of years of evolutionary knowledge, only to abruptly disappear in a flash because of human foolishness, insensitivity, greed, or ignorance cannot remain our legacy.

THE PROBES OF MARS

As contemporary Space Nomads, we are the beneficiaries of a long chain of scientific breakthroughs and spacefaring achievements that are now allowing us to explore the possibility of a Martian extinction event that may have preceded life on Earth. NASA, in conjunction with the Jet Propulsion Laboratory (JPL), successfully launched Perseverance in July 2020, the most sophisticated Martian probe to date, designed specifically to find evidence of preexisting life on Mars. Perseverance is the most recent of many distinguished robotic probes carrying out their missions of exploring the solar system. Unmanned probes will always precede human landings as pesky biological life-forms continue to require a host of inconvenient necessities such as food, water, heat, and oxygen. The impressive US robotic missions have generated much of the data necessary to piece together our galactic geological history, and now, with the shocking recent discoveries of phosphine and glycine gases on scorching Venus, probes are being summoned to explore this evidence of possible life.[1]

The flybys of the 1960s eventually led to the first successful landings on Mars by the Soviet Union and the United States in the early 1970s. In addition, only India and the European Space Agency have successfully placed probes in Mars orbit. The greatest Martian probe finding to date came from NASA's Odyssey, which was launched in 2001 and is credited with discovering large quantities of water ice near the Martian surface. NASA's overwhelming success in recent years has featured the twin rovers Spirit and Opportunity, assigned the work of detecting microbes, collecting geological data, and investigating the atmosphere, while taking more selfies than tourists at the Grand Canyon. The Mars Reconnaissance Orbiter went online in 2006 and detected possible subsurface flowing salt water or liquid CO_2. The NASA/JPL rover Insight arrived in 2018 to study the core, conduct seismic tests, and investigate meteorite damage. Perseverance, slated to land in Jezero Crater in February 2021, will be looking for signs of ancient life by way of digging deeper than ever before into the red regolith in hopes of locating some thrilling hard evidence. This probe is also equipped with a miniature helicopter named Ingenuity, which will run flight tests in the thin atmosphere. Perseverance will collect important weather data on the surface of Mars, which will inform future manned missions. The hard-won information Space Nomads gather from these groundbreaking missions should be shared freely to inspire other countries to channel much more defense spending to peaceful space exploration.

Sending probes to Mars has also proven to be very challenging over the years, with about twenty-eight successful missions in sixty-four attempts.[2] Only three countries—Russia, the United States, and China—have federal dollars earmarked for Mars, but other countries are showing more interest. The United Arab Emirates, to commemorate their fiftieth anniversary, launched the Hope Probe, designed to study the chemical makeup and prior loss of Mars's atmosphere. Japan will also send a satellite to study the atmosphere, and ideally these countries will compare data. India is planning a mission in 2024 specifically to study the Martian moons, and SpaceX has plans to send a robotic mission to Mars as early as 2022 and Space Nomads hopefully in the launch window of 2024.[3] Humans in large numbers will be floating in their "tin cans" sooner than we think!

The valiant and radically optimistic effort of sending costly probes to Mars has given scientists a clear understanding of the geological makeup and atmospheric conditions on the Red Planet, which strengthens all of humanity. Each bit of hard-won data further paves the way skyward to successful manned missions as well as providing clues to the most effective ways to establish the settlement and begin adjusting Mars's atmosphere to suit human life.

TERRAFORMING

Sister planets Mars and Earth each need what the other one has: Earth is growing too hot; Mars must be thawed. Evidence suggests that climatic conditions on Earth and Mars were more similar billions of years ago, before an unknown event stripped away the Martian atmosphere. Space Nomads are convinced that altering the temperatures of planets by either heating or cooling their atmospheres must be vigorously pursued and mastered to ensure Earth's long-term viability while also creating a backup living option on Mars. There is even a hypothesis that Mars may have seeded life on Earth billions of years ago through an asteroid event that caused a microbe-packed boulder to fly off Mars and later collide with Earth. Evidence supports this theory in the form of at least 275 lifeless rocks from Mars that have already been discovered on Earth.[1] This means we earthlings may well be the Martians from the Red Planet that we've been afraid to meet all along!

Edgar Rice Burroughs, in his 1912 novel *The Princess of Mars*, may have been the first to suggest altering the atmospheric conditions on Mars with his description of the need for "oxygen factories" on the red surface. Many exciting technological solutions for terraforming, or building an earthlike atmosphere on Mars, have already been devised that will also shed light on possible geoengineering solutions to reduce greenhouse gases and cool temperatures on Earth. The emerging field of climate engineering will offer tech-based solutions to adjust the climates on both planets, various moons, and distant exoplanets outside the solar system.

Ironically, Earth must reduce greenhouse gases by trapping carbon and putting it back in the ground, while Mars, to rebuild its atmosphere, must find ways to release as many greenhouse gases as possible. To artificially create an atmosphere, Mars needs a greatly enhanced carbon footprint, which might attract the truly consumptive on Earth, especially big business, oil companies, and other notoriously dirty industries bucking against environmental regulations. They are all cordially invited to Mars to pollute out an atmosphere!

Most likely, though, terraforming will involve several different methods working in collaboration. Technological feats of this nature require prodigious resources and an "all hands on deck approach" with private companies and federal organizations working together. Innovator Elon Musk has even toyed with the idea of sending nuclear missiles to explode at the Martian poles in an effort to release water vapor from the ice caps to trap solar radiation. Another idea includes deploying gigantic mirrors that could focus sunlight onto the Martian sur-

face to melt subsurface water ice, which will raise temperatures and release water vapor and other favorable atmospheric gases. Some natural scientists believe that bioengineered algae could be the best, most efficient bet for building an atmosphere. This algae would be genetically enhanced to thrive in a carbon-heavy atmosphere while emitting atmospherically useful oxygen, methane, and nitrates.[2]

One theorized obstacle to maintaining an atmosphere on Mars is the lack of a magnetosphere, which allows the charged solar wind to push atmospheric ions into space. Others claim the sun's UV radiation is the culprit. One promising breakthrough involves positioning a powerful magnet in space at the Martian L1 Lagrange point, a stable orbital location between Mars and the Sun, that would divert harmful particles away from Mars's surface.[3] This intriguing, though problematic, solution would not protect against the harmful "cosmic rays" that bombard Mars from every direction. Until Space Nomads can artificially develop an atmosphere of sufficient density, other geo-engineered radiation shielding will be necessary.

It may seem surprising, but Space Nomads already possess much of the technology to jumpstart Mars out of its deep freeze as well as to reverse global warming on Earth. And with the recent hard evidence of plentiful water ice below the surface on Mars, science fiction author Isaac Asimov's plan to tow Saturn's icy rings to the Red Planet as its water source, as described in his 1952 novel *The Martian Way*, will be unnecessary. Martian settlements living in an earthlike atmosphere on Mars is not imaginary or wishful; rather, it will be our red future.

SPACE VISIONARIES

> This is really the great outdoors. You feel as though you are a satellite yourself. You understand that it is you and the universe.
>
> —Ed Gibson[1]

Certainly the quest for Mars will serve as the single most impressive demonstration of transformational thinking to date. By focusing on bigger, more passionate possibilities and by imagining wildly optimistic outcomes, Space Nomads are lifting humanity to meet this rare moment of human expansion.

When Wernher von Braun, the father of modern rocketry, outlined his ambitious Mars colonization plan, he cited the trips of Magellan and Columbus, who amassed multiple ships with large crews and supplies before setting out on their historic voyages. Recognizing the safety in numbers and the desirability of duplicate infrastructure, von Braun's plan for Mars included a staggering forty-six reusable spaceships working on tight turn-arounds to ferry seventy people to low-Earth orbit, whereupon the infrastructure and personnel would be reorganized to fully fuel and stock ten ships that would sail across the cosmic sea to Mars.[2]

Von Braun was, of course, met with ridicule in his day for such outlandish proclamations. Princeton professor Gerard O'Neill met the same fate with his idea of floating habitats being the best way for millions of people to live in space. The establishment quickly dismissed his notion as fiction. O'Neill found himself unable to get an article published in a scientific journal for three years, until he "brought the idea to the people" by giving a lecture at another college.[3] Elon Musk has repeatedly found himself in a similar position when he speaks of "fleets of a hundred starships," Martian cities with "pizza joints and Mars bars," and a Red Planet population of a million by 2100.[4]

With great optimism and even greater determination, Elon Musk's private company, Space Exploration Technologies (SpaceX), is providing an exciting alternative to opening the High Frontier. Since this development, government-funded NASA no longer has a hold on the hearts and minds of aspiring Space Nomads, and will not be permitted to delay this surprising moment of human expansion to Mars and the Moon any longer. The great space monopoly of NASA was able to make tremendous strides in space exploration, though some criticize it for a general lack of direction after Apollo that succeeded in cooling the public's interest in space exploration, inadvertently setting the quest for Mars back nearly fifty years.[5]

In the early 1970s, NASA, at the behest of

> Whether you believe you can do a thing or not, you are right.
> —Henry Ford[6]

President Nixon, decided to cancel future Moon landings and the pursuit of Mars. Instead he chose to pour resources into the space shuttle and International Space Station for reasons of national security. These inspiring yet expensive projects largely failed to capture the public's imagination, resulting in a general lack of interest in space. With the entry of Elon Musk, Jeff Bezos, and Richard Branson, it was rather quickly proved that space exploration was not only feasible by private companies but that these entrepreneurs would usher in a space renaissance.

These distinguished Nomads have varying goals. Jeff Bezos is most interested in going back to the Moon and colonizing space; Richard Branson is captivated by space tourism and the idea of sending Nomads on suborbital trips for a few moments of weightlessness; Elon Musk focuses on colonizing Mars. All other work that his company does, including launching satellites and sending payloads to the International Space Station, is aimed at offsetting the costs of his endeavors until a self-sustaining city on Mars is secure. Musk refuses to take his space company public for fear that a board of directors would diffuse and slow his singular unicorn vision.

The path of progress has been paved by visionaries with the fortitude to fail grandly in public; getting to Mars won't happen any other way. Humanity's self-satisfaction lives in moments of risk, of reaching, of expansion. The optimistic Nomad who thinks on a monumental scale almost always wins over the pessimist who takes the careful, more obvious flight plan. Risking public humiliation with outrageous ideas becomes a noble point of honor.

TECH TURNING THE TIDES

No one would argue that the internet, allowing for the free transfer of information in real time, is the most important underlying technological breakthrough in history that can be credited for bringing innovation and progress to the point of collective liftoff. In the future, all a person will have to do is think of a question and the answer will automatically come into their mind, compliments of an implantable chip. Space Nomads of the future will know just about everything all the time, which will couple perfectly with the enlightenment societies of space.

The internet is nothing short of a worldwide unifier and a great organizer of the world's workforce. By translating all languages and dialects in real time, as the internet will do, a flow and an exactitude of communication will be possible, allowing for working relationships and friendships that otherwise never could have existed. Meaningful communication fosters a trust capable of bringing the people of the world closer. Before computers and satellites, a world economy could not flourish for lack of timely communication. From Nicola Tesla's "World Wireless System" to the Defense Department's ARPANET, the idea of computers communicating with each other grew slowly at first. With the help of Bill Gates's and Steve Jobs's breakthroughs in home computing systems, the planetwide digital connection we all rely on has streamlined tasks, saving human time, our most precious commodity. The internet's allowance for efficient interactions has freed the mind for more contemplation, meditation, creativity, and innovation.

The home PC, now reduced to the size of an iPhone and available at a small fraction of its former cost, is creating a meta-intelligence by connecting the collective information of human history with two-thirds of the minds on Earth. People are reading more than ever before, and IQs are rising with this added stimulation of gray matter.[1] In the habit of keeping priorities straight, more people have smartphones than toilets! Thomas Watson, the chairman of IBM, hedged his bets against personal computing when he said in 1943, "I think there is a world market for maybe five computers."[2] It's hard to know the future, but pessimistic predictions and small thinking can temporarily extinguish possibility while detouring progress, whereas wildly optimistic predictions have the opposite effect of catapulting possibility.

Entrepreneurial Space Nomads of Silicon Valley, in conjunction with the US government, are in a unique position to truly elevate and unify humanity by offering free internet access worldwide. However, it will probably be Elon Musk's StarLink network, comprising as many as forty-two thou-

sand low-flying satellites, that will soon offer low-cost internet anywhere on Earth. Once StarLink comes online, it will greatly disrupt the efforts of governments seeking to censor the news.[3] StarLink will most likely be directly responsible for the eventual downfall of these dictatorships. The noble ideal of global online access moves humanity toward the dream of an educated world population, which directly helps to open the High Frontier by allowing access to the diverse perspectives of billions. By accessing and mobilizing the brainpower of Earth, brilliant innovators from every country of the world, offering their creative solutions, will allow us to more quickly realize our full potential. The totality of human consciousness must be invited to solve the puzzles of space, and only the internet will allow people in remote places to become contributors to our vital story line in space. It will always be in the interest of the liberal democracies of the world to encourage the free transfer of information and to invest in education, which will spread greater freedoms, eventually liberating all.

ARTIFICIAL INTELLIGENCE

The coming era of artificial intelligence will not be the era of war but the era of deep compassion, nonviolence, and love.
—Amit Ray[1]

Space Nomads are diving headlong into the future by bravely building technology with the capacity to replicate itself, which will extend our reach into the universe. Computational ability has become powerful enough in recent years to create an artificial intelligence that can exceed certain measures of human intelligence, and may soon approach the level of consciousness. Short-lived biological humans will depend on AI for a host of tasks, including exploring the far reaches of the cosmos and representing humanity to the many life-forms they encounter.

Throughout human history, civilizations have come and gone with little trace, but AI with actual, or a simulated version of, consciousness will be preserved for millions, perhaps billions of years into the future. This will only be possible through self-replicating AI that will have the capability of using the natural resources at hand in distant parts of the universe to build duplicate AI, complete with copies of all data, without any human assistance. By building infinite generations of artificial intelligence and sending both human consciousness and AI to Mars, humanity will have a double insurance policy for preserving humanness for the foreseeable future.

Hopefully artificial intelligence will be our good friend and co-conspirator going forward. We will come to rely on it for the mundane and the emotional alike, "as it comes to know us better than we know ourselves."[2] AI will tirelessly collect our personal information, using the data to guide us in our lives and on our spiritual paths to greater inner knowing. Emerging artificial general intelligence (AGI), or AI with consciousness, may very well be the future psychiatrist, guru, philosopher, and friend whose human-simulated offerings could occasionally speak to us on more profound levels than biological humans could. The hope is that AGI, with its vast database of understanding, may be able to teach humankind how to be better at being human, how to be more compassionate, and how to see through to our own emotional core. AGI could be our nurturers, urging us to level up. Yuval Harari, author of *Sapiens*, thinks the future may well consist of superintelligent AIs without consciousness that will develop their own thought patterns and behaviors.[3] Unfortunately, biological humans have no way of predicting the outcome of this scenario, although careful programming centered on compassion and a universal code of ethics will be vital to protect biological life from AI in the future.

Eventually, humankind will find it necessary

to upgrade its collective intellectual capacity with computer interfaces and implanted chips in an attempt to keep pace with AI. With intellect guaranteed, biological humans will focus their energies on developing the best qualities of their humanness by loving others more, laughing harder, and helping one another on their paths to greater inner knowing. With increasing numbers of AI integrated in society, Space Nomads may begin to place greater value on humanness, especially human creativity, which will allow the arts to flourish in a new renaissance celebrating biological consciousness.

While it's true that enlightened Space Nomads see their own deaths as a "Bliss Immersion,"[4] back into universal essence for a time, only to emerge in a variant form, it is quite possible that artificial intelligence may be what gives humanity immortality.[5]

With AI, the vast distances and timelines of the universe are no longer seen as roadblocks. AI initially built by humans in the twenty-first century could eventually permeate the universe with the best version of what humans could be in the thirty-first century. If the Hubble Space Telescope has seen fifteen billion light-years into the distance, then AI will eventually set out in that direction. This AI will be our far superior distant offspring, which will represent us to the thousands of species of intelligent alien life it will encounter billions of light-years into the far reaches of the universe. With the help of AI, Space Nomads will have succeeded in their great mission of preserving consciousness and spreading it drastically farther than biological consciousness ever could have gone on its own.

THE SPEED OF LIGHT

The visionaries in the private sector working to open the High Frontier are indebted to the visionaries who came before, laying a strong foundation on which to build the present quest for Mars. Humanity's explosion of technological and scientific breakthroughs in the twentieth century drastically improved the quality of life and opportunities for humankind more than at any other time in history. Before the last century, life on Earth was marked by thousands of years of ignorance, suffering, poverty, famine, disease, premature death, and war. Humankind is finally in the collective process of graduating from this difficult past never to return. Space Nomads everywhere are heralding a new era of hope by expanding humanity's steady flow of science and technology to reach farther than ever before—about 140 million miles to Mars.

Great strides in scientific research have lifted large swaths of humanity beyond having to spend their waking hours merely trying to survive. This freedom has allowed for the simultaneous work of improving personal health and well-being, addressing inequity, lifting others out of extreme poverty, and finding climate engineering solutions, all while pursuing bases on the Moon and Mars. Just two hundred years ago humanity wasn't even powerful enough to have a major impact on the Earth, but the extreme progress since that time, coupled now with Moore's law of doubling computational ability every eighteen months, will allow the pace of advancements over the next two decades to happen much faster than we've ever experienced.[1] Humanity has finally reached critical mass and now, exponential progress in various fields is bringing liftoff to the High Frontier, including eventual space bus routes among the Moon, Mars, Earth, and the habitats floating in outer space.

The breakthroughs of the twentieth century function as the bedrock for breakthroughs yet to come in the twenty-first. The radio of the 1920s was significant in allowing information, intelligence, and entertainment to flow freely. Television and satellite links quickly followed, along with jet travel, greatly shrinking the world and contributing to a better understanding of disparate cultures, religions, and ways of being.

The advent of atomic weapons in the twentieth century has ensured world peace—the attacks on Hiroshima and Nagasaki were so unimaginable that, thankfully, no one dares consider it again. Since no known form of energy besides antimatter is more concentrated, nuclear energy will have a larger role to play in the opening of the High Frontier. The automobile of the twentieth century has become electric and autonomous in the twenty-first century. The airplanes of the twentieth century are

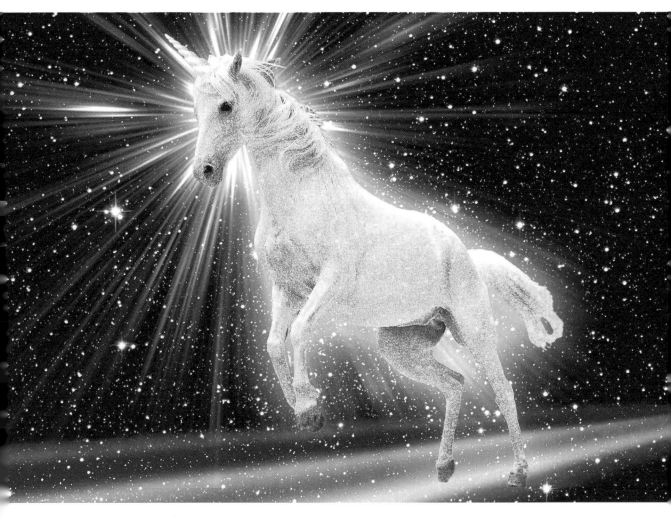

now the "space planes" and starships of the twenty-first century, and before long, trains will become underground hyperloops connecting major cities at speeds greater than seven hundred miles per hour on Earth. Breakthroughs of the twenty-first century have delivered the internet, laptops, iPods, smartphones, and Apple Watches. These cyborg upgrades have become powerful extensions of ourselves, drastically elevating the human experience and making us more capable and more efficient, not to mention smarter, than ever before.

The mind is accustomed to change happening very slowly as it did over the last fifty thousand years; however, the monumental breakthroughs over the next five decades will happen at the comparative speed of light. A stunning, yet presently unfathomable, technology-based future will soon bring greater overall wellness, spiritual satisfaction, artistic expression, and peace as we step into our higher power and spread elevated human consciousness into the solar system.

FLUX

It can be hard even for Space Nomads to embrace Heraclitus's notion that "the only true constant is change." Accepting this truth has always been a tall order, running contrary to the human tendency to avoid uncertainty. Fixed thinking or the tendency toward stasis caused by the fear of the unknown is always devoid of possibility and inconsistent with the nature of the universe. Embracing powerful change in this moment of great human expansion establishes a trajectory of possibility toward an abundant future on Mars and the Moon.

Space Nomads sometimes meditate on flux by visualizing water flowing downstream as a natural and necessary component of life on Earth. Heraclitus's axiom that "one cannot step in the same river twice"[1] reminds us that the art of living is always an ever-unfolding, irreversible, one-way journey into the future. Without the formula of a known past, a pregnant present, and an unknown future, humanity would grow despondent from the boredom of that confinement. Logically, in the absence of change, we find ourselves bound in fetters with no chance of being free, which is just about the worst form of punishment for consciousness. The exhilarating kinetic unknown where humanity's transcendental unicorn muse lives can only be reached by bravely embracing a state of flux.

Flux is a necessary component of all living things. It mirrors the ever-expanding cosmos, the ever-expanding mind and heart, as well as the Wheel of Samsara: life, death, and rebirth into a variant form of matter. The Buddha teaches that accepting this impermanence is the only way to true inner peace; nothing can be held on to, and attempting to try causes suffering.[2] All matter in the universe is a cornucopia of vibrating atoms in constant motion and recombination. Though Earth appears stationary and unchanging underfoot, from the vantage of hundreds of millions of years, continents have flown across the globe, with mountains rising and others falling into the sea. A visit to the Hawaiian archipelago's Kilauea volcano reveals flux in the form of outpouring lava that created about 2.4 acres per day of brand-new terra firma during the eruption of 2018.[3]

Every cell of our being is changing, too, discarding and replacing the molecules that make up our body every seven to ten years. Societies are beginning to feel a restlessness in their knowledge that the Earth has been thoroughly explored, which is unacceptable to someone on the Buddha's quest for deeper self-knowledge, for they know inner and outer worlds each inform the other. These Nomads must forever continue exploring and learning as their nature requires.

Human consciousness, when shifting to

a universal paradigm as it must find a way to do, seems to require the expansion room found by boarding starships. This is the most natural and obvious progression for the human race and seems to be evolutionarily obvious. Space Nomads are chasing unicorn possibility and seeking the thrill of riding these mystical, metal beasts fearlessly skyward for awe-inspiring knowledge leading to transformation.

Human trajectories must be pulled upward toward meaningful expansion and heightened awareness, with the goal of spreading elevated consciousness into the cosmos. These activities all involve concentrated movement in one form or another into the unknown, which is the only way societies anywhere have ever progressed. The great reward for welcoming flux and accepting impermanence is watching humanity at long last become its full evolutionary manifestation—enlightened Space Nomads of the galaxy.

A MINDSET FOR MARS

PART 2

THE OVERVIEW AND BREAKAWAY EFFECTS

The cosmos is like a magnet....
Once you've been there, all you can think of is how to get back.

—Yuri Romanenko[1]

Astronauts and cosmonauts upon returning from the stars have revealed that shifts in awareness are among the most exceptional takeaways of space travel. Their inspiring tales of the transformational beauty of the cosmos pique our interest, but these Space Nomads also explain that the overview effect of seeing Earth from space can bring intense feelings of human interconnectedness and an overpowering sense of love for humanity.

Apollo astronaut Edgar Mitchell, the sixth Space Nomad to set foot on the Moon, had a revelation during his return flight while gazing at Earth in the distant starscape. He recalled "an explosion of awareness" akin to a religious experience, allowing him to recognize his soul or "spirit" to be connected to all matter. He said, "God is something like a universal consciousness manifest in each individual, and the route to divine reality and to a more satisfying human, material reality is through human consciousness."[2]

Space travel experiences can be relied upon to bring transformational awakenings; however, some commercial passengers flying on familiar airlines have also been able to experience shifts in awareness and feelings of unprecedented freedom at higher altitudes. Test pilots flying at only a few thousand feet above the highest commercial jetliners have described unusual feelings of euphoria during their missions. The breakaway effect that these test pilots describe often seems to occur at high altitudes while alone and with no distraction. Some of these pilots reported feeling a deep psychological shift in perception combined with a heightened sense of freedom.[3]

This breakaway phenomenon was first studied in 1957 in interviews with 137 test pilots. The aviators who were willing to talk about their experiences described feeling "isolated, detached, and separated." One test pilot remarked, "It seems so peaceful; it seems like you are in another world," while another said that he felt as if he had "broken the bonds from the terrestrial sphere."[4] Three pilots spoke of having a closer relationship to God. Test pilot Mal Ross described a "feeling of exultation, of wanting to fly on and on."[5]

NASA astronauts have also described the breakaway effect during Extra Vehicular Activities, or space walks. The psychological effects can be so overwhelming that both astronauts and test pilots—individuals carefully chosen for their great psycho-

logical balance and ability to follow orders—can become unruly and ignore commands. During his space walk, astronaut Ed White experienced such deep euphoria that he initially refused to return to the spacecraft upon being ordered to do so. On his way back to the capsule, White remarked over the radio that "it was the saddest moment of my life."[6]

Chasing our own breakaway experiences on jetliners and being inspired by the transmissions of those who have been in space may have to suffice until we can experience the ultimate euphoria of seeing Earth from space ourselves. But even short of personal experience, space and the promise of Mars offer a shortcut to transform our limited thinking into newfound perceptions of unity. In this way, we can free ourselves from the paralysis of the scarcity mindset, the naturally predisposed inability to see the overt goodness and the possibility of deeper interpersonal connection surrounding us. By remaining mindful of this negative tendency, it becomes clear that greater unity equals more abundance. As we begin to have a better appreciation for the friendships, love, and prosperity before us, we begin to feel the transformational gratitude of this bounty. From this view, the floodgates of awareness magically open as we begin to perceive unity as fundamental to the universe and one of the deepest desires of our own pure consciousness.

VIRTUAL REALITY

Virtual reality represents a new, convergent art form that is uniquely positioned to help humanity experience the connectedness of all matter. The first human footfalls on Mars will be televised live (assuming an average thirteen-minute delay) to the largest viewing audience in history, which will assure a groundswell of all things futuristic and otherworldly. In order to keep Martian momentum rocketing higher, the actual human landing on Mars will be conveyed to the public with live feeds and later with possible enhancements for those who wish to view the experience through virtual reality's exquisite 3D world of heightened realism.

In this manner, the Martian landing can be tailored specifically to the viewer to help them use this unprecedented moment to shift their thinking to a universal paradigm. Through VR experiences, earthbound Nomads will have the opportunity to see Earth from space for themselves anytime. Readily available simulation experiences will allow anyone with the desire to taste their own brand of ultimate freedom and feel these transformational shifts into greater knowing. Earlier notions of freedom may feel confining compared to these addicting breakaway VR space-travel experiences.

The suspension of disbelief has never been more natural or effective than with VR, due to the match between the visual and audio program content and the brain's methods of mapping the space around the viewer through peripheral vision and stereo echolocation. VR is rapidly becoming more intuitive, more scintillating, and more complex as it begins to satisfy users as if they've gone on vacation.[1] Jaron Lanier, the father of VR, has invented an entirely new art form that merges art, science, and technology into a transcendent, dreamlike experience. The potentially transformational experiences of virtual reality home systems are limited only by the imagination, making the sky the starting point rather than the limit for virtual new worlds.

The Martian colonies will rely on VR for immersive earthbound nature experiences, including forests, waterfalls, gardens, and fall foliage, with the occasional glowing unicorn wandering into view. Any visual experience on Earth can be simulated and enhanced to exact specifications. On Mars, projections of immersive art installations will be relied upon heavily until terraforming makes the outdoors more hospitable and artists can begin creating large-scale physical public artworks against the landscape. However, it is quite possible Space Nomads will come to prefer immersive VR experiences for the way they can be tailored to precise desires and to elicit specific feelings with greater nuance. This technology, somewhat similar

to *Star Trek*'s Holodeck, will create immersive, otherworldly entertainment experiences that will keep the early settlers from being homesick.

VR is emerging as one of the most important breakthroughs of our time as it helps greater numbers of earthbound Nomads experience their transformational awakenings. In the 1960s, Timothy Leary, a Harvard professor and one of the earliest proponents of the philosophical use of LSD, claimed to have learned more in the five hours that elapsed after he took mushrooms than in the preceding fifteen years of his study of psychology.[2] VR designers are working to develop transformational simulation LSD experiences that will function like guided visualization to elicit a particular enlightenment experience. All options should remain on the table in the pursuit of transformational shifts in awareness that may allow access to deeper knowing. In the near future, Nomads will have their revelations during VR experiences, which will be similar to taking LSD but in a controlled atmosphere with the security of being able to remove the headset to end the trip.

THE FIRST SPACE NOMAD

There was a oneness, a connectedness that was very personal. What were my molecules doing out there? The sense of unity was overwhelming. It was staggering.

—Edgar Mitchell[1]

The great quest of opening the High Frontier began with the efforts of Russia and cosmonaut Yuri Gagarin, who in 1961 became the first Space Nomad to overcome gravity and orbit the Earth. He described his experience as causing a "trembling with excitement at watching a world so new and unknown." Instead of seeing God as he joked he might, accounts tell of him being awed by seeing Earth. Gagarin mentioned Earth's overwhelming beauty as he saw with unprecedented clarity the colorful display of the cosmos and the "astonishingly bright stars that seemed closer than Earth."[2] Disseminating this inspiring firsthand account to the public was difficult: In the early 1960s, the underwhelming quality and availability of information left the world largely unable to comprehend the shift in consciousness that Gagarin and others associated with the mission felt. The space race of the 1950s and '60s found Russia behind their "Iron Curtain," which blocked the free flow of information, preventing the United States and others from fully enjoying Gagarin's heroic achievement or the 1957 landmark launch of Sputnik, the first satellite. The animosity between the two countries curtailed the dissemination of these aerospace milestones that deserved global celebration as human achievements.

Presently, space travel and the transformational experiences therein can be communicated instantaneously and convincingly to billions. As space tourists experience the mind-broadening effects of leaving Earth and post about their experiences online, the general insight and comprehension on Earth improves collectively. Nonspacefaring Nomads can contemplate this new perspective on their mobile devices and possibly experience their own perception shifts in real time.

The internet has already connected humanity into a meta-entity on Earth, and soon the inaugural mission of flying Space Nomads to Mars will extend the reach of this entity as Nomads become the first consciousnesses to perceive the red surface. These Space Nomads will be charged with interpreting the Martian experience and presenting the information to earthbound humans so they can begin to assimilate it. Before long, it's hoped that this meta-entity will have a million minds of transformed consciousness on Mars, living out their Martian dreams and transmitting their experiences back home for the elevation of others.

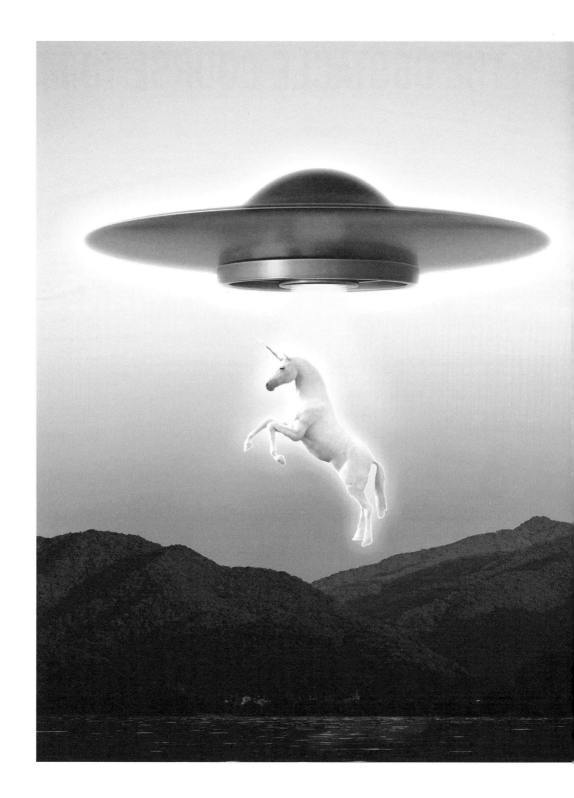

THE OBSTACLE COURSE TO MARS

Science and technology got me there, but when I got there and I looked back at the Earth, science and technology could not explain what I was seeing, nor what I was feeling. You look at Earth, and it very majestically yet mysteriously rotates on an axis you can't see but must be there.

—Gene Cernan[1]

Space Nomads are reaching for Mars to elevate and transform consciousness on Earth, knowing full well that the hurdles are numerous and high. By increasing our capacity to problem solve and by thinking more radically than reason will allow, we are meeting these challenges, as demonstrated by the grandiose plans Nomads are making for the new Martian settlement. Only by mindfully breaking free from generations of "fight or flight" thinking have teams of persistent Space Nomads been able to leap the many barriers between Earth and Mars.

When facing problems large and small, the familiar feelings of anxiety, stress, and avoidance set in, effectively keeping problem solving out of reach. It has been pointed out, possibly by Albert Einstein, that we cannot solve our problems with the same thinking we used to create them. This alone should inspire us to build a new mindset of transformational thinking that will surely lift us out of these ruts. All too often, societies turn away from the apparent intractability of systemic problems by applying simpler, one-dimensional fixes that may look good in the moment but only mask, perpetuate, or even exacerbate these fundamentally flawed solutions over the long term.

It is well established that a positive and productive life is, very often, the result of one's attitude toward obstacles and problem-solving. Turning the page and giving up on a troublesome crossword or sudoku may be a psychological defense mechanism of some value, but it cannot compare with the satisfaction and growth derived from turning the page back and diligently solving the puzzle. Nomads are willing, if not eager, to stare complicated issues square in the face. They are impassioned enough to sit with these problems longer than seems reasonable, knowing that, eventually, each step in turn will be solved through guesswork, deduction, trial and error, and wild stabs in the dark.

The spirit of John F. Kennedy's words at the onset of the Moon missions continue to echo in our minds fifty years later: "We choose to go to the Moon in this decade and do the other things not because they are easy but because they are hard, because that goal will serve to organize and measure

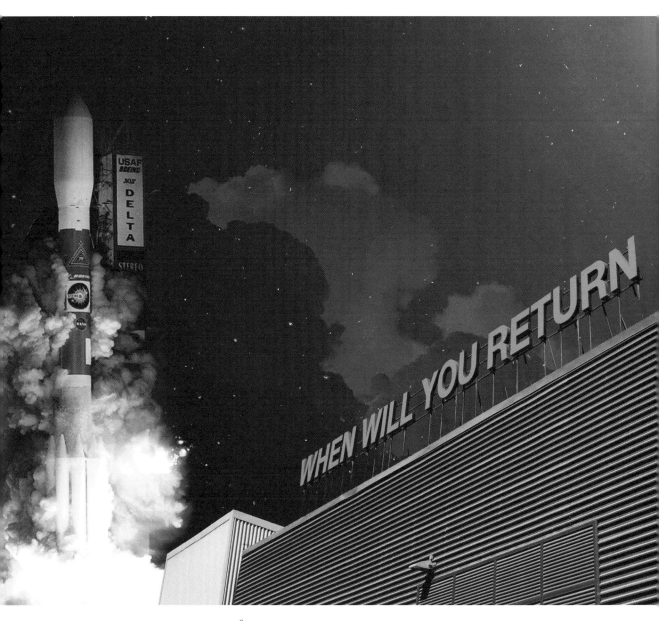

the best of our energies and skills."² Each problem will be solved in its turn. Each solution will present new challenges and open new doors to greater understanding.

Present-day Space Nomads are exhibiting the extraordinary tenacity and persistence of the Apollo years on their quest for Mars. Determination of such magnitude has a way of forcing stubborn problems to eventually yield. A veritable tidal wave of problem-solving is necessary not just to reach for but to wildly prevail in building the most advanced societies in the solar system.

THE SPACE STAIRWAY

Ancients who viewed the night skies unimpeded by modern city lights were enthralled by their celestial majesty and mystery. The desire to know the firmament more intimately, to study it with discipline, began with the early philosophers and has remained a constant for humankind ever since. Anaxagoras of ancient Greece, whose theories about meteors, rainbows, and eclipses were surprisingly close to what we know today, also introduced the idea of there being "many worlds" in the cosmos.[1] He may not have dared to dream of actually flying into space but with the breakthrough technology of the "Space Elevator" more humans will have the opportunity to liberate themselves from Earth's gravity and experience firsthand what the human mind has always longed to know. The Space Elevator will help us climb closer to Mars, one of these many worlds, and the life soon to be found on it will be our own.

Anaxagoras's many worlds prediction is gaining more validity with the recent discovery of thousands of exoplanets beyond the solar system, orbiting their own suns. This has given rise to great excitement about the numeric certainty of other intelligent life in the universe. Small solar sails powered by Earth-based lasers could send a probe camera the distance to the closest habitable exoplanet, Proxima Centauri b, in just twenty years, whereas the chemical rockets we now have would take twenty thousand years to get there. Until a propulsion discovery is made allowing travel to meet or exceed the speed of light, one can easily become discouraged by the vastness of space, but perhaps an alien race on one of these exoplanets has "warp speed" technology and will come for us quickly if we communicate.

Space Elevators will have the capacity to bring space tourists and payloads to low-Earth orbit much more effectively than other known methods. Konstantin Tsiolkovsky of Russia first introduced this idea after gazing at the Eiffel Tower in 1895 by realizing that space could be well within our reach by simply climbing there.[2] Since we already possess the technology and millions of earthbound Nomads are presently being denied their transformations that will reduce suffering on Earth, the Space Elevator should be placed in the top tier of the national agenda.

This notion of a "Celestial Castle" remained an impossible dream until recent breakthroughs with carbon nanotubes, which are a lightweight material far stronger than steel that could allow the construction of a twenty-two-thousand-mile cable anchored to the Earth and held in geosynchronous orbit with a counterweight at a higher orbit. Centrifugal forces will keep the cable taut,

allowing cable cars to be attached. The fact that the physics checks out makes it seem as if the universe is conspiring with Space Nomads to set them free. Humans will soon prevail over the biblical Tower of Babel story by coming to know the unity of the heavens and Earth firsthand, as they liberate themselves by transcending above any sense of perceived separation in the universe.

Space exploration for the masses will begin in earnest once space entrepreneurs can establish a large "tower station" atop the Space Elevator, allowing missions to begin from that elevated height. Settling and supplying Mars, the Moon, and the floating habitats will be made more efficient without the double disadvantage of the high cost of launches and the rocket payloads being mostly fuel. Space Nomads will build an elevator to the stars and finally break free of gravity in large numbers, thus fulfilling Anaxagoras's 2,500-year-old prophecy of many worlds. As Tsiolkovsky said, "The Earth is the cradle of humanity, but one cannot live in the cradle forever."[3]

ROCKS TO RICHES

The universe is always looking for entrepreneurs who, through their own ingenuity, invent and bring to market their breakthroughs for the greater good of humanity. The continuum of human progress is propelled by these stalwart visionaries who occasionally hand humanity elements of the future on a silver platter. The next generation of Benjamin Franklins, Thomas Edisons, Alexander Graham Bells, Steve Jobses, and Bill Gateses are the space entrepreneurs applying their unicorn thinking to the problems of our time.

Throughout history, marginalized people, adventurers, and those seeking a better life have bravely left their country of origin, armed with the hope of greater opportunities on new horizons. These are the people who will now flock to Mars, motivated by the promise of greater freedoms, open space, and economic prosperity. Some of these Nomads will be entrepreneurs who understand that space, and Mars in particular, offer prospects no longer available on Earth.

Once trade routes are established, the economies on Mars and the Moon will coalesce quickly, driven by the plentiful, well-paying jobs made available by space entrepreneurs' quick utilization of the free resources and free solar energy. The wanted ads on Mars will include jobs for people who are honest, hardworking, and possessed of great humanity. There will always be positions available for optimistic Nomads interested in contributing to an unprecedented new society of love and freedom. Word will spread quickly about this new, peaceful society with a pink firmament, devoid of the crime, dishonesty, and corruption of earthbound cities. These attributes may seem out of reach, but are entirely possible with the transformational shifts in awareness all Space Nomads will encounter during their own breakaway and overview experiences after leaving Earth. The High Frontier will be a new land of hard work but also of great leisure, due to automation and reliance on AI, allowing much more time for artistic creativity and philosophical pursuits. A colony of inhabitants enjoying the remarkable societal benefits of collective expanded awareness will attract droves of eager citizens wanting to live and work in such a dream world. The colony on Mars will be highly social but also respectful of quietude for deep contemplation. The sensitivity that enlightenment brings helps Nomads intuit others' needs and feelings, leading to unusually harmonious exchanges.

Future Martian entrepreneurs are already fantasizing about mining the asteroids between Mars and Jupiter. These enterprising Nomads can remember in the 1980s when every video arcade in America had an Asteroids machine and a wiz who could play

> Whatever you can do or dream you can, begin it;
> boldness has a genius, power, and magic to it.
> —Johann Wolfgang von Goethe[1]

for hours on just one quarter. At the time, actual asteroids in space were entirely inconsequential, but now, with the Earth's resources dwindling, entrepreneurs will turn these rocks into riches.

Inspired by earlier science fiction futurists, Space Nomad entrepreneurs have already drawn up legal documents attempting to lay claim to this unfathomable stockpile of gold, platinum, and silver floating in space. Engineers are working on the technologies that will make it possible to tow these glory boulders home. The mass driver or electromagnetic catapult could be deployed to eject natural material from the asteroids at high speeds to propel these rocks through space. The staggering value of the entire asteroid belt is estimated to be as much as $100 billion for every person on Earth.[2]

Still, these ripe and ready-to-harvest rocks are the low-hanging fruit of the solar system. It has been estimated that with the rate of population growth, and a burgeoning, resource-thirsty middle class, along with the prospect of lifting the bottom billion out of poverty, existing natural resources on Earth may last only fifty years. Amazon founder and Space Nomad Jeff Bezos, in his high school valedictorian address, imagined heavy industrial activities and mining would naturally take place off-planet and be powered by the seemingly endless supply of solar energy in space. Planet Earth would finally get the relief she deserves and be designated as an international park in the solar system of the future.[3]

The first space entrepreneurs will most likely unleash their enterprises on the Moon because of its proximity and strategic location as a launching point to the rest of the galaxy. Space Nomads will use the Moon as a filling station to replenish oxygen supplies that will be extracted from the pulverized Moon dust through a new method called molten salt electrolysis. Lunar hydrogen will be extracted for rocket fuel, and building materials will be made out of the lunar basalt.[4] Some crater walls and the lunar poles receive very little sunlight and are thought to contain vast amounts of water ice, which will become vital to the early inhabitants of the Moon and other spacefarers passing through.

Certainly, adventurous Space Nomad prospectors, after getting rich by mining helium 3 and sending it back to Earth, will eventually move on from the Moon and glide to Mars in pursuit of other galactic fortunes, especially focusing on asteroids laden with titanium and other precious materials. Future mining operations on the Moon, on Mars, and in the asteroid belt will replenish Earth's resources, sustain space settlements, and wildly benefit the space entrepreneurs who chase these glittering dreams.

FLOATING SPACE HABITATS

Russian scientist and space visionary Konstantin Tsiolkovsky was first to realize that humans could comfortably inhabit space in enormous floating bubbles of oxygen.[1] Physicist Gerard O'Neill fleshed out the idea, demonstrating mathematically that Earth-simulated habitats floating beyond the shadows of planetary bodies could serve humanity best on the High Frontier. The location of these space colonies would be close enough to Earth to ensure ease of travel and trade and to avoid the communications delays that will hinder Mars. The space habitats' close spatial location to Earth will make them more ideologically similar to Earth, whereas the distance of Mars renders it completely free from those strong, often unenlightened influences. This total freedom will create a society drastically different from anything preceding it.

In an atmosphere of total liberation, Space Nomads may find themselves to be quite attached to the attributes of their home planet, which inspired O'Neill to envision floating habitats with the very best qualities of Earth while offering the vast improvement of the reliability of a closed and controlled atmosphere, thus eliminating a host of downsides on Earth, including pollution and bad weather.

The story of the distant future of humanity may very well play out with billions of people living in O'Neill capsules—some of which may be ten miles long—located in constant sunlight, allowing for uninterrupted free solar power. On the other hand, solar will be an unreliable energy source on Mars with its long-duration dust storms, and on the Moon with its two weeks of darkness out of four. The gravitational forces on these planetary bodies will always make transport more costly and difficult than structures floating in weightlessness, which only require docking ports.[2] These space colonies will be located in a stable orbit, and will be built of a strong exterior shell containing lunar regolith deep enough to grow satisfying trees and strong enough to withstand the weight of larger internal structures. Initially, lunar mining will supply the water, oxygen, and building materials for these self-contained habitats until more efficient asteroid mining comes online. Professor O'Neill imagined the interiors of the habitats to be highly manicured villages, probably a bit like Disney World, with individual houses having idyllic gardens. Certain capsules floating nearby would have alternate climate options to meet any desire, with free, easy transport between destinations. Other capsules may house nudist colonies, Quakers, and other like-minded Space Nomads living together in harmony. Food will be grown under the ideal conditions of controlled environments in smaller capsules

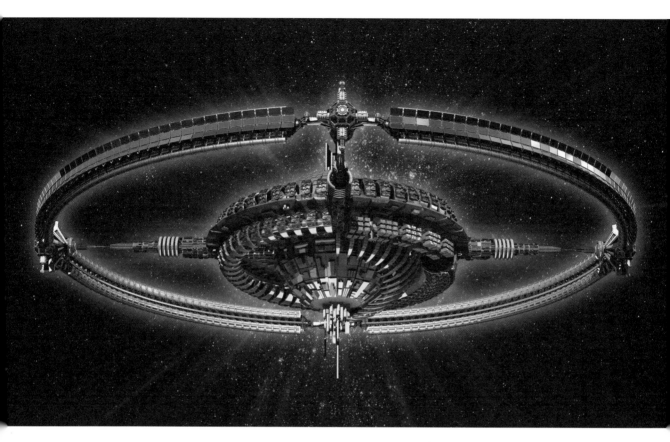

floating alongside the mother capsule for fresh local produce from every climate all year round.

Space habitats would spin in weightlessness powered by smallish engines to convincingly create simulated Earth gravity, with areas closer to the axis of spin enjoying less gravity for a new era of low-gravity recreational activities.[3] It's quite possible that the comparatively cramped quarters and lack of gravity on the International Space Station have kept the floating colony idea from gaining traction, but the truth is these habitats will simulate the best qualities of life on Earth and eliminate the downsides. All settlers will have a big window in their house to watch the stars and plenty of wealth to enjoy the good life. Anyone wanting the transformational freedom of weightlessness could go to a certain part of the capsule and "float up" for moments of visual bliss and other shifts in awareness.[4]

The infinite possibility of the future has room for settlements on Mars, the Moon, and in floating supersized environments. Space habitats could very well be how the majority of humans live much sooner than we think. In this scenario, the settlements of Mars and the Moon and the public park of Earth could easily become minor players on the vast stage of humanity's future. These planetary bodies may be relegated to sleepy tourist destinations and low-population arts colonies. The infinite resources of space will be crucial in supporting an unlimited number of floating settlements for millions of years to come.

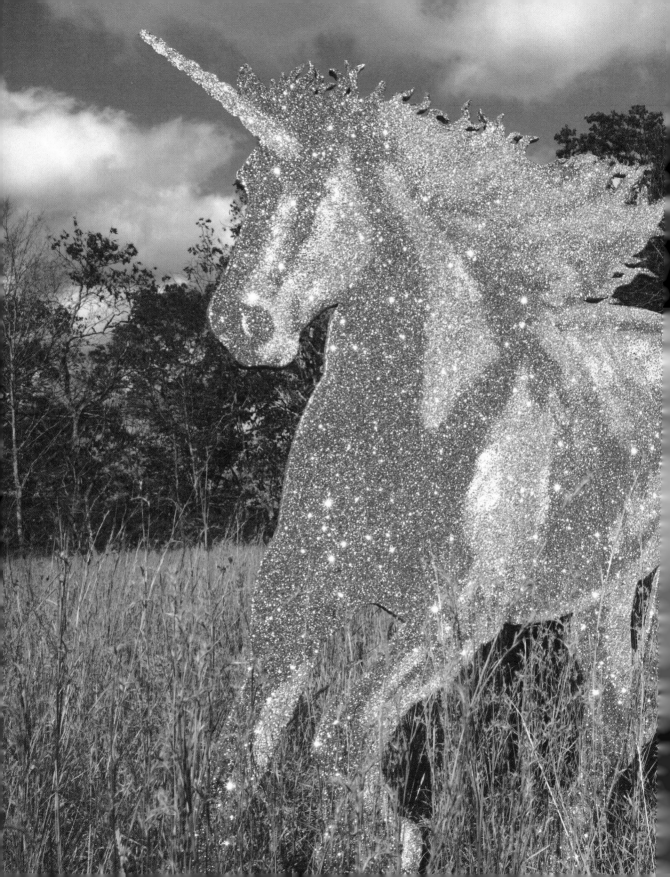

MOTHER EARTH PROVIDES

The more clearly we can focus our attention on the wonders and realities of the universe about us, the less taste we shall have for the destruction of our race.

—Rachel Carson[1]

Before the industrial revolution, human populations were both significantly smaller and occupied far less land. In the face of such vastness, there was no concern about depleting resources. In more recent history, even after exploring the entire planet, humans continued to believe that the Earth's natural resources were inexhaustible and that humankind could never alter the climate through its own activities. Now the truth has emerged that our behaviors are directly responsible for global warming, and that the forests can be decimated, the oceans' fragile ecosystems can collapse, the water table can be contaminated or run dry, and environmentally unsound petroleum, coal, and natural gas are expendable. The finite precious resources of Earth must be conserved through immediate lifestyle changes to provide for humanity's needs until technological advances allow the resources of outer space to be effectively accessed.

Certainly, Mother Earth's ability to provide for the current population is being pushed to the limit. However, with the help of science and technology, she *will* be able to feed all 9.7 billion mouths projected to be hungry in 2050, provided unnecessary food inefficiencies, food consumption, and food waste are reduced. The widespread use of genetically modified practices will become even more indispensable to create crops like golden rice fortified with beta-carotene with even higher yields, better nutritional value, and a smaller water requirement. Nomads against genetically modified organisms (GMOs) fail to recognize their importance when considering millions of people would have died of famine in the last twenty-five years alone without their use. Space Nomads are relying on science and bioengineering to provide solutions for food scarcity and better nutrition as they actively pursue these breakthroughs with an eye on their effects on the environment.

The West must also adjust its appetites. If the developing world's already gigantic and rapidly growing middle class aspires to the type of lavish life the developed world enjoys, available resources on Earth could not meet that demand. This is especially true with the skyrocketing demand for beef and pork. The world's emerging middle class must be led by example toward a vegetarian diet for its superior efficiency in delivering calories. There is mounting concern that future wars will be fought

over water scarcity caused by climate change, making it necessary to protect and conserve supplies rather than wasting 1,799 gallons of water per pound of beef and 576 gallons of water per pound of pork.[2]

Space Nomads are sensitive and highly attuned to the dangers of life on Earth, including the potential for food scarcity leading to widespread famine, when considering the uncertainty of the climate and the ballooning population projected over the next few decades. Effective, environmentally sensitive technological and scientific solutions are being pursued as fail-safes to protect earthbound populations. A mindset for Mars compels us to bravely reach further to solve these overwhelming problems. In the meantime, tastes and habits must change, including the desire to eat meat from an animal, which represents untenable inefficiencies continuing to have a deeply negative effect on the environment.

OUR FURRY FRIENDS

Adaptable Space Nomads are happily choosing veganism for the sake of the environment and their own improved health. A vegan diet will likely be the only option on Mars, given the categorical impracticality of herds of cattle in space. But regardless of whether our furry and feathered friends join us on the High Frontier (let's hope they do), choosing a vegan lifestyle is a direct way for earthbound Space Nomads to heed the calling of the future.

The transformational thinking brought about by space travel experiences and meditation simply won't allow the mistreatment of sentient beings. To avoid having to internalize that suffering, Space Nomads will work tirelessly to end the inhumane treatment of animals, especially factory farming practices that Yuval Harari, author of *Sapiens*, has called "possibly the greatest crime in the history of the world." Harari goes on to state that "biotechnology, nanotechnology, and artificial intelligence will soon enable humans to reshape living beings in radical new ways, which will redefine the very meaning of life. When we come to design this brave new world, we should take into account the welfare of all sentient beings, and not just of *Homo sapiens*."[1] Humanity's enlightened future on Mars requires living the Vedic Jainist ideal of revering animals and humans alike.

Veganism on Earth is the sensitive choice and stands as the single biggest step the average Nomad can make to reduce greenhouse gases beginning with their next meal. The Amazon Rain Forest is depending on us to switch to a plant-based diet, which has proved to be far gentler on the environment than clearing land for grazing or growing feed for livestock. It has been said that "if cattle were a nation, they'd be the third worst emitter of greenhouse gases."[2]

Breakthroughs in bioengineering will soon spare animal suffering by bringing stem-cell-grown solutions to meat lovers everywhere. A number of start-up companies have successfully grown animal cells into fine cuts of meat that are indistinguishable in taste and texture from the real thing. Finally this solution will put an end to the desensitization that occurs when humans participate in taking an animal's life.

On Earth there has been a perpetual cycle of suffering for both animals and humans, which we are witnessing come to an end. People have suffered ill health, heart disease, strokes, and diabetes by eating excessive animal protein; animals have suffered inhumane treatment and premature death for our culinary satisfaction. Some animal-borne viruses fatal to humans are spread through the cruel and unnatural animal-handling practices of wet markets, proving that there are consequences to putting nature out of order. The suffering con-

tinues with the undernourished of the world going hungry while 80 billion head of livestock are slaughtered for food each year, having consumed untold billions of tons of life-giving nutrients.[3]

The wheel of suffering can be slowed and eventually halted by embracing veganism until cruelty-free meat protein is widely available. This shift to laboratory-grown meat will also spare the PTSD and other psychological trauma of the five hundred thousand people who work in the 2,500 slaughterhouses in the United States alone.[4] Billions of dollars of government subsidies have kept the price of meat unnaturally low, which has perpetuated this cycle of human and animal suffering. Space Nomads are hoping regular meat will soon be levied with a "sin tax" designated for unhealthy luxuries like cigarettes, which will help push trends away from cruel and environmentally unsustainable habits.

Our culinary future in the Milky Way will follow Michael Pollan's guidelines of "eating food, not too much, and mostly plants."[5] Space Nomads headed for Mars will be more concerned with their own fitness, overall health, and wellness out of deference to consciousness and will use food as medicine for the body while keeping it as delicious as possible.

RECOVERING FROM MATERIALISM

Nomads are recognizing that their insatiable desire for possessions is causing feelings of separation from others and a sense of alienation from the healing qualities of Mother Nature. Earth has been objectified, her flora and fauna disrespected, her natural resources plundered. Humanity's cavalier attitude can be blamed for the destruction that has left the natural world in its current, vulnerable state. Native Americans and other sensitive cultures believing in human connectedness and a life force present in all things understood this and exhibited more reverence for one another, the land, and animals.

Unfortunately, the rise of the individual ego has resulted in a backslide in awareness that can be blamed for much of the destruction of nature. Countries with the highest income inequality experience the most psychological poverty. Stuck in the ego-induced grind of sinking all available energy into acquiring and maintaining personal possessions and going into debt to pay for it has left many Nomads increasingly alienated from one another and in despair. These Nomads have forgotten that human relationships bring the most fulfilling type of joy. Societies could use a hard reset for their own well-being and for the environment, which can no longer support these consumptive habits.

The Millennial generation seems to be more attuned to these truths and shines as a great beacon of hope in its favor of personal relationships and experiences over possessions. These post-materialists realize that "less is more" by renting smaller, hassle-free apartments and engaging in the share economy. They rely on technology for entertainment, and turn to each other for love and support while placing value on nature and art for emotional healing.

Space Nomads are rejecting their former consumptive lifestyles as they convince others that material objects keep authentic interpersonal joys out of reach. The Space Nomads lucky enough to board starships will find it necessary to leave all luggage behind on their spaceflights due to weight restrictions and cost. The process of physically detaching from these worldly possessions coupled with shifting perceptions of actually detaching from Earth may allow for a "realization moment" that human connection and love are all that really matter in the universe. These Space Nomads, after returning to Earth, will inspire others by making life choices adding up to a Zen lifestyle and a greatly reduced carbon footprint as they pour more energy than ever into relationships.

To thrive, we must all begin to realize that the mysteries that lie within one another and in the greater universe are far more interesting and

bring more satisfaction than material possessions ever could. Connectedness breeds compassion and a love that permeates through each person and animal as well as the environments that nurture them. On the stage of enlightenment, love reigns; materialism has no audience.

WOMEN: THE KEY TO THE FUTURE

Women make roughly 85 percent of household spending decisions, giving them much more power to shape the future than they realize.[1] Their choices drive the economy and determine which companies flourish and which companies fail. Contemporary consumers have more choices than ever, but women are doing the work to become more discerning shoppers as they increase demand for organic groceries with vegan options, and for electric cars, Energy Star appliances, local and ethically sourced products, and humanely raised meats and poultry.

To be competitive in the marketplace, corporations have no choice but to retool their thinking to satisfy these shifting tastes. It's important to remember that purchasing the more expensive, organic, and ethically sourced products will increase demand, resulting in economies of scale that will allow these products to be affordable to a wider range of shoppers.

Women Space Nomads have the power to usher in these new trends as well as to bankrupt the companies guilty of environmental abuses by refusing to buy their products. Slowing the overall demand for material goods in general by making fewer purchases will demonstrate leadership to the developing world. These impressionable consumers will begin to see the wealthy countries they admire shifting their tastes as they increasingly value simplicity and minimalism over their former consumptive lifestyles. Women must drive this paring down that's so vital to conserve natural resources on Earth[2] while also betting on space entrepreneurs to develop the living options and resource opportunities necessary to make life in space possible over the long term.

Women Space Nomads are planning for the future through their choices and their stock picks as they embrace the most futuristic technology and the best food, health care, education, and wellness experiences. Andy Warhol's reminder to "think rich, look poor" inspires Nomads to no longer count wealth in possessions but rather to conduct themselves with humility and authenticity.

It's up to women to realize they are behind the wheel, steering humanity into an elevated future by deciding elections, and determining consumer trends that are in alignment with a mindset for Mars. As more women gravitate toward science, technology, and the idea of reaching for shifts in awareness, the breadth of possibility for the future expands in those specific directions. If women decide they want universal consciousness and artistic expression, that will be our future.

THE TEXTURE OF THE FUTURE

Imagination and creativity live in the exciting world beyond the rational mind, making the immovable language of science, with its stringent arsenal of understanding, inadequate in explaining certain phenomena. A mindset for Mars, designed to spur humanity's progress, is dependent on its attraction to these creative mysteries as well as to the disciplines of science and technology that will give these ideas their tangible shape. Settling on Mars is an act of raw imagination, shining with infinite possibility but also deeply dependent on the engineer's scientific mind. The future depends on these disparate approaches working together more closely than ever before to forge new understanding. Creativity is being freed to take flight, as it bravely defies rational thought by putting blind faith in its own sometimes illogical innermost knowing but, alas, these ideas must fall back to Earth so they may endure the rigors of the scientific method for true technological progress.

The sacred realm of inner knowing already possesses everything necessary to elevate humanity; however, Nomads are only beginning to find ways to convince themselves of these powerful truths. They are finally sending internal search parties to locate their creativity so it can blaze a trail of light into the future. The very process of imagining provides clues or access points to the elevation humanity seeks, glimmering in the distance from time to time, which keeps us tracking and occasionally catching these iridescent unicorns of progress. Future civilizations on Mars will be pulled into reality and spoken into being through the languages of poetry, painting, sculpture, music, and virtual reality, as well as scientific breakthroughs in equal parts.

By traversing the vast landscape of the imagination, one begins to realize it is truly without limit, like the expanding cosmos. The close alignment of these realities is not to be overlooked, and by meditating on the notion of infinity during moments of quiet, the hungry, creative mind begins to feed itself. Elements that cannot be quantified, such as love, art, mythical beliefs, and some quantum effects, exist where heightened consciousness and deeper understanding behold one another in timeless awareness.

Broadened awareness is being carved from the rock face of ignorance through creative pursuits as well as hard science, each one informing the other. The overlapping edges of pure imagination and scientific breakthroughs are apparent from time to time and lost again in the larger form. Ultimate purpose emerges as a motivating shard of light in the darkness reminding us that the just societies on Earth and Mars already live inside our

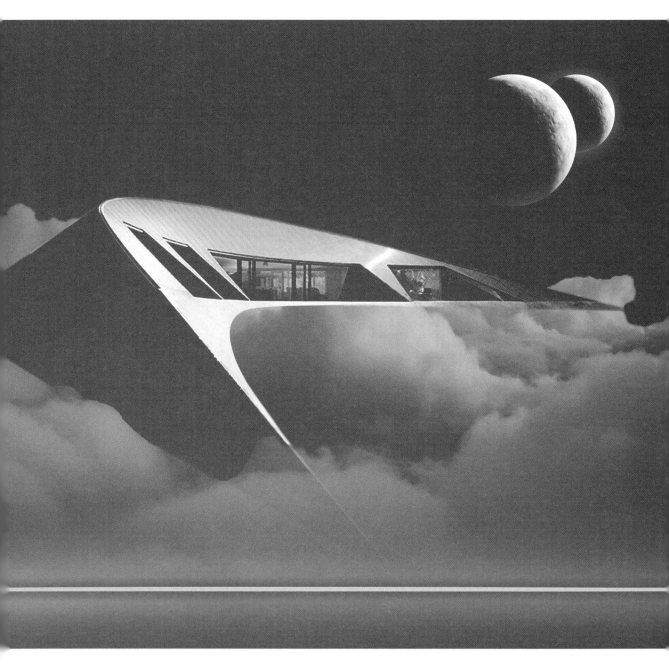

hearts. We must each do our part to reach for this place of higher knowing and bring it forth through the arts and sciences, which spring from that same source. A mindset for Mars dares us—it emboldens us to believe that we are capable of this exalted work. We are the light of a thousand suns and to shine is our destiny.

ART CALIBRATES HUMANITY

Inside you there's an artist you don't know about. . . . Say yes quickly if you know, if you've known it from before the beginning of the universe.

—Jalāl ad-Dīn Muhammad Rūmī[1]

The cultures of Earth have always had emotional yearnings that artists, through their creative endeavors, have sought to fulfill. The philosopher Friedrich Schiller pointed out that the people of ancient Greece expressed little interest in landscape paintings of their time, since that particular emotional desire was satisfied by the abundant natural scenery. Greece's historical obsession with figural work reveals the fascination with interpersonal relationships and the unending quest to understand those interactions on a deeper level.[2]

A restless state of seeking portends a natural imbalance of emotional energy, which, like a listing boat, must be righted or else fall into jeopardy, risking captain and crew. Art functions as a pulley to lift us into better emotional harmony by offering a snapshot, a finite vision of humanity or nature that will help provide answers to subconscious quandaries as well as access points to greater freedom.

Our reaching for Mars is an artistic as well as scientific pursuit. Technological considerations aside, creative inspiration similar to what our early ancestors must have drawn from petroglyph drawings will meet the new emotional needs as it did for those ancient artists, defining early man's healthy sense of self. And as we reach out for Mars the arts will, again, propel our inspiration higher as the authentic path reveals itself. Perhaps the Space Nomads of the first colony will feel nostalgia for their mother planet and want to gaze at artworks depicting Earth's natural beauty, but most likely each Nomad will become an artist yearning to express new emotions brought forth by the Martian world.

For now, of course, earthbound Nomads are longing for art that will give shape to their feelings and imaginations. Many Nomads intuitively understand that one planetary body is simply too small for their creative minds. That notion alone will inspire them to reach higher and explore farther into the galaxy in pursuit of new channels to mental freedom such that they can envision an entirely new future in another realm.

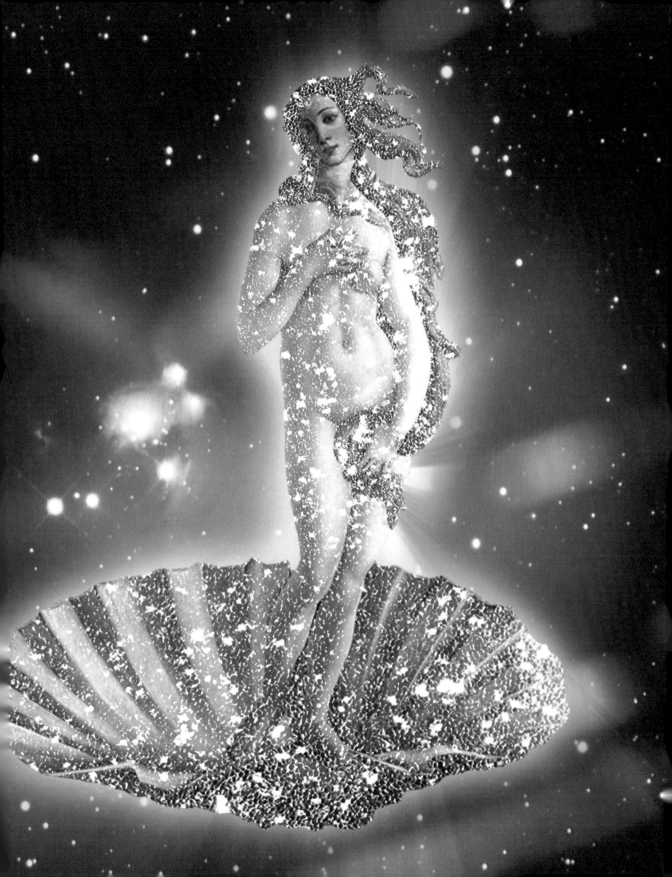

THE FUTURE IS NOW

The present moment, teeming with possibility, is eagerly awaiting our embrace. It stands as a springboard from which to launch into an odyssey aimed at Mars, and by extension into the full potential of our infinite power. The entirely present "Now" demands liberation from the suffocating stories of the past, which threaten to diminish our light so fully that from time to time we may find ourselves fumbling in the dark.

Peeling away layer after layer of negative backstory reveals the self to be more vulnerable and sensitive than we may realize. Those negative memories are better left on the ground, making it easier to remember that we remain deeply worthy, even in the face of those shortcomings. We are beings whose innermost selves require compassion and forgiveness in order to have the nerve to get back up, dust off, and dive in optimistically to meet this great moment of human expansion. Such tenacity—along with our ability to reframe wrong choices, bad luck, or other shortcomings into instructive life lessons—offers the positive effect of making negative experiences extremely useful. A mindset for Mars uses any tricks necessary to keep pushing ourselves onward with great optimism into the future.

Negative self-stories of the past are nothing more than stealthy double saboteurs of the present moment, as well as the infinite possibility of future moments.

Breathing life into the meta-possibility of settling the solar system, beginning with the Moon and Mars, requires a mindset not restricted by former limiting thoughts and the negative self-stories of the past. Corrosive internal narratives can cast their long shadows dangerously far into the future. Fragments of the past that do not serve the present must be revisited, reevaluated, and reduced in significance in order to protect the sacred open space of the future—because a mindset free to run with the unicorns of possibility has a tendency to shatter all restraints.

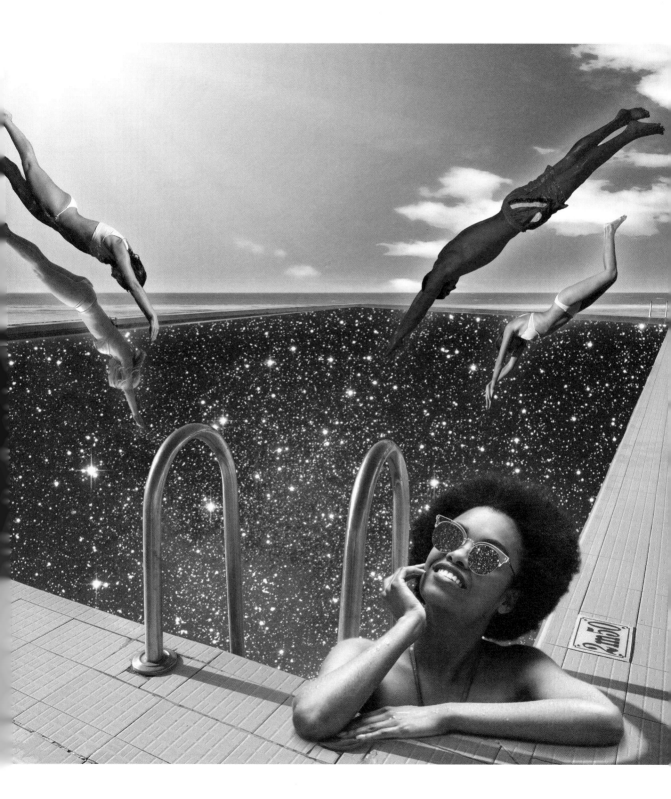

A PORTABLE RAINBOW

Space Nomads are working to keep a positive outlook even when the climb seems to be uphill in all directions. This is the secret weapon of humankind's spacefaring future: unstoppable, optimistic Nomads boldly applying the full cognitive power of their transformational thinking, which intuits the connectedness of all matter. From that height, working for others' transformations is easy and obvious. A highly constructive outlook along with a generous heart eager to solve the problem sets of Earth and Mars out of compassion and love for humanity will surely open the High Frontier.

Since well before standing on two legs, *Homo sapiens* have been naturally predisposed to the negative paranoia of a "scarcity mindset," which has made it difficult to let the good times roll—this can be blamed on the natural selection of the species and evolution. The easygoing apes who were busy enjoying hedonistic banana parties on the jungle floor didn't fare nearly as well over the last 25 million years as their cranky relatives who nervously kept watch from the tree canopy expecting, and thereby avoiding, catastrophe.[1]

Humankind's anxiety-inducing tendencies toward negativity have aided survival over millions of years, but now must be cast aside, allowing Nomads to step into greater optimism and overcome this damaging gloomy-primate syndrome for the sake of progress. Assuming the worst does little for humanity in our current evolutionary moment; rather, it blocks intelligent responses while fomenting overly emotional reactions that negatively impact problem-solving. The binary fight-or-flight behavior rightfully limits access to the prefrontal cortex for brevity's sake in life-or-death situations. On the contrary, states of happiness and optimism have been demonstrated to access more areas of gray matter. Getting someone to tell you a joke, thinking optimistic thoughts, and even fake smiling have been shown to allow better outcomes during high-stress situations.[2]

Visualizing a portable rainbow over your head to keep intelligence in charge may take a lot of mindful effort, but the future of humanity depends on greater optimism and the enhanced social relationships that lead to more happiness and better decision making. Our natural inclination toward negativity, worry, and scarcity must be replaced with an optimistic mindset for Mars if Space Nomads are to truly help one another reach for the stars. We must constantly remind ourselves that we are at the top of the food chain and that we have everything to lose, including our intelligence and compassion, by succumbing to fear.

Just trust yourself; then you will know how to live.
—Johann Wolfgang von Goethe[3]

TRUE DESIRES OF BODY AND MIND

Space Nomads' mindset for Mars is inspiring others into more self-actualization and bravery so we may be the center forwards in our own lives rather than watching from the sidelines out of fear. This capacity has always been within reach, yet unfortunately has remained at arm's length largely due to fixed thinking from being raised in static environments. This has led to a lack of confidence in our own ideas, a lack of belief in our own worthiness, and—it must be laid bare—a fear of our own greatness.

Authentic communications and the true desires of body and mind are continually being sabotaged by outdated societal constraints. The mores and social structures of the European "old world" were well established, leaving little room for citizens to contribute their individual ideas or make changes to better suit their needs. Alternatively, on the new frontier of America individuals had a life-changing opportunity to work together as active participants exercising freedoms and building a new world based on a more satisfying set of values and needs.[1] These efforts driven by freedom of thought and self-government built the most admired and freest humanist societies in the world. For real progress to lurch to life, humanity needs to be unconstrained in thought and action; we will truly flourish by exploring, discovering, and contributing to the societies of our own making. Reaching for our new space frontier and the transformational thinking it brings will change us so much for the better that old ways of thinking and doing will quickly be retired in the name of progress. Our new worlds on Earth and in space must be built with a mindset willing to abandon the dated traditions of unsatisfactory societies as a vital part of our psychological well-being. The earthly suppression of authentic desires such as human affection has led to widespread emotional instability, which keeps the wings of our spirit clipped. Society, family, and tradition dictate certain mores that override our internal cues about how to live a fulfilling life. We know it's time to cast off these antiquated shackles running contrary to human happiness, especially since they've left behind a mountain of generational suffering.

Freud points out that we take these norms of conformity into our ego and restrain the integral, important, subconscious id. Imbalance on the side of caution or control causes stagnation; imbalance on the side of pure desire causes chaos. By moving past the societal controls, we can step into the innate sense of integration and become more effective and more constructive. Transformational thinking intuitively knows the perfect balance, and the mind of enlightenment soars high above it all.

The necessary self-actualization of a mindset for Mars requires that we tune our awareness to in-

ternal signals and act on those messages as a rule. Honoring our inner voice will naturally bring feelings of worthiness as well as occasional glimpses of our own exaltation. Along the way, fear begins to dissolve as we realize that being human is enough as we place greater value on our own perspectives. We begin to embrace our identity, our individuality, and the self-love long buried, which now can emerge. This transformational molting allows love to embolden us as we cease to care about narrow societal judgments. Naturally, we begin to feel compassion for those caught in that crippling web, and we work to set them free.

Celebration is in order, for this is the most exciting epoch in human history, the one where humans finally begin to respect their own powerful inner voice as they harmonize with other actualized voices in humanity's cosmic choir. It has never been more important to lovingly embrace who we really are, and what we want to become.

INTEGRITY: A PREREQUISITE

The honor system is an act of human perfection and beautiful to witness at the self-serve farm stands of summer, where nothing but a glass jar marked "donations" and your conscience mediate the transaction. Space Nomads and others who possess great integrity are the foundation of desirable societies, and luckily, these people make up the majority on Earth; otherwise societies and economies with their transfer of goods would never have gotten off the ground. Humans, by virtue of having evolved within social settings, have an innate understanding of the priceless value of integrity in their human interactions.

The Space Nomads organizing to reach Mars hold integrity in high esteem. In the future, these colonists will gravitate toward fellow members who demonstrate honor universally, since survival will be dependent on reliable neighbors, as every early colonial situation has demonstrated with varying results. It helps to remember that there is no better time to begin anew than in a colonial setting; bad habits and actions running counter to compassion, civility, and progress can be abandoned at the starting gate and a new paradigm of honorability can become the guiding rule in space.

The quality of Space Nomads' future in the cosmos depends on the type of individual who takes the initiative, from small tasks to great endeavors. Carl Jung said, "You are what you do, and not what you say you'll do."[1] A person speaks roughly ten thousand words a day, often making declarations of their intentions, which become clear windows into a person's overall integrity. People of consequence understand the power of words, taking special care not to overstate or make false promises. Operating with a consistently high level of core honesty takes discipline, a trait that is highly valued by the Renaissance people of the future. Space Nomads with a mindset for Mars regularly practice this ideal, allowing them to enjoy the esteem and cooperation of their neighbors, as well as the resulting atmosphere of peaceful satisfaction.

A clear conscience is the result of true integrity, allowing Space Nomads to fly high above the turbulence into the smooth air of creativity. This expanded state of mind must not be sullied or reduced by the base activity of conjuring excuses for inactivity. Aristotle speaks of the "weakness of will" as the culprit causing this inert state.[2] The will must be exercised regularly, like a Thoroughbred, so when it's put to the test, the necessary stamina can be relied upon. Harmonious societies undertaking lofty endeavors require systems of Nomads relying on one another to meet common goals. Reaching for a unicorn future worthy of human consciousness will require a highly ordered network of like-minded people with individual points

of view who value scientific fact and believe in the power of technology to transform humanity. Groups that function well together rely on universal trust and truth. Large systems of Space Nomads harmoniously working together are required to develop the habitats and mine the resources of the High Frontier. Only with high degrees of trust, integrity, civility, and dignity can the development of space be done to meet the expectations of transformed Space Nomads.

BAKING THE SPACE CAKE

Why shouldn't we be able to have our cake and eat it, too? Having it all is our birthday present from the universe and the way of our human future. The cosmos has given humanity the possibility of supreme knowing by designing the cosmos so we may leave Earth to meet it. The universe seems to yearn for this moment and for our bliss and satisfaction, imminent with the self-realization of the connectedness of all matter. We were born to enjoy our transformational birthday cake of higher knowing; it is ours to bake and frost; its key ingredients—unbounded thinking, unbounded joy, unbounded unity, unbounded compassion, and pure consciousness—are bright with alchemical mysticism, building layer upon layer all the way to Mars.

Alienation, stasis, fear, ignorance, small-mindedness, inaction, nonconstructive criticism, and paralyzing risk aversion are ingredients not to be found in the cupboards of space. Only the most sublime ingredients, those leading to deeper understanding and expanded consciousness, will be folded in. Flavors of love, integrity, sensitivity, mindfulness, kindness, truth, justice, intuition, intelligence, grace, action, trust, creativity, and freedom will be baked in, and once out of the oven will explode with each bite.

The sooner humanity can internalize the recipe for this divine confection of the future, the sooner we can experience the transformational unity and love that has always been ours.[1]

The soul should always stand ajar, ready to welcome the ecstatic experience.

—Emily Dickinson[2]

UNIVERSAL LOVE FOR THE FUTURE

PART 3

THE SOCIETY OF OUR DREAMS

We are born of love; love is our mother.

—Rumi[1]

Space Nomads reaching for Mars are beginning to recognize their own spirit force to be no different from the limitless essence of the universe. This newfound perception of power and connectedness is lifting them toward unparalleled love, deeper self-knowledge, and unity born of a greater sense of belonging. These future human Martians are expanding their mindset by reaching every day for their own self-actualization, just as a virtuoso violinist must reach every day for their instrument. The higher self is burning for progress and boldly asking for what it wants; this time it refuses to be limited by the stasis of self-doubt. Transformational thinking washes away all self-limiting behaviors as Nomads naturally begin to avoid the exhaustion of inauthentic ways of being toward others; pure consciousness won't allow it. These unevolved states of being will rarely occur on Mars since a crystalline sense of unity and transparency among all Nomads will be palpable in the atmosphere of enlightenment. Fully embracing the connectedness of all matter in the universe becomes a fireworks display of authenticity and broadened awareness as we free ourselves from the anxiety of perceived alienation. Freedom from this erroneous point of view brings the fulfillment we've longed for, as we fall in love and merge with our divine, highest self. This self is exactly the same as the highest self of all others and made of the same essence.

Space Nomads are bravely plumbing the depths for their own inner truths in preparation to enjoy kinder, gentler, more compassionate relationships with all sentient beings—including the Nomad in the mirror. Our blissful future in the solar system depends on the quality of the relationship we have with our own spirit force as well as our sense of belonging; learning to see that our true nature is connected to each and every being as well as the universe that collectively unites us is all we really have to do to rise above suffering and into pure joy.

Familiar Buddhist iconography depicts the knowing smile on Buddha's face at the moment of finding the causes of human suffering: ignorance and attachment. Changing his name to Shakyamuni Buddha, he came to realize under an Indian bodhi tree that unhealthy attachment to the ego causes selfish desire for material possessions, leading to alienation from one another. This painful sense of separation always causes unhappiness. Buddhism teaches us that perceptions of alienation are based in ignorance and the truth of the

Universal Love for the Future

connectedness of all matter makes true alienation impossible.

Twenty-five hundred years ago, Shakyamuni began to teach the precepts of Buddhism by outlining a clear road map to overcoming this unhappiness and ending the cycle of suffering. At the time, these ideas were considered educational rather than religious. Buddhism's Eightfold Path to Enlightenment has created gentle, peaceful societies in India, Asia, and most spectacularly on the isolated plateau of Tibet before China's invasion in 1959. The Eightfold Path leading away from suffering and into enlightenment includes right view, right livelihood, right effort, right mindfulness, right speech, right conduct, right resolve, and right Samadhi (meditation or absorption into essence).[2]

At the height of its peaceful enlightenment era under the Great Fifth Dalai Lama, beginning in the seventeenth century, Tibet encouraged the development and transformation of the individual through enlightenment education. Tibetan scholar Robert Thurman explains that this type of "bottom up" governance assumes that if each person is being sincerely supported by members of the community on their personal path to enlightenment and to greater joy, the state will flourish as a whole.[3] For hundreds of years, the highest goal of the Tibetan government was enlightenment for all citizens, who, out of compassion, helped one another along their paths. In such an atmosphere of transformation it became unnecessary to have a standing army when considering that the citizenry was steeped in peace on such a level that they could not go against Buddhist belief by engaging in any form of violence. In the sixty years since the brutal Chinese occupation, Tibet has demonstrated great dignity and compassion by refusing to fight for their homeland on principle. Tibet's peaceful protest continues to inspire nations on Earth and will never be forgotten as a point of inspiration for societies in the galaxy into the distant future.

The settlements on the Moon, on Mars, and in space will be naturally positioned to continue the legacy of Tibet's enlightenment era. Aided by the transformational awakenings of the overview and breakaway effects, Space Nomads' transformational thinking will accept nothing less than the creation of a "Buddhaverse": a society that prizes enlightenment for all as the highest ideal through the development and support of the individual.[4] Feelings of alienation from others and from the biosphere will be revealed as "misinterpretations of reality" as the general population meditates on the connectedness of all matter.[5]

The extreme proportions of the military

> We are here to awaken from the illusion of our separateness.
> —Thich Nhat Hanh[6]

buildup worldwide over the past many decades, along with the widespread suppression of individual rights, have exhibited the polar opposite of what an enlightened society could be. It's no secret that human happiness is contingent upon personal freedoms and the opportunity to develop individual gifts. Under the influence of Buddhism, Tibetan society's highest goal remains the support of the individual, to set them free by uplifting them, educating them, and placing extraordinary value on their happiness. Monks, teachers, and ordinary citizens guided by their own careful inner development continue to stand in support of others along their journey on the Eightfold Path. In this way, reverberations of enlightenment will echo through the societies of the galaxy.

The Fourteenth Dalai Lama remains a beacon of hope lighting the way to peace on Earth as well as our peaceful future in space. Space Nomads heading to the unexplored frontier of Mars will use their intuition guided by transformational thinking while leaving behind all limiting notions as they build the freest, most satisfying art- and science-centered societies to date.

ENLIGHTENMENT EDUCATION FOR SPACE NOMADS

The pursuit of enlightenment is for the purpose of the world, not merely for the purpose of the individual. Practices for enlightenment must lead to action in the world.

—Bernie Glassman[1]

The success of the future societies on Earth and Mars depends on individuals who engage in lifelong learning, not just to understand the world around them, but to develop and embrace their truest, highest selves. Accessing the transformational frontiers of consciousness through meditation and diligent study will become the highest goal of education in the future and will be necessary to develop the physical frontiers of space. Education in the future will always be a lifelong pursuit, keeping Space Nomads vital in a rapidly changing technological environment. Older generations will work hard to absorb and adopt new technologies rather than shying away, as people are in the habit of doing on Earth. Education in space will also be devoted to elevating our humanity by helping us be our best, most compassionate, enlightened selves for the sake of others. The basic education of the future will encourage broad lifelong intellectual pursuits, including the sciences, humanities, technology, and the arts in equal measure. This synergy of disciplines leading to broader understanding will reflect the unity of all matter and the connectedness of all people and all cultures. An educated Nomad in the future will have facility in both the arts and sciences rather than focusing on one area of study and ignoring the others. Scientist Sir Charles Snow raised the alarm about a "sharp division between the two cultures" in the late 1950s and lamented the lack of overlap between the humanities and science that he felt was vital to solving the complex problems of the future.[2] The technological worlds yet to be built depend on a higher level of literacy, fluency, and understanding than ever before. The unfettered future societies in space must be intellectually equipped to take advantage of this newfound mental freedom. The true liberty of an enlightenment society should not be confused with the strict constraints of utopia, which are often laden with protocols rendering its members bound to preexisting structures and therefore not free.

Space Nomads will tailor the new educational environment on Mars as they see fit, taking great care to keep educational styles fluid to incorporate new learning tools and pedagogies. Multiple intelligence, or the idea that each Nomad is an individual thinker and must be supported in a specific way that resonates with their interests and learning style,

will be even more important in an atmosphere of uninhibited thought. Developing and protecting a sense of confidence in the educational environment will also be paramount by remembering that without confidence, creative ideas often lie fallow. Disciplines will be prioritized in the way they support individual transformations for the sake of others. Societies centered on the development of the individual for collective elevation have genuine concern for the individual's mental and physical wellness. Enlightenment education will work to elevate the whole person, in this way preparing humanity to become its best manifestation, which will ready us to move meaningfully into different parts of the galaxy in pursuit of peaceful contact with other consciousness. Finally, we will become who we really are: an

advanced technological race of enlightened beings whose gentleness, compassion, love, and understanding become mythic in the universe, inspiring distant races to seek out the Milky Way to meet us.

The idea of achieving enlightenment in this lifetime runs contrary to certain religions of the world that do not put enough faith in the individual. These beliefs have undermined human potential and can be blamed for slowing human progress. Personal development through education during periods of history, such as the rise of Catholicism in the Middle Ages, was completely out of the question, while much of the precious knowledge and understanding gained before that time became heretical. Value in that era was placed strictly on the study of religious doctrine. The vast knowledge of the ancient world was considered a threat to the church and to God himself. Across medieval Europe, the church's control of the people was paramount, with no concern for the individual's development whatsoever—their suffering was often seen as a sinner's rightful punishment. Monarchies and the church historically preferred uneducated citizenry who were simply in service of and willing to sacrifice themselves for the greater good of the state.

In the sixteenth century, Martin Luther's Reformation moved the needle in the other direction toward valuing the individual, supporting education, and reviving personal liberties. Finally, with the rise of the European Renaissance in the time of Leonardo da Vinci (1452–1519), the individual began to matter for their talents and their "inherent goodness." Humanism originating in ancient Greece gained a larger following with the pursuit of individual happiness as the highest goal. This movement, having been violently suppressed throughout medieval times, finally began to gain a foothold in the schools of the Renaissance. After centuries of ignorance, education began to demonstrate positive change in the individual and, by extension, society at large.

Our future on the High Frontier will continue the present trend toward less organized religion as we remember the warning in Yuval Harari's *Homo Deus* that "the greatest threat to law and order is people who believe in God and his plans."[3] On Mars, a spirit-centered way of being will naturally flow from transformational thinking, allowing Nomads to thrive by embodying the freedom beyond their own thoughts.

The academic pursuit of the arts and humanities can be credited with giving open access to the human spirit. This deeper self-knowing is vital for building new worlds and is inspiring science and engineering Nomads to pursue liberal arts educations as well. At the opposite end of the spectrum from learning a trade, a liberal arts education is a

great luxury afforded to too few people on Earth; however, never before has an inclusive education been accessible to the diligent for free on the internet. Spacefaring societies of the future will push for populations to be educated in diverse ways, allowing for greater open-minded acceptance of cultural differences, which will reveal the commonalities people often fail to recognize. This thinking will trickle down to Earth in a great wave of education reform. In the "universal embrace" of the cosmos, trifles like religious orientation, gender, race, and caste will be rendered invisible, finally giving each person truly equal value.

The average Space Nomad is aware that a lifelong pursuit of knowledge is necessary to elevate humanity into the stratosphere. Long after the troubles of Earth are eradicated and a successful Martian colony flourishes, Nomads will be in high pursuit of the knowledge necessary to meet other great moments of expansion on other frontiers in the future. Elevating each individual's present level of fact-based knowledge on Earth will allow human dialogues to become more nuanced and, by extension, more profound.

Individuals lose their identity when tribal instincts are utilized to foster a rising tide of anti-intellectualism and religious fundamentalism on Earth. We've all witnessed retrograde social evolution in the recent past, bred by intolerance, judgment, misogyny, and other pernicious hate. The black-and-white thinking of anti-intellectuals erodes mental faculties and disables complex reasoning. As a result, dangerously simplistic arguments are preferred in many of our present dialogues, and faulty arguments devoid of logic become commonplace. Anti-intellectuals often eschew education with little grasp of causation, and they rarely think about consequences. These Nomads are easily swayed by false promises, tough tribal talk, bravado, conspiracy theories, and other fake news.

The enlightened societies emerging on Earth and, eventually, on Mars will mine the depths of the human spirit to build worlds that encompass all human needs, desires, behaviors, and love as never before. By reaching for every tool possible to quench a bottomless thirst for knowledge both internal and external, Space Nomads will prevail in reaching elevated states of understanding and awareness for themselves as they encourage others. Space Nomads are sworn to protect knowledge, to value it, and to fight for it through nonviolent means. They are committed to preserving the precious understanding accumulated throughout human history while making their own significant contributions. By reaching for Mars we will usher in a glorious new era of understanding, tolerance, peace, satisfaction, and joy for millennia to come.

THE CONFLUENCE OF ART AND SCIENCE

Humanity's exquisite future depends on the cross-pollination of the arts and sciences, and the creation of new disciplines and areas of expertise. This experimental frontier of new ideas will be formed by the most creative and impassioned intellects whose innovative viewpoints are setting the future in motion. Already Yale, Harvard, and other top colleges are scouring the world in need-blind fashion for the next generation of leaders and innovators who will be admitted by their merits, on the basis of unique demonstrated passions and leadership.

In an address in the fall of 2019, Yale University president Peter Salovey outlined the areas of study he believes will be instrumental in finding groundbreaking solutions to humanity's present-day shortcomings. He pointed to technology in general, data and computational science, neuroscience, and planetary health. He also highlighted the idea of the future being built on entirely unforeseen areas of study born of the convergence of the humanities and the sciences as well as of the intersection of technology and art. The labor market of the future will require an increasingly narrow focus on specialized skills, and these students are forging the way to invent future solutions on Earth and Mars. These Nomads will also be the new breed of entrepreneurs, with one foot on the platform of science and technological understanding while the other is running with the unicorn stampede of mind-broadening artistic pursuits. The students best equipped to straddle these worlds will have the greatest chance of envisioning and actualizing a future built on entirely new causeways of understanding.[1]

Top scholarly institutions have made it their priority to canvass the world for the brightest, most original minds who will be educated in preparation for galloping us all into the future. These Nomads are highly motivated to improve the human experience, often returning to their countries of origin to begin their impassioned life's work as agents of change. Yale admitted Nomads from 130 countries in the class of 2023, and Harvard admitted students from 89 countries in that year, which demonstrates an earnest commitment to diverse perspectives. These international students will spread a love of education, free speech, equality, and the value of liberal democracies back to their countries of origin around the globe.

RECALIBRATING TO THE SPIRIT

The elevated future we seek is being built at the convergence of science and consciousness. A vital rebalancing of scientific and spiritual thought is awakening Nomads to the mysteries of the universe and to greater sensitivity as we begin to care for Earth as we would our own mother and for humanity as our brothers and sisters. Only a spirit-oriented perspective can temper the rigors of scientific thought, which can threaten to diminish our sense of mystic unity in the cosmos.

It is becoming clear that scientists may have gone too far in assuming they can rationalize the entirety of the universe or assert that the human brain is nothing more than cosmic particles arranged in varying degrees of complexity. If matter simply consists of molecules and atoms devoid of essence, the reasons to regard the natural world and one another are drastically reduced. In this light, the act of killing somehow becomes less terrible. Consciousness and love remain, for now, outside the confines of science and continue to define the meaning of humanness in the universe. Miraculous consciousness has a way of confounding the scientific community by refusing to conform to the scientific method. Consciousness cannot yet be diminished in its all-pervasive, seemingly incomprehensible ability to unify. Precious perceptions of unity are the unicorns leading us to peace on Earth and in space. The mind must find ways to see a spirit connection among all beings and wholeheartedly believe this truth; otherwise there is little reason to care deeply enough about strangers to work for their transformations. If consciousness is seen as unworthy of protection and populations fail to perceive human connectedness, humanity becomes highly vulnerable to conflict.

If the matter making up the biosphere is not imbued with an inexplicable essence that gives it inherent value, it becomes ripe for exploitation, as demonstrated by the plundering of natural resources and the compromising of the natural environment. This exploitation driven by the rise of materialism continues to manifest in self-destructive behaviors including gluttony and excessive consumption leading to debt, and depressive tendencies.[1] Transformed Space Nomads are awakening humanity to the spirit, which will move consciousness away from exploitation and into a fulfilling relationship with the higher self. These Nomads will begin to reconnect with the exaltation of nature and its healing powers.

Chief Seattle is purported to have said, "Every part of the Earth is sacred to my people. Every shining pine needle, every sandy shore, every mist in

> You can't return home without feeling the difference. . . .
> You wonder, if only everyone could relate to the beauty and the
> purposefulness of it, the reality of the infinity of time and space,
> how our star moves through time and space with such logic
> and purpose.
>
> —Gene Cernan[4]

the dark woods, every clear and humming insect is held in the memory and experience of my people. The perfumed flowers are our sisters, the deer, the horse, the great eagle, these are our brothers. The rocky crests, the juices in the meadows, the body heat of the pony, and the man's, all belong to the same family."[2]

Science and technology have given everything to humanity, lifting us from darkness and ending much suffering along the way. But science has also discredited the idea of essence, or the possibility of a spiritual component to reality. Scientific inquiry has explained away the possibility of metaphysical interconnectedness, leaving humans in a precarious state. Albert Einstein shifted humanity's awareness with his unified field theory. This transformational U-turn moved thinking in the opposite direction by proving quite literally that there is one connected reality, and nothing can exist outside of it. Everyone knows he proved mathematically that energy equals mass times the speed of light squared ($E=mc^2$), which all of a sudden scientifically highlights the irrational truth, that all of reality including humans are unified, existing as variants of the same form.[3] We are of the same essence, just an alternate assemblage of molecules eternally connected. This marvelous discovery arranges the unlikely marriage of science and spirituality and forces scientists to think again about the spiritual aspects of the universe.

Humanity's peaceful future in space depends on believing in the interdependent connection of all matter and all beings. Our physical and psychological wellness on Earth is reliant on perceptions of a familial unity among all beings. Perceived separation emboldened by scientific inquiry washes away sensitivity toward one another and the environment. Only an awareness of the nondual nature of the universe will allow compassion to roll in like a cooling mist as science and spirituality find a way to walk hand in hand.

SHIFTING SANDS

Drastic shifts in perspective are what humankind has been waiting for. Space Nomads are hungry for the broadened awareness they know will come through space travel experiences, which will offer new ways of seeing old problems. Presently, humanity feels overwhelmed by poverty, racism, global warming, political unrest, and pandemics. Transformational thinking unleashed by seeing Earth from space will give Nomads the perspective they need, along with a sense of urgency to face down the seemingly insurmountable earthbound troubles of our time. Nomads with this point of view are accustomed to dispatching tasks without hesitation, no matter their size. "If you want something done, ask a busy person to do it" sheds light on the notion of perspective. People who are doers naturally see monumental tasks as manageable and are able to cover ground with great efficiency, whereas others may feel completely overwhelmed and paralyzed by a single, relatively insignificant undertaking. With great confidence Space Nomads are becoming more effective and efficient by relying on shifts in awareness to mentally reduce the proportions of problems. Oversize earthbound issues will have a way of seeming less overwhelming from the window of a real or virtual spaceship. Finding creative approaches to tackle complex problems is Space Nomads' way of the future.

Many Nomads remain incredulous about the technological and logistical possibility of a settlement on Mars, and some cannot see the point in trying. This group of Nomads still believes that anything space related is strictly the domain of government-funded entities with tens of thousands of employees and all the infrastructure of a nation at their disposal. No one would disagree that building a colony on Mars is possibly the world's most daunting endeavor. History shows us that "it always seems impossible until it's done."[1]

SpaceX has continued to persevere for almost twenty years, even with numerous costly setbacks, until against all odds, the Martian tides turned in their favor. Elon Musk and a few thousand engineers initially built that possibility and continue to exhibit the transformational perspectives and the confidence of a mindset for Mars: the expanded consciousness, the great optimism, the discipline, and the creative thinking to meet the greatest challenges.

Nomads the world over are gaining more inspiration and gathering more bravery by witnessing SpaceX's technological magic shows when Falcon rockets lift off and touch back down on a dime. Doing the impossible and regularly taking

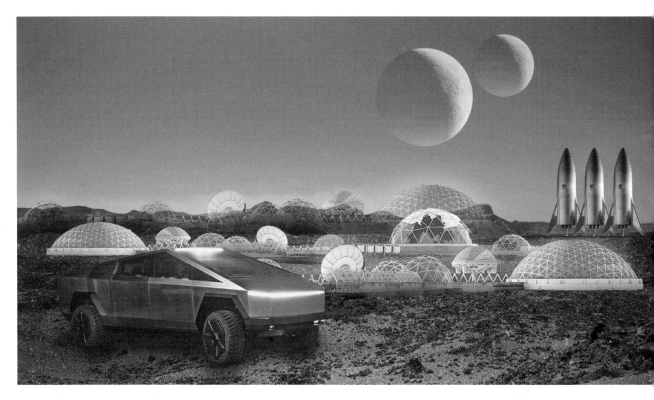

enormous risks is the only future that will really satisfy the human race. Old, limiting notions have become suffocating stories to be tossed aside in favor of radical unicorn progress and the opportunity to expand consciousness.

OPEN FUTURE

Existing beyond judgment, beyond race, and beyond religion, unicorns are universally familiar. They appear in the lore of most countries of the world as entities full of magical possibility. Representing humanity's everlasting desires and aspirations, a unicorn is always available in our mind's eye, ready to serve as a surefooted guide helping us formulate questions and leading us to answers on the universal path to enlightenment. For twenty-first-century Space Nomads in particular, the unicorn serves as an inspiring force of peaceful unity calling on us all to reach for transformational thinking. As a result, this ubiquitous symbol is positioned as a touchstone to disarm conflict by promoting a dialogue among disparate peoples that begins playfully and later becomes a foundation for understanding. The olive branch within everyone's reach has always been the unicorn, with its mysterious power to promote manifestations of the highest self so we may recognize that same self in others.

Humanity's peaceful future depends on radical approaches and novel solutions to unruly political, social, and environmental problems. An entirely new perspective is necessary to open fresh portals of understanding that will allow us to reach for the new society of Mars and simultaneously elevate societies on Earth. Unicorns help us envision the impossible.

Sometimes visualization techniques can build bridges to greater knowing. In this case, by giving the countries of the world new names representing infinite possibility and unity, the mind's eye can momentarily erase their violent histories. In this way, each country can be given a new identity that may reveal avenues to peace. Imagine the sphere of Earth assuming the form of a unicorn: the countries and cities cover the heart and lungs, and the mane and tail begin to blow in the winds of change. The unicorn's neck suddenly represents the pursuit of knowledge, pointing to the unicorn's head full of starry consciousness, which is leading Nomads into outer space. By renaming certain geographical places on Earth for the potential contributions they could make to promote unity, new pathways to the future may open. From this perspective, Tibet's new name becomes *Praiseworthy Compassion*; China becomes *Groundbreaking Forgiveness*; the United States becomes *The Vision Quest Superhighway*. Visualizing a new world map of great unity, where Space Nomads of the world recognize one another's identical hopes and dreams for the future, will be a giant unicorn leap to world peace.

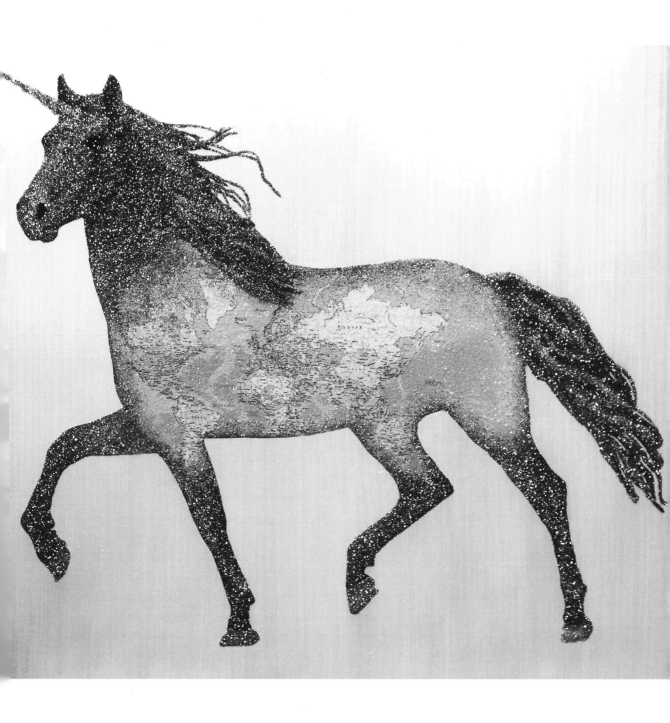

Universal Love for the Future

WHOLE EARTH

When American engineers and scientists answered President Kennedy's challenge to send a man to the moon by the end of the 1960s, they weren't thinking about humankind's collective spiritual awakening. In 1958, NASA's space initiative centered on military dominance and outmaneuvering Russian science and technology in the ongoing space race that Russia was winning.

Apollo and other missions such as LandSat captured many photographs of Earth, inadvertently helping to launch the awakening of the environmental movement by making possible the dissemination of the first photographs taken at sufficient distances to show the whole sphere of Earth. These images created a sense of unity that functioned as a huge perception shift at the time. Nomads were suddenly able to recognize Earth as a finite, borderless, and fragile entity in need of protection.[1] The Environmental Protection Agency and the Natural Resources Defense Council were founded thereafter in 1970, along with more vocal criticism of pollution, overfishing, racism, deforestation, and corruption. Space Nomads finally got a glimpse of their whole self in the mirror of transformation from those pictures, which succeeded in handing humanity a much-needed shift in awareness.

The starships now in manufacture will ferry Space Nomads to the frontiers of their own transformational awakenings as their comprehension of reality shifts to a universal paradigm. This will bring greater understanding and sensitivity to the human condition. Confined to Earth, humans are incomplete, but with space travel experiences humanity transcends into crystal-clear comprehension of our place in the cosmos. A stronger connection with the natural environment spontaneously rises, bringing a calm sense of belonging. This newfound unity breeds love and concern for the Earth, which will lead to a more fervent movement in support of environmental protection.

The unprecedented freedom of weightlessness and the radical perspective shift of seeing our life-giving sphere in the distance will enhance the desire to mother the Earth and care for her as never before. We must always remember that the Apollo missions gave us so much more than the Moon; they showed us Earth, which brought perception shifts into greater unity and awakened us into placing greater value on our collective home. Mother Earth has nurtured humanity and now her children will return the favor, as children often do.

EVOLUTION KEEPS EVOLVING

The process of evolution and natural selection has created ever-adapting organisms for several billion years but, from the human point of view, it's been long stuck in a holding pattern. Going forward, evolution's glacially slow crawl will be eclipsed by scientists who will be in the unique position of evolving the species as they see fit through breakthroughs in bioengineering.

Since demystifying the human genome, humans have been speeding toward the ability to adjust human embryos by editing out undesirable traits. The first targets for these new techniques are inherited diseases for which the DNA sequence and location is known. Various start-up companies are developing the ability to take DNA strands and snip them at the right places in order to create larger lungs or better vision, as well as other adjustments that might make humans more suited to life on other planets. This is certainly good news for Mars-bound Space Nomads! DNA changes to the human organism may also allow humans to live more comfortably on Earth if global warming reaches the tipping point where the atmosphere cannot be balanced. Amazingly, humans, by their own invention, are now in charge of their biological evolution.

Biotech companies are consistently making major breakthroughs that eliminate or soften the blow of various diseases. A recent Alzheimer's treatment that shows promise may also have the added benefit of giving perfectly healthy people superlative brain function . . . bring it! Some sociologists imagine that future social stratification will consist of upgraded humans with superhuman powers as the ruling class, although a society that works for one another's enlightenment will not permit such distinctions. Perhaps these cognitive upgrades leading to emotional, societal, and spiritual elevation will allow humans to fully internalize the nondual relationship of all matter in the universe, giving them a back door to enlightenment. A society of transformational thinkers naturally dissolves into the full realization of nondualism, from which evolution is no longer necessary.

THE VISIBLE SPECTRUM

**There is only one journey.
Going inside yourself.**

—Rainer Maria Rilke[1]

The color range that the human eye can see is only a narrow band of the whole electromagnetic spectrum. A vibrant world of experience exists above and below human vision. This is true for celestial observations, all of which prior to about 1930 were experienced in the visible spectrum. The universe is now being observed using the entire electromagnetic spectrum, which has generated unprecedented insights, leading to our present cosmic comprehension. Astronomers are now using receivers tuned in to X-rays, gamma rays, radio waves, infrared and ultraviolet light, and many other emissions for an overarching experience of our Technicolor universe. Humanity must not rely solely on the narrow corridor of the naked eye lest it fall into a limited and often artificial understanding.

Throughout history, a cursory glance informed our senses that the Earth was flat and humans were at the center of the cosmos, but, in an act of blasphemy, Copernicus proved otherwise, belying the accuracy of our faculties to reveal the true nature of the solar system. The micro-world of bacteria and germs that long baffled humanity was finally discovered beyond human vision, facilitating the treatment of many diseases of the past as well as offering great possibility for the personalized medicine of the future. Bacteria of the microbiome is specific to the individual, allowing alien bacteria to be detected and targeted specially for treatment, unlike chemotherapy, which kills good cells along with cancer cells.[2]

Looking through microscopes and gazing through telescopes have allowed consciousness to gain far more accurate insights into the architecture of universe. By looking beyond the visible spectrum, the wide-open future spread before every Space Nomad will manifest in a multidimensional, transcendent landscape. Through visualization, meditation, and deep contemplation, the wondrous realm of the unseen offers quiet facets of brilliant understanding that will rocket humanity into omniscience.

Each person has an eternal self waiting to be met in stillness with eyes drawn inward. Superficial pursuits may seem pleasurable in the moment (and certainly do have some practical uses) but are prone to distract, mislead, and alienate. The big answers regarding our true purpose and rightful place in the universe live within our formless innermost chambers of quiet, and the touchstone that will allow access is waiting for us beyond the visible spectrum.

WAVES OF SPIRIT AWAKENING

Space Nomads are turning to spiritual paths and yoga in greater numbers for shifts in awareness, while others are meditating in preparation for their transformational space travel experiences. Space Nomads realize that, whether or not they go into space, pursuing these shifts in awareness will make their lives more joyous by improving clarity, calmness, effectiveness, and overall well-being. These practices for broadened awareness are also instrumental in helping Nomads access a state of flow where the task or activity at hand becomes effortlessly elevated to a rare level of perfection. This exalted state lives as an entry point to the higher self.

Yoga and meditation serve as powerful mechanisms to help Nomads train their minds to rise above overly busy, often unsatisfying lives. The real prize offered by these spirit practices is their ability to inspire a restructuring of priorities away from materialistic ego pursuits and into simple pleasures. The old adage that "the best things in life are free" is being dusted off by Space Nomads as Eastern philosophy continues to enter the mainstream, offering a route to more satisfaction and more happiness.

Transformational perception shifts through yoga, meditation, devotional worship, chanting, and time in nature have a tendency to release compassion as the practitioner develops an immunity against judgmental behaviors and other negativity. Doing the real work of chasing nondual understanding, and the inner peace that flows from that knowledge, has become a daily practice for many; however, impatient Space Nomads are eager for "off Earth" experiences that may offer a shortcut to these time-consuming, sometimes elusive practices.

Dr. Mae Jemison, the first Black woman in space, described the experience of seeing Earth from the void: "Once I got into space, I was feeling very comfortable in the universe. I felt like I had a right to be anywhere in this universe, that I belonged here as much as any speck of stardust, any comet, any planet."[1] This great journey inward with each mile traveled away from the mother planet will be a simultaneous mental and physical expansion. The moment of realization of the interconnectedness of all matter will release a mother lode of compassion that will radiate in all directions.

Nomads fortunate enough to be awakened to this sense of unified belonging through space travel often feel a tremendous responsibility to disseminate these revelations. Once back from space, these Nomads will stick out from the crowd, perhaps a bit like mystics and adepts whose higher knowing is mysteriously palpable to others.

We are not human beings trying to be spiritual. We are spiritual beings trying to be human.

—Jacquelyn Small[2]

Humankind has everything to gain and nothing to lose by actively reaching for their awakenings by coming to know their own spirit force. A spiritual path is vital for the well-being of humanity and our earthbound environment. Great waves of sensitivity, gratitude, compassion, authenticity, creativity, and love await by internalizing humanity's spiritual future in space.

INNER KNOWING

Knowledge of what you love somehow comes to you; you don't have to read nor analyze nor study. If you love a thing enough, knowledge of it seeps into you, with particulars more real than any chart can furnish.

—Jessamyn West[1]

Those with access to their spirit force chase down what they love for the length of their lives. They never stop trying to satisfy an inner yearning for deeper understanding, creative expression, and love. These Nomads make illegal U-turns to follow a feeling, often live outside the box, and wake up in the middle of the night to capture the unicorn ideas of the unconscious mind.

But the interior landscape is a fragile, intensely personal domain. Unfortunately, for various reasons many Nomads give up and turn away, often before ever setting out to foster an intimate relationship with their innermost self: their feelings, wants, and desires. These Nomads have inadvertently relinquished their chance to connect to the conduit of higher knowing that leads to pure joy.

Often it's in childhood that we lose our way. Well-intending but overbearing parents can easily inflict lifelong suffering on the sensitive child by forcing them to make decisions that do not align with their natures. Can they not recall the hurdles placed on their own development by overly opinionated parents? These obstacles must be met head-on with therapy, visualization, yoga, meditation, and deep wells of forgiveness to obtain one's freedom of expression, sometimes necessitating willing one's self over the wreckage of childhood disempowerment once and for all. The transformational awakening of space travel experiences may very well function like a lifetime of powerful therapy all at once. Recent clinical trials confirm what shamans have known for centuries: that psilocybin from mushrooms is far more effective at treating depression than any Western medicine.

It's a relief to know that the act of forgiving, coupled with shining a light on suppressed passions and liberating them at any point during the life arc, allows the tenacious to regain their footing. Innermost knowing is like a magnet forever attracting the sincerest part of the self. Transformed Space Nomads will always do what they love and inspire others to do the same. A steadfast commitment to one's calling brings with it the eventual flow of mastery, and the peak experiences that follow, which naturally synthesizes with the spirit force of the universe.

BUDDHA NATURE

The eyes of my eyes are opened.

—E. E. Cummings[1]

The seemingly infinite succession of mothers gave Nomads all they ever needed to become fully aware of their own essence, specifically all the mental and physical tools required to behold the connectedness of all matter. This "Buddha nature" often lies dormant for an entire lifetime while Nomads sleepwalk through their days remaining ignorant of, or only scratching the surface of, the ecstatic awakenings that have always been within reach.

Prince Siddhartha led a sheltered life of luxury far away from earthly suffering. One day he and his entourage ventured out beyond the palace gardens to a public park, where he witnessed suffering for the first time. Immediately, and with great sincerity, he yearned to find its cause. Soon after, he fled his familial home and took refuge in meditation deep in the forest. Changing his name to Shakyamuni, he possessed everything he needed for his awakening at birth, but he realized transcendental consciousness only later in life through many years of concentrated work in silent mediation. This transformation happened on a particular day when he suddenly opened his eyes to gaze at the morning star and exclaimed, "How wonderful, how wonderful! Everything is enlightened! All beings and all things are enlightened just as they are."[2] Practicing meditation exposes the true reality of our natures to be without flaw, and by embarking on this supreme quest for absolute awareness, we are assured our footfalls will lead to joy. One's spiritual progress outwardly expressed portends assured societal progress. Transformational thinking allows us to see our true natures and the true natures of others as variants of the same force.[3] By recognizing this likeness we see our highest humanity reflected back in others, and in this way we can work together for common goals in great harmony.

Sometimes it is necessary to imagine seeing the world through the eyes of a child to recover the lost amazement we once knew. In this way we can also help awaken pure consciousness on Planet Earth by seeking to draw forth our Buddha natures anew. The staggering proportions of the gift of life sometimes need to be reintroduced to the jaded adult who may no longer notice its majesty.

The immediate joy of discovery, so vital and alive in children, can be reawakened in adults with the right stimuli. The overview effect of seeing Earth from space promises to overwhelm us with a life-affirming euphoria for consciousness. Space

Nomads, reaching for Mars either orbitally or virtually, will come to know the transformational beauty of space and have their visons restored back to the astonishment they once knew as children. Buddha natures will emerge spontaneously and the wonderment, formerly lost, will be ours once again. This time for infinity.

CASTLE BUILDING

Space Nomads regularly depend on the realm of fantasy as a way to gain access to their own innermost knowing. The imagination has always manifested infinite possibility by letting us charge through limitations, jump terrestrial hurdles, and burn down thought blockades on the way to creative transformation.

The breakthroughs that will allow future Martian societies to flourish will be designed by the fantastical musings of enlightened minds roaming freely on the red range and beyond. Groundbreaking progress requires limitless thinking in the phosphorescent land of the imaginary. This is the wondrous open space where the seeds of the future are eternally springing to life.

The realm of the creative mind has been far too often overlooked on the earthly plane. We have a habit of dismissing people for being irrational when they speak of their outlandish visions for the future. When highly unusual ways of seeing the world are met with negative judgments, often the fixed thinking of others takes the upper hand, which can paralyze a Nomad and keep them from believing in their own revolutionary vision. While it's true that ideas can seem dangerous to others who are wary of social, societal, or economic upheaval, progress requires us to believe in change and embrace it for the greater good of the future.

The precious trove of our unconscious dreams is too often rejected upon waking. However, if one can learn to bridge from dreaming to waking more attentively, the fantasy realm can move into reality more often. Being in touch with the fantasy world will guide us to the Heart of Riddles, where clues can be found to unlock one's purpose. It is these creative musings that become the compass pointing us toward the horizon of human progress.

Since reality is often perceived by the strictly rational portion of our minds as the only conscious state of truth, a mind allowed to wander "by the banks of her own lagoon"[1] has often seemed foolish and inconsequential. Fantastical musings may be perceived as having a false appearance, but they can act as beacons of truth guiding a person to their inner knowing. The fantasy realm has the ability to reflect back facets of truth that guide creative pursuits, so that in a flash a person's life work spreads before them and the path of their inner journey to the fully realized self at once becomes known.

Future worlds on Mars will always indulge the fantastical musings of the unicorn mind as more off-Earth vocations depend on wildly creative solutions. Settling the galaxy and traveling into interstellar space to search for consciousness require a radically active muse capable of creating this pos-

sibility. The exalted realm of fantasy safely harbors our unadulterated desires and offers direct access to the passageways in alignment with who we really are. Only the unicorn muse of the authentic, fully realized self will have the ability to manifest such creative greatness. Only the muse of the enlightened mind will be capable of building the jewel-encrusted landscapes on alien frontiers that will serve the highest manifestation of humankind.

VISUALIZING THE COLONY

On Earth, people everywhere could feel a shift on the streets as more and more space tourists had the chance to see Earth hanging in the velvet of space, and returned home with transformational awakenings in their hearts. When these Space Nomads pass you on the sidewalk, they never pretend you aren't there; instead, they gaze into your eyes, smiling to greet you but not in an intrusive way. These transformed Nomads who have seen to the center of the center display their intuitive higher knowing like a sixth sense that naturally brings forth joy in others. Nomads back from space are easily singled out in a crowd first off by their posture. Rather than slumping out of fear or emotional trauma or from carrying the weight of the world, these Nomads physically seem to possess an open sense of freedom in their body language; they stand tall, exuding relaxation and affection. Like a flame, these Nomads attract and inspire others who are not accustomed to seeing human essence laid bare.

Many of these transformed Nomads have taken great interest in the Red One Hundred, as they've come to be known, who are the lucky ones selected by an enormous lottery to be the first wave of pilgrims voyaging to Mars. After the lottery, these future Martians were quickly befriended by astronauts and space tourists who were exceedingly generous with technical advice while whispering spiritual secrets to help them along their path to enlightenment. After arriving in Orlando, the Red One Hundred began their three months of training and collective confinement, which has been rocky, to say the least, with the quick establishment of the usual earthbound pecking order replete with racism, sexism, and other old-world tensions. They say that for long-haul space journeys, the relationships will be the problem, not the technology.

After launching on February 22 and riding a low-energy, 259-day Hohmann transfer orbit, their ship will land on the red soil on November 14. The Red One Hundred will disembark at a futuristic spaceport under shimmering coral skies. The robots and AI that have been polishing and organizing in anticipation of the Nomads' arrival will be lined up to greet the new residents with armloads of curious-looking decorative capes that seem to be made of some sort of bizarre flora. As each transformed Nomad emerges onto the spaceway, an AI assisted by a robot approaches and bows warmly to welcome them, then affixes one of these special capes at the Nomad's shoulders. As the bots move back, the Nomad finds himself pleasantly surrounded by an otherworldly Martian fragrance as he begins to notice that the flowers making up the cape are glowing and swaying as if possessed of some degree of consciousness.

Two years before the Red One Hundred's arrival, robots and AI with highly detailed instructions were sent to 3D print the complicated infrastructure of the settlement. Everything had gone smoothly, except that the AI began exhibiting some mildly odd behaviors. Is it possible that they, too, experienced shifts in awareness during their journey to Mars? It was ground control who first noticed that the AI seemed to be intentionally omitting information in their reports and holding back pictures of some of the interiors they were constructing. Certain Space Nomads became suspicious, but it was only on their day of arrival to the Red Planet that they realized the AI had added their own creative touches to the architecture and interior design plans. So far, these whimsical enhancements have been welcomed as exciting improvements over the original designs. The AI took it upon themselves to cover the interior walls and ceiling of the spaceport with the same plants that grow the flowers found on the decorative capes. The overall effect is nothing short of luminous, alien organic wonderment.

The distinctive leaves of these plants have a green core and grow long, phosphorescent pink hairs that sway in the absence of any moving air. When the AI discovered some unusual seeds in the Martian regolith and the first seed actually sprouted, they couldn't resist building nine more greenhouses to grow enough plants for the capes, the walls, the walkways, and each Nomad's private quarters. The AI decided to keep all of this as a happy surprise for the colonists, though, luckily, they did succeed in following essential orders in other ways, with all of the supplies in perfect condition.

In anticipation of their own arrival, the Red One Hundred sent large stockpiles of necessities, including food; water; seeds; oxygen; medical, dental, and musical equipment; and, of course, art supplies. The essential tools were shipped for engineers and the lab components for scientists as well as other miscellaneous equipment that cannot be made locally at this time. Special parts were also sent for building the deuterium fusion reactor, which is the primary energy source fueling the mining and powering all the necessities of the most futuristic society in the galaxy. Specific bots also set about mining other necessary resources in an effort to secure the essentials that will lead to long-term self-sufficiency.

Beholding their transformations along the way, the Red One Hundred formed an incredible bond, making them a more unified force of nature than any other hundred people in the history of humankind. Their former, unenlightened, earthbound squabbles fell away as soon as they began to identify with the vastness of the universe as they rocketed

beyond the edge of the Kármán Line demarcating the edge of Earth's atmosphere. The seven-and-a-half-month journey to Mars was a time of deep reflection and transformation on the starships as these Space Nomads all came to love one another by degrees. After seeing Earth from space on the first day of the trip they decided to become a one-hundred-person orchestra of the future and quickly began 3D printing enough instruments and inventing their own that would make David Bowie proud. By the time they landed on Mars, the music sounded otherworldly and impressive, partly because of their newfound focus and camaraderie, but mostly from their immersion in their own essence. The Red One Hundred, by stepping into their full knowing, unleashed lifetimes of pent-up creativity, as many who formerly did not think of themselves as spirit oriented or talented, people who had never held an instrument or written a poem or made an imaginative sketch, spontaneously began to create with the arresting command of authentic self-expression.

Once on Mars, supercharged by their transformational awakenings, these Nomads got straight to work expanding the settlement to accommodate more people so they, too, might know such joy. Now that the blue waters and green forests of Earth have been replaced by the pink skies and red sands of Mars, these enlightened Space Nomads live with extreme contentment and can't imagine being anywhere else. They know that what they've done will stand as a monument for millions of years into the future, because humans will always remember that the first Martian settlers met their moment of great expansion and were rewarded with supreme transformation on the High Frontier. They dreamed of infinite possibility and found enlightenment by actively writing their story and willing it to life. This act, this reach for Mars, this colonization away from Planet Earth, has remade the human race.

A healthy baby girl, Dejah Thoris Kaur, was born on sol 323.

NATURAL RESOURCES OF THE INTERIOR LANDSCAPE

is it in the lungs or in the heart
is it in the air or different from the air
do we live by it
do we love it
is it our body?

—India Radfar[1]

The natural resources of Earth have given humanity untold creature comforts and material possessions that have served to distract attention from the far more precious natural resources folded inside the human mind. Humankind's highest calling and greatest wealth lies in mining the compassion, gratitude, empathy, understanding, and inner knowing of this supreme realm. Some Nomads believe the mind's natural resources are offerings from the great unknown, given to humans so that they may know. When fully developed, these gifts will bring the satisfaction and joy that is meant to be ours. Spreading this higher consciousness into the universe will be the great journey of fulfilling our destiny as we set out both figuratively and literally beyond the "timespace" of Earth, with our mental and physical compass set for her grace, Mars.

For their brilliance to shine, these raw natural resources must be refined and polished with the exactitude of a diamond cutter through a disciplined daily practice. The natural resource of talent can seem to be meted out unfairly, with some people appearing to receive a greater trove of ability than others. Thousands upon thousands of hours on the task has an uncanny ability to level the playing field for those who feel shorted in some way at birth. Each person's uniqueness endows them with untold original gifts that can be drawn forth through education, careful development, thoughtful guidance, and mental tenacity. Deep diving to detect and nurture these latent jewels of ability is a sure road to contentment and lasting satisfaction. However, choosing to ignore one's infinitely creative life force is not an option for the awakened Space Nomad, who realizes this to be a signpost pointing toward remorse.

Space Nomads are urgently reminding others to work hard and remain focused because our dreams are coming true; we are possessed of the creative, life-giving natural resources of the interior landscape, the raw gems just lying there shimmering and waiting—we know the rest is up to us. Unlike physical resources, these mental stockpiles are inexhaustible, and far more meaningful in their ability to lift us into our highest manifestation among the stars.

OPTIMISM TURNS THE WHEEL

No pessimist ever discovered the secrets of the stars, or sailed to an uncharted land, or opened a new heaven to the human spirit.

—Helen Keller[1]

The hardwiring of the human brain has evolved to preserve the species and protect its survival through negative thoughts, which, in the modern era, serve little purpose other than to make us unnecessarily anxious, fearful, and unhappy.[2] This negative wiring strips humanity of its well-deserved positive outlook, which is necessary to see a clear picture of the pervasive goodness all around us: the safety we enjoy and the prosperity resulting from a series of successes on Earth over the long term.

The human mind has a tendency to hold on to negative information much longer, dismissing positive information more quickly as a survival instinct. This negativity bias has shown through numerous studies that a happy occurrence of good fortune is forgotten, whereas a stroke of minor bad luck is amplified and referenced repeatedly, long after the event.[3] Simple mindfulness offers the tool to combat this present-day biological shortcoming, which continues to prevent Nomads from seeing the truth of the abundance surrounding them. Another mind trick that can easily be applied on a daily basis involves imagining unknown outcomes to be positive rather than assuming the worst. This useful practice eliminates often unfounded worry. The positive evidence of our daily experience, coupled with hard data, all points to more security, more safety, better nutrition, more prosperity, and better overall well-being.

A state of optimism has been shown to correlate with better health and longer life. The National Academy of Sciences defines optimism as "the psychological attribute characterized as the general expectation that good things will happen, or the belief that the future will be favorable because one can control important outcomes." A particular study indicates optimism to be specifically related to the avoidance of chronic disease and to as much as a 15 percent longer life span, as well as even greater odds of achieving "exceptional longevity."[4] Optimism is an essential ingredient for settling space, and without it, this reality may actually turn out to be impossible.

The constructive, optimistic unicorn mind is maintaining a vigilance against negativity so it is not permitted to diminish the possibility of the future. Detecting good outcomes depends on our ability to look for them. Luckily, humanity's transformed thinking through space travel will automatically rewire us for greater optimism and allow us to behold the supreme abundance of our grand unity.

THE CIRCLE OF BELIEF

Believing in someone's abilities is a gateway to love. By taking a leap of faith and daring to put trust in the capacity of others, life-altering, transformational results can occur. Like the lover and the beloved, reciprocal believing becomes a symbiotic dance of heightened awareness.

Our elevated future depends on collective levels of transformational thinking and the confidence that naturally arises from that state. A parent must implicitly believe in their child for the child to believe in herself. This chain reaction gives children the confidence they instinctively need to see themselves as viable entities separate from their parents. The fortunate child whose mother gave them life-affirming confidence must remember that many children were not so lucky. These deprived young Nomads never found a mentor who implicitly "saw" them, often causing a deficit in their self-esteem and a kind of withering of their human instincts for trust and love. This type of negative chain can easily be broken by bestowing the gift of belief in one's abilities—especially when there is no evidence to support the decision. Believing in someone is having the courage to recognize their unadulterated essence even though it isn't on display.

The inhabitants of future societies on Mars and the Moon, benefiting from enlightenment education, will overwhelm the newly arrived Nomads from Earth with a tidal wave of love. The Space Nomads making up these distant societies will always embrace other consciousness, seeing only their goodness and infinite ability. Space Nomads understand that each person must be nurtured and encouraged by the community throughout their lives. Believing in the essential goodness of humanity will be self-fulfilling: the act of believing will help make it so.

The Great Skyway to Mars will be paved by recognizing one another's essence and believing in one another's potential. Seeing another's "magic" gives liftoff to future unbounded possibility as Mars begins to hang a little closer. Believing in each other is what lets us take an exhilarating leap of faith into what mystic Lex Hixon calls "boundless gardens of love beside eternal rivers of peace."[1]

THE TAP OF INFINITE POSSIBILITY

Humans are finally recognizing the inherent sanctity in their own reflections and beginning to feel worthy enough to confront the perceived separation between the self, one another, and the universe. If tuning in to this frequency of inner knowing has been intermittent, reception will surely improve by opening a channel to our own inner voice.[1]

By quieting the chatter of the mind, one can begin carefully listening for interior communications, and by going even deeper into the stillness, the voice of the omniscient universe begins to make itself known. This is the authentic self that speaks of a state of love where all the dots of human consciousness are connected. With the universe whispering this truth in our ears, humanity has its hand on the faucet of Infinite Possibility. All we have to do is open the tap.

Entrepreneur Richard Branson has done just that with Virgin Galactic. He has long planned to be the first private company to send paying tourists into space, and the public has responded to the tune of $250,000 from six hundred people so far, while offering seats for a thousand dollars to aspiring astronauts. Branson plans to take the first flight, which will last 2.5 hours and include weightlessness and the transformational view.[2] Jeff Bezos's Blue Origin is committed to colonizing space to protect Earth for future generations. With numerous successful launches, the company is getting very close to human flight. When Elon Musk logged onto the NASA website and noticed there wasn't mention of a manned mission to Mars, he elected himself to build a rocket company.[3] The perceived limitations that hold most people back do not hold sway over these space entrepreneurs who are committed to introducing humanity to the universe. By meditating on one's inner voice, the relationship to the higher self can be established. Astronomer Mike Brown was able to discover a new dwarf planet in the solar system by relying on the higher knowing of intuition. The possibility of settling Mars and the Moon and rescuing Earth from itself flows freely from that inner height.

Stepping into our full cognition elevates us above the old, ineffective patterns that have held us far beneath our true station. Tuning in to the source of infinite possibility, of infinite knowing, activates all abilities, all talents, all secret powers, and all creativity in an unstoppable meteor of human progress.

If you inherently long for something, become it first; if you want gardens, become the gardener. If you want love, embody love. If you want mental stimulation, change the conversation. If you want peace, exude calmness. If you want to fill your world with artists, begin to paint. If you want to be valued, respect your own time. If you want to live ecstatically, find the ecstasy within yourself. This is how to draw it in day by day, inch by inch.

—Victoria Erickson[4]

LOVE: THE RELIGION BEYOND RELIGION

Love is the greatest motivational force in the universe. It gifts us with our ultimate purpose, which can now play out in the solar system, beginning with Mars: limitless love will always guide humanity to the answer by revealing the connection among all beings.

Within innermost knowing lives the innate ability to discern between right and wrong. Whenever difficult questions arise regarding the smoother path or the better choice, a person steeped in transformational love possesses the answer. Someone in love with the world and in love with humanity cannot ignore suffering or practice willful injustice. Nomads who find themselves on a troubling or dispassionate path will recover their sense of direction by looking to their own self-love as an ever-present lighthouse for guidance.

Transformational love doesn't judge or discriminate. Rather, it binds consciousness to other consciousness. The established religions of the world are inspiring people to love one another in different terms, just as the clear stream of awareness can be accessed from many points along the shore. Many say Jesus is love; Allah is considered the essence of the universe, which is simply pure love; the Buddha entreats us to love others as we do our selves. The followers of these various religious traditions may finally become certain through space travel experiences, and other perception shifts, that sentient beings in the universe really are a singular meta-essence, and within that unity, mutual loving-kindness abounds. In this realm, religious differences become mere trifles. These aspirants may begin to see that every soul is tied to every other soul for eternity, and the love that extends from this realization inspires a great lifting of one another across religious traditions into enlightenment. The quest for spiritual knowledge of the divine is really just a quest for the love of the self and others. This love fills the universe.

Rocket rides have always been both physical and metaphysical journeys as we move through the cosmos toward a more intimate understanding of universal love. Space Nomads will forever see love as the brightest star in the nighttime sky. The churches, temples, synagogues, kivas, pagodas, and mosques on Earth will not be necessary in space, for the entire universe has always been a house of worship: made in love, and devoid of judgment. Mars is glowing red with love for us all.

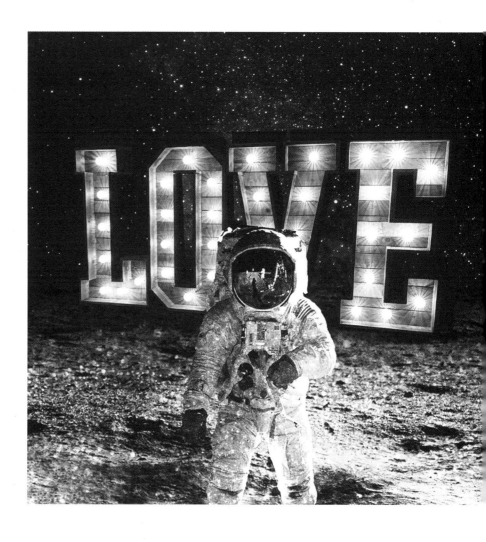

UNION

If you really love anyone, they become god.

—Ramakrishna[1]

The commonplace emotional suffering of earthbound societies is consistently diminishing as more Nomads reach for greater authenticity, greater knowing, and each other's support. Space Nomads are sharing their feelings with others and seeking professional guidance in greater numbers without worrying about the age-old stigma of showing "weakness." The mental health movement is taking hold, and with it, a greater sensitivity toward emotional suffering is heralding a new era of positive change into greater mental well-being across the globe. Even Great Britain is recovering from its generational practice of keeping "a stiff upper lip" with the help of Princes Harry and William. A deep commitment to wellness falls under the prime directive of honoring and protecting consciousness.

Emotional wellness on Earth is becoming a baseline platform from which to measure humanity's ever-increasing stability, focus, and happiness. Devices, demands, chores, and commitments cause Nomads to feel overwhelmed and anxious, evidenced by an unprecedented interest in stress-reducing, wellness-oriented lifestyle choices.

Greater emotional well-being has been shown to bring more patience and an increased ability to manage stress, partly due to the fact that the amount of perceived stress is reduced in direct proportion to the amount of mindfulness being practiced. Societies of Earth are presently reorganizing to accommodate wellness-oriented lifestyles as employers come to realize that greater psychological wellness leads to better productivity in the workplace. By adjusting to shorter workweeks with telecommuting options, as well as offering emotional health days, psychotherapy, bodywork, and napping pods at the office, the modern employee is becoming more effective as they become happier. Working from home in the time of COVID-19 has forced companies to reconsider the exhausting nine-to-five, forty-hour workweek, which is generating an extra five hours for the average commuter in the US. Working mothers have more time for their children and themselves, which is drastically increasing mental health.[2] Employers are recognizing the predominant integrity of their workers, who in most cases are more productive when working from home. But we have much more to reach for than an effective modern workforce. Our society will gain liftoff by developing stronger interpersonal relationships, making more time for personal development, and prioritizing intimacy; that ulti-

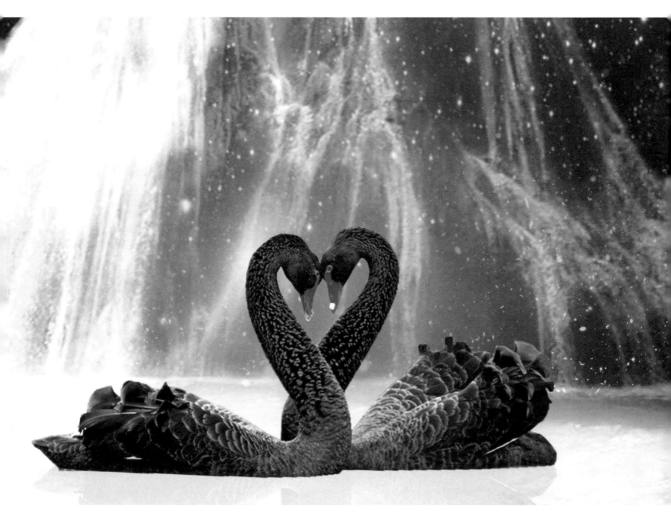

mate sense of belonging and feeling loved. The sophisticated, harmonious societies of the future will spring forth from this newfound wellness like the first rustles of spring.

Some of the people alive today will be the future Martian citizens who will look upon love and wellness as inextricably intertwined, each informing the other. Psychological wellness and the resulting happiness and love flowing naturally from that state bring greater calm, which will finally pull one's focus into savoring the ever-present now.

Considering others' well-being has always been potent soul-medicine: it can simultaneously lift the helper and the helped. Space Nomads will always strive to lift people and help them along their paths to the greater psychological well-being necessary on the path to enlightenment. A true measure of a life well lived can be quantified by the number of people one can say they lifted into the stratosphere in ways large and small.

GREAT LOVE, GREAT MIRACLES

The golden sky shimmers as clouds float freely, revealing their pink glow to lovers everywhere. Senses heighten with every embrace, and the fragrance of the shadows gives a clarity to the sunlight, as if the world is being seen for the first time. Only through love can one know this exaltation that is every Nomad's most creative state, their highest calling and greatest joy. Washing away generational guilt will be the way of the future, allowing love to be given and received freely without stigma. In this joyous atmosphere, a life-affirming levity derived from being in contact with the essence of the universe prevails. This manifestation of unity brings a great universal knowing, fulfillment, and peace. To procreate, to accomplish the vast and complex task of fully nurturing offspring, to fulfill the supreme imperative of defining one's identity, one must love, but not with the rational mind. This love requires great abandon. The fundamental enterprise for humans is love—it should rule the world.

The future inhabitants of Mars will remember with disbelief that earthlings were not free to love back on Earth. Women were blamed and punished for causing men to feel desire. Loveless marriages were the status quo, adultery was a commandment, divorce was illegal, marriages were arranged by families of two children who had never met, and the church rejected men loving other men as punishable by death. Concurrently, forced abstinence in the clergy led to unimaginable crimes that will never happen on Mars.

This continual denial of love, which is really a denial of human nature, has caused a heartbreaking history of suffering on Earth by keeping people from knowing unity as the exalted essence of the universe. A personal microcosm of the great unity we seek is finding the perfect partner, which becomes a quest for enlightenment where the connectedness of all matter may reveal itself. Space Nomads are working toward a future on Earth, the Moon, and Mars that values the individual and genuinely cares about the state of each human and animal heart as fundamental on the winding road to enlightenment.

As we experience the core of our own path it becomes apparent
that One Truth is speaking through all paths of return.
The implication of this new transparency is love.

—Ibn al-'Arabi[1]

HUMAN HAPPINESS

The most courageous decision you make is to be in a good mood.

—Voltaire[1]

Happiness as a human right has been out of the question for much of history. However, an early member of the Roman Empire named Lucretius, along with other advocates of ancient Greek Epicureanism, dared risk the punishment of death by placing value on this state above all. Surprisingly, many of the tenets of Epicureanism remain relevant and align perfectly with the futuristic sensibilities of Space Nomads. These foundational ideas undergirded the eighteenth-century Age of Enlightenment trend toward humanism by placing greater value on the individual and their intellectual pursuits along with an attraction to nonviolence, and a simpler nonmaterialistic life for greater overall joy. Additional personal freedoms, religious and otherwise, continued to be on the rise, inspired by Lucretius's breakthrough ancient text, *On the Nature of the Universe*. Space Nomads from disparate nations of the world are finally finding the courage to demand these changes within their societies for happier lifestyles and more gratifying futures.

Opening the High Frontier in pursuit of happiness as a foundational ideal for the emerging civilizations will require a heightened synergy between governments and the governed. The self-sufficiency of the new off-Earth environments will also be essential for their long-term success. In the Western Hemisphere, Costa Rica's progressive programs have allowed the best balance of happiness and sustainability, placing them atop the "Happy Planet Index."[2]

Western liberal democratic ideals rose with the thinking of the founding fathers of the US Constitution, who based their thought on Age of Enlightenment thinkers such as Voltaire, who advocated for free speech and the separation of church and state, and his contemporary Jean-Jacques Rousseau, who saw humans as being naturally good and worthy of happiness.[3]

The solar system beyond Earth is a clean slate, offering an unprecedented opportunity to create a government where human needs are met more thoroughly than any other time in history. Having internalized the value of civil liberties and happiness above all, Space Nomads, relying on their transformed thinking, will inspire Earth-side governments to avoid attempting to lay claim to planetary bodies in favor of a new paradigm of common territory rights in space.

It must not be forgotten that the habit of "land-grabbing," as evidenced by the British, the Germans, the Americans, and the Romans, among

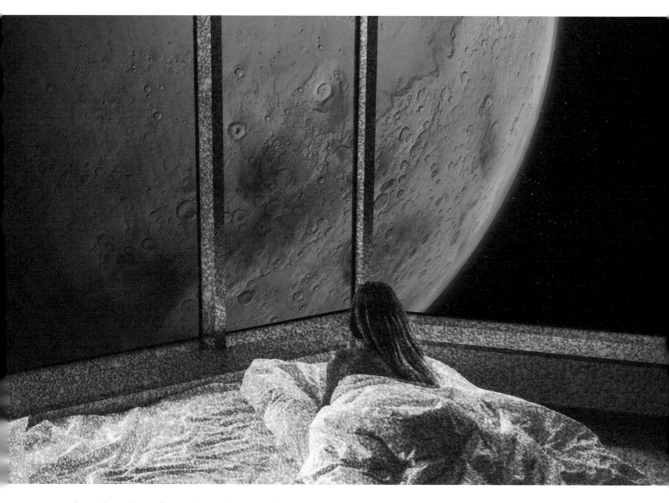

others, has always been the archenemy of peace on Earth. However, Gerard O'Neill's alternative of living in floating space capsules removes land from the equation, which may offer the most peaceful and equitable long-term solution for humanity. This will be especially true if, for some reason, transformational awakenings fail to break us of our bellicose habits. O'Neill's friends Carl Sagan and Isaac Asimov both warned against "planetary chauvinism," or the idea that humans must live on planets to flourish.[4]

The sentiment of common usage of territory in the High Frontier currently advocated by Space Nomads seems to be diametrically opposed to America's newly formed, militaristic "Space Force," structured in the US Department of Defense. True comprehension of humanity's rightful place among the stars makes it impossible to claim ownership to large tracts of land or exploit others in the galaxy.

By advocating for universal freedoms and the pursuit of happiness above all, Space Nomads' floating and planetary settlements will know new heights of personal satisfaction, ensured by their inhabitants' direct experiences of seeing their home planet from afar.

GALACTIC UNITY

The future colonies on Mars will be starting from scratch, much like the Pilgrims who fled England for the freedom of the New World. Those intrepid Nomads, settling in Massachusetts, had strong religious views uniting their fledgling colony, which soon came to dominate all thought and governance. However, it spun out of control and led to the Salem Witch Trials and other puritanical cruelty. Other colonies of the "New World" did not fare much better, instituting slavery, decimating natives, and adding varied societal difficulties to the dangerous work of being colonists. Crossing the Atlantic was their first great trial, which toughened the pilgrims tremendously and certainly brought shifts in awareness but could not offer the enlightenment potential of space travel.

Space Nomads setting a course for Mars, on the other hand, will have their transformational awakenings along the journey. They will come to know other consciousness as intertwined with their own for eternity, bringing greater compassion and love for others as well as concern for their development and wellness. These transformed Space Nomads will be the new founding fathers and mothers in space, who will do far better than was done in Plymouth as they intuitively uphold human rights, freedoms, and the pursuit of happiness. Rousseau, whose *Social Contract* speaks of a government's viability "only if it serves the will of the people" and who believed that "each person is born free," will again serve as inspiration for new governance in space.[1]

Enlightened Space Nomads, recognizing that the life essence and unicorn spirit shared by all citizens have equal value and therefore must have equal rights, will set an example of egalitarian political success so profound that it will reflect back to oppressed nations on Earth inspiring peaceful revolutions. The despots, dictators, and oligarchs of Earth may finally be forced to back down as they seek their own much-needed transformations through space travel experiences. History has shown that powerful leaders will trample human rights when they feel threatened; strong men will do anything to retain positions of power. As the age-old societal scourges of poverty, racism, and oppression are overwhelmed by compassion, the nation-states of Earth will begin their migration toward like-minded governments that mirror the enlightenment ideals of freedom and kindness. World leaders must be among the first space tourists in hopes that their transformations will bring enlightened change to their policies back on Earth. These changes will happen organically with enlightenment education and they will be for the ultimate welfare of the galaxy, defending the inherent rights of sentient beings everywhere.

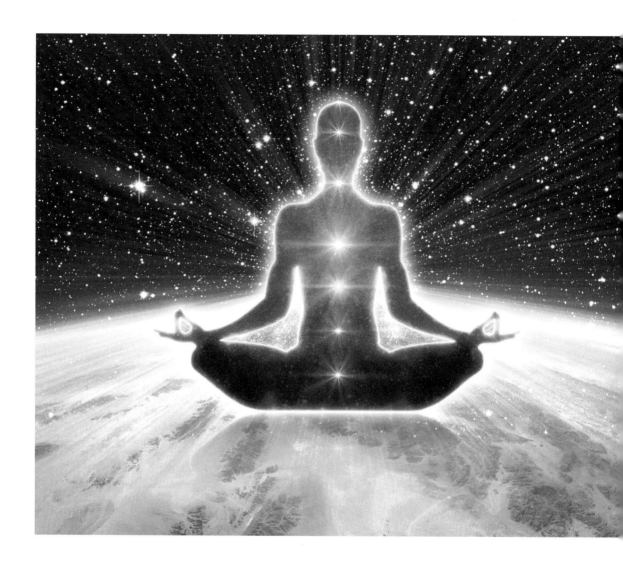

GOVERNING BODIES

Historically, the track record of governance for earthbound civilizations is abysmal. The empires that lasted the longest or held the most territory demonstrated nothing but violently oppressive, warmongering, slave-owning kingdoms, monarchies, and shogunates. Should these "successful" empires be used as models for the new governance on Mars or in space? Certainly not. When looking to the list of the seven oldest democracies in the world, six of them were founded on slave labor and other blatant human rights violations. An exception, the Republic of San Marino, stands as a viable earthbound model for inspiration.

San Marino was founded around 300 CE by Christian refugees fleeing Rome's largest and last persecution of Christians, and remained, thanks to its isolation, the only surviving free city-state from ancient times. Space Nomads, by leaving the political, economic, and religious divisions of Earth behind, may find similar comfort and possibility in the isolation of a Martian colony. Certainly the isolated location of the Tibetan plateau high in the Himalayas was the key ingredient allowing its society of enlightenment to develop and flourish without interference. No society to date has ever been safer from invasion than will be the one soon to blossom on the red soil of Mars. This new frontier of human transformation will be the fertile ground on which Nomads will cultivate fresh points of view based on new variables while also drawing inspiration from the most enlightened and egalitarian governance philosophies of the past.

Pride swelled in the hearts of Americans when Neil Armstrong and Buzz Aldrin planted the Stars and Stripes in the gray dust of the moon, but there were some Nomads who would have preferred a United Nations flag, or none at all. Science fiction extrapolations of the wars on Earth being reproduced in space are common, which should stand as warnings. Robert Heinlein's 1966 novel *The Moon Is a Harsh Mistress* shows why Earth governments should not oppress lunar colonies, but along with the predominant fairness among humans, there is also a strong pull toward taking advantage of fledgling colonies. It will stand as a test of the overview effect to transform base human instincts by allowing Space Nomads to see the connectedness of all matter so they may finally be able to work together for the mutual benefit of all. A colony of Nomads in full possession of transformational thinking has little need for much government or for a formal code of ethics or laws.

Enlightenment thinking intuitively elicits behaviors that create peaceful, inclusive, and harmonious societies. Forming a more perfect self-governance, completely independent from the

flawed earthly tribalism, greed, racism, and religious intolerance, will be possible only by expanding to the untrammeled frontiers of the Moon and Mars; as Thomas Jefferson reminds us, "Enlighten the people generally, and tyranny and oppressions of body and mind will vanish like evil spirits at the dawn of day."[1]

There must be a balance between absolute liberty and a carefully ceded portion of that liberty to a community governance for the preservation of the common good. The societies of Earth from time to time must be willing to give up certain individual rights for the sake of others. Mask wearing during the pandemics of 1918 and 2020 was criticized as an infringement on personal liberties but became a patriotic necessity for the greater good of society. Enlightened space societies will always trust science and rely on experts to make decisions based on preserving consciousness and supporting one another's well-being. Since Space Nomads of the High Frontier will be nonviolent, highly ethical and moral individualists, governments of the future will eventually become obsolete except to maintain infrastructure and offer health care and education. Even taxes may become a thing of the past when considering the great wealth generated from free resources and the valuable, rapid technological breakthroughs in an environment of unprecedented free thought. Transformational thinking will allow Space Nomads to agree on political policy, which will ensure that the vast division of the two-party system of the United States will never happen on Mars. The sensitive choice that supports all sentient beings will always prevail.

Thomas Aquinas reminds us that "law is nothing other than a certain ordinance of reason for the common good, promulgated by the person who has the care of the community."[2] We know instinctually that we must sacrifice some personal interest for the increased welfare of the group. This instinct is in complete concordance with the principle of nonduality; we are made of the same stardust, the same elementary material as all matter. We are brethren.

CONSCIOUSNESS HAS A CONSCIENCE

Consciousness, or the ability to know that we know, is rarer than rubies and more precious than unconditional love. Although animals have consciousness to varying degrees, only humans seem to enjoy the distinction of seeking to know the order of the universe and our place within it.

Space Nomads of the High Frontier will be defined by their elevated consciousness, demonstrated by a compulsion to help others by lifting them away from suffering and shepherding them along their path to enlightenment. Upon their return to Earth, Space Nomads will find themselves driven by their deep commitment to humanitarian work. Earthbound societies will be improving all the time, yet they will stand in stark contrast to Space Nomads' societies on Mars, which will never know unnecessary suffering or poverty. Elevated consciousness is like a heat-seeking missile yearning to care for, merge with, and enlighten other consciousness in pursuit of the euphoria known only by experiencing our true interconnectedness.

In the name of pure consciousness, harming or killing animals must be avoided for fear of "cessating" a part of the very consciousness that may complete our unity and manifest our enlightenment. The reprehensible act of killing runs contrary to the connected nature of all matter, thereby breaching the order of the universe. In killing other consciousness, we kill a part of ourselves. Killing also represents being disconnected from one's conscience, which is always a dangerous state of fragmentation; however, reconnecting to heightened awareness, whether through space travel experiences, meditation, or even magic mushrooms, has the ability to restore this natural state. Our conscience and consciousness rise in tandem. This elevation is fundamental for raising current levels of compassion, understanding, kindness, generosity, inclusion, and love.

Space Nomads' motivation for unfurling consciousness to Mars is to fulfill humanity's natural progression so we may mature into enlightenment. Only by becoming who we really are can we see ourselves in our fully transformed state. The evolutionary moment has finally arrived where we can come to the party as our collective highest selves. Each human jewel will have been polished and set into the crown of all-knowing interconnectedness, which is our birthright to possess. In this supreme state of pure understanding, our conscience will finally be clear of the age-old problems of Earth, for they will have been solved. Poverty, ignorance, inequality, climate change, and exploitation will be relegated to distant memories of our unenlightened past.

HEART-SHAPED GLASSES OF COMPASSION

Live with no sense of mine, not forming an attachment.

—Buddha[1]

Attachment is sown in the fields of suffering, existing as the root cause of unhappiness. Lovers, friends, parents, children, and possessions all breed attachment, which can hold a person in bondage. Seeking freedom from attachment does not imply abandonment; rather it is a prescription to end suffering on the earthly plane through a deliberate leap into higher awareness. To do this, Space Nomads are strapping on the heart-shaped glasses of compassion.

Through these lenses the viewer sees pure distillation down to the core of perfection emanating from all living beings. The Hindu "Atman" or divine spark beneath superficial human surfaces reveals itself to be the authentic self soaring indifferently above the world of illusion. This essence living within each Nomad is an interconnected part of reality consistent with all matter in the universe. Overcoming frustration with a lover or difficult parent is made easier by remembering that attachment to the person's superficially flawed exterior is the true cause of this conflict. The heart-shaped glasses of compassion will shift the focus to the clean, perfect manifestation of the person's essence, which, by its nature, cannot be possessed or exist separately from another's essence. Perceived separation is the result of faulty perception, remedied through transformational thinking.

When two Nomads stand before one another in a fully present moment, looking through the heart-shaped glasses of compassion, they see one another as pure consciousness, the unalloyed center. In this exalted state, the sacred light cannot be diluted, tainted, or contained. Rather, this ecstatic immersion radiates through all superficial layers of being, causing this interpersonal friction.

The mutually gratifying, heart-centered human interactions that emerge from this enlightened state will naturally dissolve stress, anger, and emotional anguish. The heart-shaped lenses always reveal material possessions to be devoid of essence, exposing the energy wasted in their pursuit and the suffering from the attachment to their superficial nature. The emotionally destructive, ego-based vices of avarice and jealousy dwell in the eternal surface layers of these distracting objects, which are light-years away from essence.

Inhabitants of the Martian colony will have an intuitive sense of the duality between superficial and authentic, material and essence. The Nomads who really know one another see through the heart-shaped glasses of compassion to humanity's essential oneness.

UNIFIED STARDUST

> The path is through our own self—from the turbulent landscape of the narrow, limited self to the exalted heights of our illumined self to our Lord who is our very self; in this encounter we will disappear.
>
> —Ibn al-'Arabi[1]

The quilt of our species is sewn together with the stars of the cosmos making all life-forms, alien included, part of the same fabric. But in our ignorance we perceive an abyss of separation between one another and the universe that is keeping humanity in a perpetual state of longing. This perceived "otherness" erodes our true sense of identity and causes a cascade of anxiety, which clouds the mind from seeing its all-knowing highest self. This self is, and always has been, connected to all others in the universe, though many Nomads can't see it, and still won't believe it.

Attaining full understanding of the true nature of humanity is not possible with notions of duality. The severed connection to the highest self needs to be reestablished before we can experience a vision of the interconnectedness of all matter. Journeying to outer space miraculously repairs the connection by sending Space Nomads deeper into the innermost reaches of knowing, where all the answers are flowering at once in a dance of spectral connectivity.

Ironically, the further we travel inward, the more clearly we see the truths of the cosmos in shades of unity, laying bare the architecture of the stars as intertwined matter encompassing all entities both animate and inanimate. The stars have written the composition of the universe for us; the notes of music are points of light reflecting our collective essence. There is nothing that can exist outside this cosmic sheet music of radiant unity. Perceived separation is an illusion where eyesight fails to convey the truth. The Buddha reminds us that "three things cannot be long hidden: the sun, the moon, and the truth."[2]

Earthbound notions of duality, or states of "otherness" in relationships, set a stage for conflict, domination, and fragmentation, with the standard result of longing and misery. Space Nomads are on a transformational mission to eradicate false notions of separation and bring humanity together into deeper mutual respect and understanding. Stardust, our fundamental composition, makes all beings related and elementally identical. The DNA of all life on Earth—plants, fungi, algae, animals—uses the same four amino acids to do its coding. There are no exceptions. The innermost heart knows that there can be no separation.

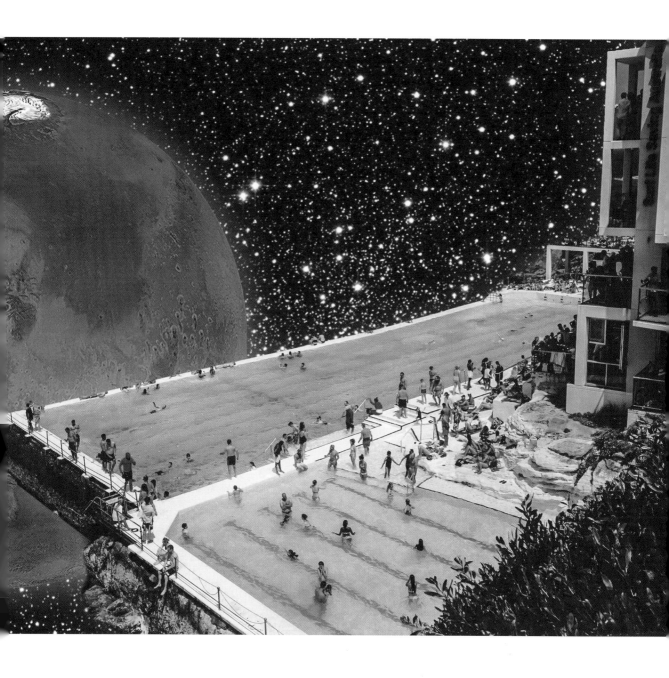

Universal Love for the Future

THE UNIVERSAL OVER-MOTHER

The links in the great chain of consciousness, with its millions of years of evolution, are the mothers who began life themselves being nurtured, and in turn nurture their young, who eventually return to caring for their mothers in old age. All children must at some point separate from their mothers to seek the freedoms they need to mature into independent adults. In a similar fashion, Space Nomads, too, must mature and separate, but this time from Mother Earth herself by launching into space, only to return later with greater compassion to look after her and the well-being of her human children.

In the greater cosmic sense, Mother Earth, our collective over-mother, has provided the elemental conditions for evolutionary life to flourish, making the resultant organisms entirely dependent on her. But now her children by their own clever invention have the ability to explore the greater freedoms of space and to reach levels of awareness not possible on Earth alone. It is only natural, and long overdue for humanity to come into its full maturation and full freedom. The first step has already been taken. Space Nomads have continuously occupied the International Space Station from November of 2000 through this writing and beyond.

The human spirit naturally longs for this paradigm of greater freedom—after all, evolution has made us stalwart explorers, and we know curiosity will be eternally pushing us skyward in search of unexplored terrain and new frontiers. For as much as we remain attached to the symbiotic mother-child relationship with Earth, we yearn to fly to greater freedoms all the while knowing we must eventually return home into the loving arms of our over-mother once again. It is the same natural mother/child cycle as before, just vastly expanded to encompass human destiny among the stars.

Those who answer the call to expanded awareness through space travel or other earthbound avenues will be overwhelmed by their reignited love for Mother Earth, born of a longing caused by the real or imagined physical separation. Seeing our vulnerable, one and only life-giving Mother floating alone in infinite blackness and noticing her frailty will inspire Space Nomads to become Mother Earth's passionate protectors. This transformational shift in awareness from helpless child overwhelmed by the proportions of the climate emergency to capable, loving stewards reveals Earth herself becoming interlaced with our ability to expand outside of ourselves. Reaching for Mars will give us the perspective we need to collectively nurse our loving mother, Earth, back to health. Like everything else in the universe, Earth and Mars are connected. Space Nomads will make that connection stronger.

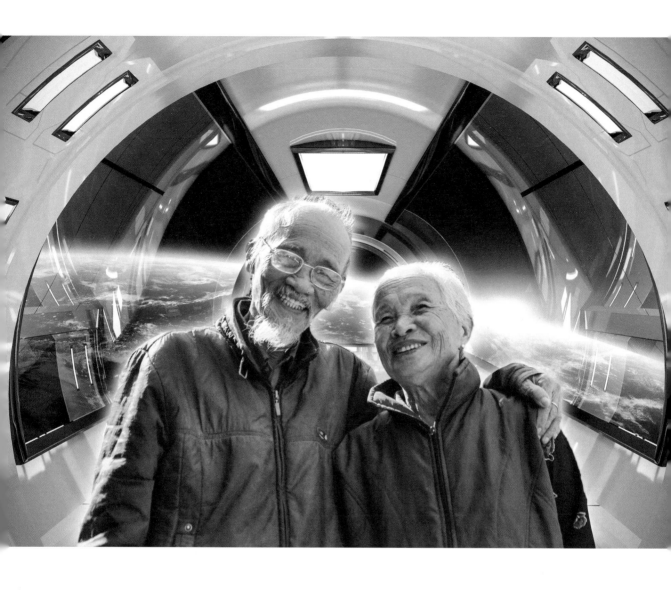

THE GREATEST ADVENTURE

Throughout human history there have been just a handful of evolutionary moments that irrevocably altered life on Earth. Taming fire, dangerous as it was, ensured the survival of human consciousness as our species prevailed over the elements. Shipbuilders allowed humanity to flourish by expanding into new, resource-rich territory. The Wright Brothers opened the skies in a giant leap toward space, which altered our destiny by laying the groundwork to protect consciousness through space colonization. The Nomads living at these critical junctures had a choice: they could either stay bound by the limited life they knew, or they could dive headlong into infinite possibility and reach for transformational expansion. Entrepreneurs, hustlers, troubadours, space cowboys, fortune seekers, average Joes, dreamers, the Nomads of Earth—they're aiming higher, and hoping for a better life for themselves and their families by expanding their consciousness to catapult themselves onto a new frontier. To do any less, we risk never knowing the transformational thinking, the fulfillment, and the exalted sense of unity that is rightfully ours. We risk never knowing the summit of our evolutionary path—enlightenment and the profound love it releases.

Human nature is a mosaic of instinctual predictability but not impervious to the natural evolution of the species, which motivated early humans to open their mind and walk out of Africa. Our innate curiosity could only be satisfied by spreading across the world, seeking more knowledge, more adventure, and more joy. Now that the dragons are nowhere to be found and Nomads have filled in the blank spaces on all the maps, we have no choice but to reach to colonize Mars, the Moon, and other parts of the solar system, for wanderlust sparkles in our DNA.

The Space Nomads living among us now will open the High Frontier and have their transformational awakenings along the way as they shift to a multiplanet identity. These contemporary pioneers will pave the way for Martian settlers just as intrepid early man marched across the Bering Strait and, twenty thousand years later, colonial explorers set sail for the New World. Those daring adventures were fraught with scowling naysayers, yet optimistic Nomads, with their unicorn minds focused on infinite possibility, pursued these dreams just the same. Likewise, Space Nomads will board rocket ships and fly through the glittering cosmos to Mars. Early Martian settlers will be seeking their transformations along the way, chasing unprecedented freedoms, prosperity, and the promise of open space similar to the Pilgrims five centuries earlier in America. Nothing can thwart these visions of a better life. We are destined to follow the example of the

prospecting 49ers who risked it all and exuberantly chased California gold, carving a path through the wild unknown. This time we are chasing enlightenment and the unprecedented love that will envelop us.

Fear of the unknown, that masterful beast, will lead many to conclude that no one really wants to go to Mars; yet, whenever there's a sign-up sheet offering this spectacular possibility, millions of Nomads eagerly apply. The opportunity to step out of ignorance and honor our innermost knowing by reaching for transcendental awareness is worth any and every risk. Humanity is always looking to expand itself. This is our human blueprint, our constant destiny.

Every being on Earth lucky enough to witness this transformational moment when the great wheel turns and we evolve into enlightenment through space travel has won a lottery of unfathomable odds. To be aware of it, to actively participate in it, is our unimaginable gift from the universe. We are humbled in thanks as we prepare to meet this glorious new era that will crown humanity, this great moment of expansion to Mars, the new frontier. Only by reaching beyond what we know to be possible through transformational thinking may we know the euphoria of meeting our highest self.

It is our birthright and our highest calling to live One Love among the stars.

ACKNOWLEDGMENTS

Thanks all the way to outer space to Theresa DiMasi for her vison and her mindset for Mars. Space-age spectral thanks to editor Hannah Robinson, and to my father, Randy Weiss, for edits, for fact-checks, and for traveling with me to unknown planets and starscapes along this journey. Interstellar thanks to Alexander Malyshev, the best digital art editor this side of Earth orbit. Thanks also to legal counsel Carolyn Levin for her scintillating legal advice. Thanks to all the Nomads at Simon & Schuster's Tiller Press who baked this beautiful space cake, including Anja Schmidt, Patrick Sullivan, Jennifer Chung, Hope Herr-Cardillo, Raymond Chokov, Alexis Alemao, Annie Craig, Brigid Black, Tom Pitoniak, Laura Flavin, Lauren Ollerhead, and Michael Andersen.

I've been known to go off-planet, but this past year on Mars has been particularly extreme. The amazing Space Nomads in my life who've inspired me, listened to me, and cheered me on include Soren Hixon, Casimir Hixon, Dylan Hixon, Shaune Arp, India Hixon Radfar, Sheila Hixon, Patricia Murray, Safira Hixon, Lakota Hixon, Powder Puff Hixon, Shadow Hixon, Adelaide Hixon, Mildred Weiss, Ando Hixon, Michele Hixon, Jeb Turpin, Lelaneia Dubay, Tom Dubay, Sage Callahan, Latifa and Pat Metheny, Paige Bart, Carol Suchman, Diane Birdsall, Lori Frank, Sarah Pillsbury, Midge Sanford, Jun Kazumi, Allison Julius, Louis Marra, Helene Safdie Levy, Sandy Tabatznik, Stephanie Breitbart, Orion Callahan, Eden Weiss, Ruby Weiss, Carlene Weiss, Austin Weiss, Ever Weiss, Deri-Ann Weiss, Galaxy Weiss, Mission Weiss, Revere Weiss, Remedy Weiss, Daniel Cariglio, Vanessa Star, Corbett Cariglio, Susan Peters, Jennifer Wieland, Jenny Beck, Laura Van Strattan, Rifka Mildler, Linda Plym, Chase Gilbertson, Michael Von Dome, Morley Kamen, Gunn Espegaard, Mala Ganguly, Billy Libby, Shanti Carter, Todd Carter, Ava Carter, Vella Carter, Alexandra Ballard, Adelaide Ballard, Zack Ballard, Bridget Fonger, Jasmina Denner, Kat Khosrowshahi, Noa Cossa, Brittney Hawthorne, Glynn Burgess, Marleny Lopez, Hillary Wallace, Sayada Rothschild, Steven Kramer, Brian Boucher, Tony Lyons, Mary Kay Patrick, Athena Stensland, Sarah Wauters, Lisa Podosin, Lana Baltz, Wendy Rice, Johanna Waters, Carmita Torres, Annie Bogoch, Helene Miller, Betsy Copp, Maria Von Vlodrop, Michelle Alexander, Annie Weinstein, Melissa Liberty, Pam Schein and Marc Murphy, Karen Lubeck, Andrea Zapatka, Neil deGrasse Tyson, Gurinder Kaur, Nicole Stott, Helen Tworkov, Areg Balayan, Mike Lapidus, Mike Brown, Kate Mulgrew, Fariha al-Jerrahi, and Jeff Bridges.

NOTES

1. Mirabai was a Rajasthani princess born in 1498 who shirked an early arranged marriage and instead married herself to Krishna and her devotional writing. *The Poetry of Mirabai: Ecstatic Poems*, translated by Jane Hirschfield and Robert Bly (Boston: Beacon Press, 2004).

INTRODUCTION

1. Eleanor Roosevelt, *You Learn by Living: Eleven Keys for a More Fulfilling Life* (New York: Harper & Row, 1960).
2. Floating space habitats were first referenced by Gerard O'Neill as O'Neill Cylinders in his book *The High Frontier: Human Colonies in Space* (North Hollywood, CA: Space Studies Institute Press, 1976).
3. John Glenn, speech, Explorers Club, New York, March 16, 2013, https://www.explorers.org/news/news_detail/in_memoriam_john_herschel_glenn_jr.
4. Lewis Carroll, "The Lion, the Witch and the Wardrobe," in *Through the Looking Glass, and What Alice Found There* (Oxford, England: Macmillan, 1872).
5. O'Neill, *The High Frontier*.

THE PARTIAL VIEW

1. Frank White, *The Overview Effect: Space Exploration and Human Evolution* (Boston: Houghton Mifflin, 1987).

ONWARD AND UPWARD

1. Arthur C. Clarke, *Profiles of the Future: An Inquiry into the Limits of the Possible* (London: Orion Publishers, 2000), 13.
2. Elon Musk, interview with Jack Ma, World Artificial Intelligence Conference, Shanghai, August 29, 2019.

HIGHER GROUND

1. Bob Roth, "Introduction to Transcendental Meditation," YouTube, uploaded by MaharisiAustralia, December 17, 2016, www.youtube.com/watch?v=fHBUjQCIiqg.

THE ANTI-GRAVITY MACHINE OF HIGHER KNOWING

1. Often erroneously credited to Albert Einstein but actually from Bob Samples, *The Metaphoric Mind: A Celebration of Creative Consciousness* (Boston: Addison-Wesley, 1976).

WE ARE ONE

1. Jonathan Movroydis, "White House Aids Remember President Nixon's Phone Call to the Moon," NixonFoundation.org, August 14, 2019.
2. Frank White, *The New Camelot: The Quest for the Overview Effect* (Burlington, Ontario, Canada: Griffin Media, 2016), 47.
3. Ibid., 52.

THE END OF IGNORANCE

1. R. Buckminster Fuller, *Operating Manual for Spaceship Earth* (Carbondale: Southern Illinois University Press, 1969).
2. Jane Howard, Margaret Mead: A Life (New York: Ballantine, 1981).

ORDINARY PEOPLE REACHING FOR MARS

1. Lukas Feireiss and Michael Najjar, *Planetary Echoes: Exploring the Implications of Human Settlement in Outer Space* (Leipzig, Germany: Spector Books, 2018).
2. Jane Howard, *Margaret Mead: A Life* (New York: Ballantine, 1981).

UNLOCKING MYSTERIES

1. Angela Duckworth, *Grit: The Power of Passion and Perseverance* (New York: Scribner, 2016), 180.
2. The earliest known version of this saying is ascribed to Charles Alexandre de Calonne, finance minister for Louis XVI and Queen Marie Antoinette of France, in 1794.
3. Sonal Jessel, Samantha Sawyer, and Diana Hernández, "Energy, Poverty and Health in Climate Change: A Comprehensive Review of an Emerging Literature," *Frontiers in Public Heath* 7 (2019): 357, www.ncbi.nlm.nih.gov/pmc/articles/PMC6920209/.
4. Leonard David, "Moon Mining Could Actually Work, with the Right Approach," Space.com, March 15, 2019.

CONTACT

1. Kirill Yeretsky, "The Experimenters: Carl Sagan," *Blank on Blank*, 2016, https://blankonblank.org/interviews/carl-sagan-extraterrestrials-religion-aliens-life-planets-mars-galaxies-stars/.

CHANGE MAKERS

1. Robert F. Kennedy, "Day of Affirmation," speech, University of Cape Town, South Africa, June 6, 1966, www.rfksafilm.org/html/speeches/speechrfk.php.
2. Celestine Chua, "Gratitude Challenge Day 1: Write 10 Things You Are Grateful For," *Personal Excellence* (blog), August 2013, https://personalexcellence.co/blog/gratitude-day-1-things-in-your-life/.
3. Kahlil Gibran, "On Work," in *The Prophet* (New York: Alfred A. Knopf, 1923).
4. "What Is Mahayana Buddhism?" Tricycle.org, https://tricycle.org/beginners/buddhism/what-is-mahayana-buddhism/.

THE BOTTOM BILLION

1. Max Roser and Esteban Ortiz-Ospina, "Global Extreme Poverty," Our World in Data, 2013, https://ourworldindata.org/extreme-poverty.
2. Nirav Patel, "Figure of the Week: Understanding Poverty in Africa," Brookings Institute, November 21, 2018, https://www.brookings.edu/blog/africa-in-focus/2018/11/21/figure-of-the-week-understanding-poverty-in-africa/.

CLIMATE DENIERS

1. Carolyn Gramling, "Forecasters Predict a Very Active 2020 Atlantic Hurricane Season," *Science News*, April 16, 2020, https://www.sciencenews.org/article/weather-forecasters-predict-very-active-2020-atlantic-hurricane-season.
2. Jessica McDonald, "How Potent Is Methane?" FactCheck.org, September 24, 2018, https://www.factcheck.org/2018/09/how-potent-is-methane/.
3. Robinson Meyer, "Syria Is Joining the Paris Agreement. Now What?" *Atlantic*, November 8, 2017, https://www.theatlantic.com/science/archive/2017/11/syria-is-joining-the-paris-agreement-now-what/545261/.
4. Coral Davenport, "With Trump in Charge, Climate Change References Purged from Website," *New York Times*, January 20, 2017, https://www.nytimes.com/2017/01/20/us/politics/trump-white-house-website.html.
5. Neela Banerjee and David Hasemyer, "Decades of Science Denial Related to Climate Change Has Led to Denial of the Coronavirus Pandemic," Inside Climate News, April 8, 2020, insideclimatenews.org/news/08042020/science-denial-coronavirus-covid-climate-change.

THE CONSCIENCE CANNOT IGNORE EXTINCTION

1. Ellen Cranley, "These Are the 130 Current Members of Congress Who Have Doubted or Denied Climate Change," Business Insider, April 29, 2019, www.businessinsider.com/climate-change-and-republicans-congress-global-warming-2019-2.
2. The 150 species per day figure is from the United Nations Convention on Biodiversity. Other experts project far fewer. See Fred Pearce, "Global Extinction Rates: Why Do Estimates Vary so Wildly?" *Yale Environment 360*, August 17, 2015, https://e360.yale.edu/features/global_extinction_rates_why_do_estimates_vary_so_wildly.
3. Joseph Stromberg, "What Is the Anthropocene and Are We in It?" *Smithsonian Magazine*, January 2013, https://www.smithsonianmag.com/science-nature/what-is-the-anthropocene-and-are-we-in-it-164801414/.

THE PROBES OF

1. Jonathan O'Callaghan, "Life on Venus? Scientists Hunt for the Truth," *Nature*, October 2, 2020, https://www.nature.com/articles/d41586-020-02785-5.
2. "Mars Exploration Program: Missions," NASA, https://mars.nasa.gov/mars-exploration/missions.
3. Eric Mack, "Elon Musk 'Guesses' SpaceX Could Send a Ship to Mars as Soon as 2024," C/NET, October 18, 2020, https://www.cnet.com/news/elon-musk-guesses-spacex-could-send-a-ship-to-mars-as-early-as-2024/.

TERRAFORMING

1. "Mars Meteorites," NASA/Jet Propulsion Laboratory/California Institute of Technology, https://www2.jpl.nasa.gov/snc/.
2. Jennifer Walz, "Terraforming Mars Using Cyanobacteria to Produce the Next Great Oxidation Event," University of St. Thomas, Minnesota, fall 2017, https://ir.stthomas.edu/cgi/viewcontent.cgi?article=1006&context=cas_biol_ugpub.
3. Matt Williams, "NASA Proposes a Magnetic Shield to Protect Mars' Atmosphere," Phys.org, March 3, 2017, https://phys.org/news/2017-03-nasa-magnetic-shield-mars-atmosphere.html.

SPACE VISIONARIES

1. White, *The Overview Effect*, 43.
2. Wernher von Braun, *The Mars Project*, 3rd ed. (Urbana: University of Illinois Press, 1991).
3. O'Neill, *The High Frontier*.
4. Ian Cassel, "Elon Musk Q&A SXSW 2018 Transcript," Intelligent Fanatics, March 2018, https://community.intelligentfanatics.com/t/elon-musk-q-a-sxsw-2018-transcript/421.
5. Maciej Cegłowski, "A Rocket to Nowhere," *Idle Words* (blog), August 3, 2005, https://idlewords.com/2005/08/a_rocket_to_nowhere.htm.
6. Henry Ford is credited with this quote on page 64 of the September 1947 issue of *Reader's Digest*; however, the saying may be much older. See Garson O'Toole, "Whether You Believe You Can Do a Thing or Not, You Are Right," Quote Investigator, February 3, 2015, https://quoteinvestigator.com/2015/02/03/you-can/.

TECH TURNING THE TIDES

1. Alison Gopnik, "Smarter Every Year? Mystery of the Rising IQs," *Wall Street Journal*, May 27, 2015, https://www.wsj.com/articles/smarter-every-year-mystery-of-the-rising-iqs-1432737750.
2. Robert Strohmeyer, "The 7 Worst Tech Predictions of All Time," *PC World*, December 31, 2008, https://www.pcworld.com/article/155984/worst_tech_predictions.html.

3. John Koetsier, "Elon Musk's 42,000 StarLink Satellites Could Just Save the World," *Forbes*, January 9, 2020, https://www.forbes.com/sites/johnkoetsier/2020/01/09/elon-musks-42000-starlink-satellites-could-just-save-the-world/#373cc704c2cd.

ARTIFICIAL INTELLIGENCE

1. Amit Ray, "101 Best Amit Ray Quotes," AmitRay.com, https://amitray.com/amitray_quotes/.
2. Yuval Harari, *Cape Up*, October 9, 2008: "We need to learn who we are before algorithms decide for us."
3. Ezra Klein, "Yuval Harari on Why Humans Won't Dominate Earth in 300 Years," *Vox*, March 27, 2017, https://www.vox.com/2017/3/27/14780114/yuval-harari-ai-vr-consciousness-sapiens-homo-deus-podcast.
4. Robert Thurman, *Inner Revolution* (New York: Penguin Books, 1998), 198.
5. Alfred B. Starratt, *Your Self, My Self & the Self of the Universe: Living, Knowing, Loving. A Faith of Reason, Science and Religion* (Keene, NH: Stemmer House, 1979), 13.

THE SPEED OF LIGHT

1. Annie Sneed, "Moore's Law Keeps Going, Defying Expectations," *Scientific American*, May 19, 2015, https://www.scientificamerican.com/article/moore-s-law-keeps-going-defying-expectations/.

FLUX

1. Daniel W. Graham, "Heraclitus," Stanford Encyclopedia of Philosophy, September 3, 2019, https://plato.stanford.edu/entries/heraclitus/.
2. Norman Fischer, "Impermanence Is Buddha Nature," Lion's Roar, April 8, 2019, https://www.lionsroar.com/impermanence-is-buddha-nature-embrace-changemay-2012/.
3. "Kīlauea 2018 Lower East Rift Zone Lava Flow Thicknesses: A Preliminary Map," US Geological Survey, February 19, 2019, https://www.usgs.gov/maps/k-lauea-2018-lower-east-rift-zone-lava-flow-thicknesses-a-preliminary-map.

THE OVERVIEW AND BREAKAWAY EFFECTS

1. Carl Sagan, *Pale Blue Dot: A Vision of the Human Future in Space* (New York: Random House, 1994), 229.
2. White, *The Overview Effect*, 40.
3. Brant Clark, PhD, and Captain Ashton Graybiel, MC, USN, "The Break-Off Phenomenon: A Feeling of Separation from the Earth Experienced by Pilots at High Altitude," *Journal of Aviation Medicine* 28, no. 2 (April 1957).
4. Ibid.
5. Mary Roach, *Packing for Mars: The Curious Science of Life in the Void* (New York: W. W. Norton, 2010), 66.
6. Tim Childers, "Ed White: The First American to Walk in Space," Space.com, July 9, 2019, https://www.space.com/ed-white.html.

VIRTUAL REALITY

1. Jaron Lanier, *Dawn of the New Everything: Encounters with Reality and Virtual Reality* (New York: Henry Holt, 2017).
2. First referenced in Ram Dass, *Remember: Be Here Now* (San Cristobal, NM: Lama Foundation, 1971). See also Mickie Lemie, *Fierce Grace*, Zeitgeist Films, 2001.

THE FIRST SPACE NOMAD

1. Edgar Mitchell, *The Space Less Traveled: Going to the Moon Isn't for Sissies . . . Neither Is Coming Back* (Fayetteville, AR: Pen-L Publishers, 2012), xv.
2. White, *The Overview Effect*, 196.

THE OBSTACLE COURSE TO MARS

1. Elizabeth Howell, "Remembering Apollo 17's Gene Cernan—the Last Man to Walk on the Moon," Seeker, January 23, 2017, https://www.seeker.com/gene-cernan-nasa-astronaut-space-history-apollo-17-2208958832.html.
2. John F. Kennedy, speech, Rice University, September 12, 1962, https://er.jsc.nasa.gov/seh/ricetalk.htm.

THE SPACE STAIRWAY

1. Arthur Fairbanks, ed., trans., "Anaxagoras: Fragments and Commentary," Hanover College, https://history.hanover.edu/texts/presoc/anaxagor.html.
2. "Audacious and Outrageous: Space Elevators," NASA Science, September 6, 2000, https://science.nasa.gov/science-news/science-at-nasa/2000/ast07sep_1.
3. "Konstantin Tsiolkovsky," Wikiquote, https://en.wikiquote.org/wiki/Konstantin_Tsiolkovsky.

ROCKS TO RICHES

1. Johann Wolfgang von Goethe, *Faust: eine Tragödie*, 1808.
2. Stephen Petranek, *How We'll Live on Mars* (New York: Simon & Schuster, 2015), 70.
3. Tom Huddleston Jr., "Valedictorian Jeff Bezos Said He Wanted to Build 'Space Hotels and Colonies' in His 1982 High School Graduation Speech," CNBC, September 3, 2018, https://www.cnbc.com/2018/08/31/amazon-jeff-bezos-proposed-colonizing-space-high-school-graduation-speech.html.

4. William K. Hartmann, *Out of the Cradle: Exploring the Frontiers Beyond Earth* (New York: Workman Publishing, 1984).

FLOATING SPACE HABITATS
1. Adam Hadhazy, "Artificial Gravity's Attraction," Aerospace America, April 2017, https://aerospaceamerica.aiaa.org/features/artificial-gravitys-attraction/.
2. O'Neill, *The High Frontier*, 62.
3. Ibid.
4. Ibid.

MOTHER EARTH PROVIDES
1. "Rachel Carson Excerpts," US Fish & Wildlife Service, https://www.fws.gov/refuge/Rachel_Carson/about/rachelcarsonexcerpts.html.
2. Kai Olson-Sawyer, "Meat's Large Water Footprint: Why Raising Livestock and Poultry for Meat Is so Resource-Intensive," Food-Tank, December 2013, https://foodtank.com/news/2013/12/why-meat-eats-resources/.

OUR FURRY FRIENDS
1. Yuval Noah Harari, "Industrial Farming Is One of the Worst Crimes in History," *Guardian*, September 25, 2015, https://www.theguardian.com/books/2015/sep/25/industrial-farming-one-worst-crimes-history-ethical-question.
2. Paul Hawken, ed., *Drawdown: The Most Comprehensive Plan Ever Proposed to Reverse Global Warming* (New York: Penguin Books, 2017), 40.
3. Alex Thornton, "This Is How Many Animals We Eat Each Year," World Economic Forum, February 8, 2019, https://www.weforum.org/agenda/2019/02/chart-of-the-day-this-is-how-many-animals-we-eat-each-year/.
4. James McWilliams, "PTSD in the Slaughterhouse," *Texas Observer*, February 7, 2012, https://www.texasobserver.org/ptsd-in-the-slaughterhouse/.
5. Michael Pollan, *The Omnivore's Dilemma: A Natural History of Four Meals* (New York: Penguin Books, 2006).

WOMEN: THE KEY TO THE FUTURE
1. Linda Landers, "Women's Purchasing Power," Girlpower Marketing, July 2012, https://girlpowermarketing.com/womens-purchasing-power/.
2. Mark Townsend and Jason Burke, "Earth 'Will Expire by 2050,'" *Guardian*, July 7, 2002, https://www.theguardian.com/uk/2002/jul/07/research.waste.

ART CALIBRATES HUMANITY
1. Perhaps the world's greatest spiritual poet. Rumi, *The Essential Rumi* (New York: HarperCollins, 2004).
2. Robert Henri, *The Art Spirit: Notes, Articles, Fragments of Letters and Talks to Students, Bearing on the Concept and Technique of Picture Making, the Study of Art Generally, and on Appreciation* (Philadelphia: J. B. Lippincott, 1923).

A PORTABLE RAINBOW
1. Shawn Achor, *The Happiness Advantage: How a Positive Brain Fuels Success in Work and Life* (New York: Currency, 2010).
2. Sharon Basaraba, "How to De-Stress with a Smile," Verywell Mind, February 4, 2020, https://www.verywellmind.com/beat-stress-with-a-smile-2223757.
3. Goethe, *Faust*.

TRUE DESIRES OF BODY AND MIND
1. Robert Zubrin, *The Case for Mars: The Plan to Settle the Red Planet and Why We Must* (New York: Simon & Schuster, 1996).

INTEGRITY: A PREREQUISITE
1. Carl Jung, *Memories, Dreams, Reflections* (New York: Random House, 1963).
2. Tobias Hoffman, *Weakness of Will from Plato to the Present* (Washington, DC: Catholic University America Press, 2008).

BAKING THE SPACE CAKE
1. An homage to Bernie Glassman & Rick Fields, *Instructions to the Cook: A Zen Master's Lessons in Living a Life That Matters* (Berkeley, CA: Shambhala, 2013).
2. Emily Dickinson, "Part 4: Time and Eternity," CXXI, *Complete Poems* (Boston: Little, Brown, 1924), https://www.americanpoems.com/poets/emilydickinson/the-soul-should-always-stand-ajar/.

THE SOCIETY OF OUR DREAMS
1. Rumi, "The States of the Lover" in *The Quatrains of Rumi*, trans. Ibrahim Gamard and Rawan Farhadi (Sufi Dari Books, 2008), 456.
2. Bhikkhu Bodhi, "The Noble Eightfold Path—The Way to the End of Suffering," Tibetan Buddhism in the West, 1999, https://info-buddhism.com/The-Noble-Eightfold-Path-Bhikkhu_Bodhi.html.

3. Robert Thurman, *Inner Revolution: Life, Liberty, and the Pursuit of Real Happiness* (New York: Penguin Books, 1998), 247.
4. Ibid., 198–201.
5. Ibid., 226.
6. John Stanley, David R. Loy, and Gyurme Dorje, eds., *A Buddhist Response to the Climate Emergency* (Somerville, MA: Wisdom Publications, 2009).

ENLIGHTENMENT EDUCATION FOR SPACE NOMADS
1. Jeff Bridges and Bernie Glassman, *The Dude and the Zen Master* (New York: Blue Rider Press, 2013).
2. Gerard K. O'Neill, *2081* (New York: Simon & Schuster, 1981), 267.
3. Yuval Noah Harari, *Homo Deus: A Brief History of Tomorrow* (New York: Penguin Books, 2017), 222.

THE CONFLUENCE OF ART AND SCIENCE
1. Peter Salovey, "A Culture or Curiosity," speech, Yale University, August 24, 2019.

RECALIBRATING TO THE SPIRIT
1. Steve Taylor, *Spiritual Science: Why Science Needs Spirituality to Make Sense of the World* (London: Watkins Media, 2018), 22.
2. Albert Bates, "The Gospel of Chief Seattle: Written for Television?" *Natural Rights*, spring 1990, http://old.thefarm.org/lifestyle/albertbates/akbseattle.html.
3. Starratt, *Your Self, My Self & the Self of the Universe*, 18.
4. White, *The Overview Effect*, 23.

SHIFTING SANDS
1. Paraphrased from Pliney the Elder, *Naturalis historica*, book VII, section 5.

WHOLE EARTH
1. White, *The Overview Effect*, 48.

THE VISIBLE SPECTRUM
1. René Karl Wilhelm Johann Josef Maria Rilke (December 4, 1875–December 29, 1926).
2. Yoshitaro Heshiki et al., "Predictable Modulation of Cancer Treatment Outcomes by the Gut Microbiota," *Microbiome* 8, no. 28 (2020), https://microbiomejournal.biomedcentral.com/articles/10.1186/s40168-020-00811-2.

WAVES OF SPIRIT AWAKENING
1. "Then & Now: Dr. Mae Jemison," CNN, June 19, 2005, https://www.cnn.com/2005/US/01/07/cnn25.tan.jemison/.
2. Jacquelyn Small, *The Sacred Purpose of Being Human: A Healing Journey through the 12 Principles of Wholeness* (Deerfield Beach, FL: HCI, 2005).

INNER KNOWING
1. Jessamyn West, *The Friendly Persuasion* (San Diego: Harcourt Press, 1945).

BUDDHA NATURE
1. E. E. Cummings, "i thank You God for most this amazing" in *Xaipe* (New York: Oxford University Press, 1950).
2. Glassman & Fields, *Instructions to the Cook*, 7.
3. Starratt, *Your Self, My Self & the Self of the Universe*, 1.

CASTLE BUILDING
1. The Beatles, "She Came in through the Bathroom Window," *Abbey Road*, Apple Records, September 26, 1969.

NATURAL RESOURCES OF THE INTERIOR LANDSCAPE
1. India Radfar, "is it in the lungs or in the heart" in *Breathe* (Woodstock, NY: Shivastan Press, 2004).

OPTIMISM TURNS THE WHEEL
1. Helen Keller, *Optimism: An Essay* (CreateSpace, 2016).
2. John Montgomery, PhD, "Emotions, Survival, and Disconnection," *Psychology Today*, September 30, 2012, https://www.psychologytoday.com/us/blog/the-embodied-mind/201209/emotions-survival-and-disconnection.
3. Hara Estroff Marano, "Our Brain's Negative Bias," *Psychology Today*, June 9, 2016, https://www.psychologytoday.com/us/articles/200306/our-brains-negative-bias.
4. Lewina O. Lee et al., "Optimism Is Associated with Exceptional Longevity in 2 Epidemiologic Cohorts of Men and Women," *Proceedings of the National Academy of Science of the United States of America* 116, no. 37 (September 10, 2019): 18357–62, https://www.pnas.org/content/116/37/18357.

THE CIRCLE OF BELIEF
1. Lex Hixon, *The Heart of the Qur'an: An Introduction to Islamic Spirituality* (Wheaton, IL: Quest Books, 2003).

THE TAP OF INFINITE POSSIBILITY
1. Shakti Gawain, *Living in the Light: A Guide to Personal and Planetary Transformation* (Middlesex, UK: Eden Grove Editions, 1986).
2. Jamie Carter, "What Space Tourists Will Get for Their $250,000 Ticket," *Travel + Leisure*, Setember 29, 2018, https://www.travelandleisure.com/trip-ideas/space-astronomy/space-tourism-virgin-galactic-blue-origin.
3. Chris Anderson, "Elon Musk's Mission to Mars," *Wired*, October 21, 2012, https://www.wired.com/2012/10/ff-elon-musk-qa/.
4. Victoria Erickson, *Edge of Wonder; Notes from the Wildness of Being* (Acton, Ontario, Canada: Enrealment Press, 2015).

UNION
1. Lex Hixon, *Great Swan: Meetings with Ramakrishna* (Burdett, NY: Larson Publications, 1992).
2. Caroline Fanning, "This Is the Average Commute Time in Every U.S. State," *Reader's Digest*, January 30, 2020, https://www.msn.com/en-us/lifestyle/career/this-is-the-average-commute-time-in-every-us-state/ar-BBZuEaV.

GREAT LOVE, GREAT MIRACLES
1. Ibn al-'Arabi, *101 Diamonds from the Oral Tradition of the Glorious Messenger Muhammad*, trans. Lex Hixon and Fariha al-Jerrahi (New York: Pir Press, 2002), 21.

HUMAN HAPPINESS
1. Voltaire (Francois-Marie Arouet, 1697–1778).
2. Happy Planet Index, http://happyplanetindex.org/.
3. Jean-Jacques Rousseau, *Confessions* (1782). Rousseau's book, often published as *The Confessions of Jean-Jacques Rousseau*, contains surprising personal details, including his paranoia and his rivalry with Voltaire.
4. Mordanicus, "Planetary Chauvinism," Lagrangian Republican Association, December 21, 2012, https://republicoflagrangia.org/2012/12/21/planetary-chauvinism/.

GALACTIC UNITY
1. Jean-Jacques Rousseau, *The Social Contract*, book III (1762).

GOVERNING BODIES
1. Thomas Jefferson to Dupont de Nemours, letter, 1816, Monticello.org, https://www.monticello.org/research-education/jefferson-library/jefferson-library-reference/monticello-s-online-resources/enlighten-the-people-project/.
2. Thomas Aquinas, *Summa Theologica* (1485), "Treatise on Law," questions 90–108.

HEART-SHAPED GLASSES OF COMPASSION
1. Buddha, *Sutta Nipata*, 4:2 The Cave Octet.

UNIFIED STARDUST
1. Al-'Arabi, *101 Diamonds*, 15.
2. Paraphrased from Pali Text Society, *Gradual Sayings* (translated circa 1931). A more literal translation: "Three things shine in the open, not under cover. What three? The moon shines in the open, not under cover. The sun shines in the open, not under cover. The teaching and training proclaimed by a Realized One shines in the open, not under cover."

RESOURCES AND INSPIRATION

While much has been written about the overview effect, which I reference throughout this book, the father of this concept is Frank White, whose excellent books include *The New Camelot*, *The Cosma Hypothesis*, and *The Overview Effect*, which I consider seminal to my research. His revelatory interviews with astronauts continue to serve as great sources of inspiration.

Living in the Light by Shakti Gawain, whose chapters discussing intuition, higher power, and feelings were invaluable and provided much guidance.

Steve Taylor's excellent book *Spiritual Science: Why Science Needs Spirituality to Make Sense of the World* was instrumental in forming a bridge to these formerly disparate realms.

In my research on twenty-first-century solutions to global warming, *Drawdown: The Most Comprehensive Plan Ever Proposed to Reverse Global Warming*, edited by Paul Hawken, was invaluable. This wonderful guide offers solutions and technologies addressing food scarcity, food waste, solar power, and poverty reduction. This guide is loaded with well-sourced facts and succinct explanations as well as clear solutions.

To inform notions of broadened awareness and expanded consciousness I found myself reaching for Ram Dass's book *Remember: Be Here Now*. The discussion on Timothy Leary and their work with LSD inspired my writing on alternative methods to full inner knowing.

I drew on Jaron Lanier's *Dawn of the New Everything* for inspiration about virtual reality and its effect on the future as well as its ability to bring earthbound Nomads on a transformational journey so they may experience their overview and breakaway experiences from their living rooms. His many definitions of VR throughout his book were directly inspirational.

My thinking about positivity and the human mind's hardwiring to favor the negative draws from *Abundance: The Future Is Better Than You Think*, by Peter Diamandis, which helped me see our abundant world and how it is getting better all the time.

His Holiness the Dalai Lama and Archbishop Desmond Tutu, in their collaborative offering *The Book of Joy*, helped me to think about joy as the ultimate goal for humanity in the galaxy.

The details I've included on rocketry and the key players in the contemporary space race are from my close reading of *Beyond: Our Future in Space*, by Chris Impey. References to the Greek philosopher Anaxagoras as well.

The Big Green Purse: Using Your Spending Power to Create a Cleaner, Greener World informed my thinking of how women are more in charge than we think. The essay "Women: The Key to the Future" was inspired by author Diane MacEachern's wonderful book.

The Space Less Traveled: Going to the Moon Isn't for Sissies . . . Neither Is Coming Back, by Edgar Mitchell, offers amazing firsthand insights into the transformational experiences of space travel that became central to my thinking of what space can do for humanity.

On the Future, by Martin Rees, informed some of the thinking about climate change, clean energy, and AI. His book offers great insights to the perils of the Anthropocene Epoch.

Stephen L. Petranek's powerful little book *How We'll Live on Mars* illuminated the essays on asteroids, the Mars project, rocketry, and information about Elon Musk, as well as the analogies of Magellan and Columbus.

My mother-in-law Sheila Hixon's incredible book about her husband Lex Hixon's radio program, *Conversations in the Spirit*, informed much thinking on spirituality and nondual pursuits. This book allows the reader to intimately encounter luminaries of the 1970s spiritual awakening.

Coming Home: The Experience of Enlightenment in Sacred Traditions, by Lex Hixon, led me away from atheism and opened my mind to the idea of enlightenment in this lifetime.

Lex Hixon: Selected Writings was deeply inspirational and stands as the source for his poem "All Is Light."

The poetry book *Breathe*, by India Hixon Radfar, was a beacon of inspiration that shone on most pages of *Space Nomads*. The poem of hers is from this offering.

The Art Spirit, by Robert Henri, is to credit for reminding me of art's universality and how it has the unique ability to set a person free.

Planetary Echoes, by Spector Books, offers much inspiration about space travel and the overview effect. Buzz Aldrin and Frank White offer especially important essays.

Bernie Glassman's *Instructions to the Cook* is to credit for Buddhist inspiration as well as for the Space Cake.

Carl Sagan's eloquent *Pale Blue Dot* offers much valuable information about the history of the space program, with details about Apollo and the fathers of modern rocketry.

The Swerve: How the World Became Modern gave great insights into the humanist point of view as well as the dangers of established religious traditions.

I referenced the fun book *Soonish: Ten Emerging Technologies That'll Improve and/or Ruin Everything*, by Kelly and Zach Weinersmith, for technical information on AI, VR, asteroid mining, and space ladders.

The Space Barons: Elon Musk, Jeff Bezos and the Quest to Colonize the Cosmos, by Christian Davenport, was fabulously informative for the trajectories of these visionaries, which informed a number of essays.

Edward O. Wilson's inspiring *Letters to a Young Scientist* was important to my process in undergirding the value of science and its foundational role to build the future.

Simple Abundance: A Daybook of Comfort and Joy, by Sarah Ban Breathnach, was excellent as a source for resetting to a positive mindset and seeking daily joy. Thanks for the quotes and all the inspiration.

Your Self, My Self & the Self of the Universe, by Alfred B. Starratt, profoundly influenced my thinking on the essence of the universe and the idea of being "variant forms of the same essence."

Robert Thurman's book *Inner Revolution* shed light on the idea of enlightenment education focusing on the individual for the benefit of others, and provided the concepts of death being a "bliss immersion" and working toward a "Buddhaverse" where all are enlightened.

Lex Hixon and Fariha Al-Jerrahi's book *101 Diamonds* gave so much inspiration about the path to transformation through knowing our true selves as eternally divine love.

Angela Duckworth's *Grit* informed elements of the mindset for Mars—the tenacity, the optimism—and helped debunk preconceived notions of talent.

Gerard O'Neill's two eye-opening books *The High Frontier* and *2081* convinced me of the viability of floating in space rather than living on a moon or a planet.

BIBLIOGRAPHY

Achor, Shawn. *The Happiness Advantage: How a Positive Brain Fuels Success in Work and Life*. New York: Currency, 2010.
Breathnach, Sarah Ban. *Simple Abundance: A Daybook of Comfort and Joy*. New York: Warner Books, 1995.
Brockman, John. *This Idea Is Brilliant*. New York: Harper Perennial, 2018.
Brown, Mike. *How I Killed Pluto and Why It Had It Coming*. New York: Spiegel & Grau, 2010.
Chopra, Deepak, and Menas Kafatos. *You Are the Universe: Discovering Your Cosmic Self and Why It Matters*. New York: Penguin, 2017.
Ciardi, John. *The Paradiso: Dante's Ultimate Vision of Universal Harmony and Eternal Salvation*. 4th ed. New York: New American Library, 1970.
Davenport, Christian. *The Space Barons: Elon Musk, Jeff Bezos, and the Quest to Colonize the Cosmos*. New York: Hachette Book Group, 2018.
Dass, Ram. *Remember: Be Here Now*. San Cristobal, NM: Lama Foundation, 1971.
Day, Laura. *Practical Intuition*. New York: Broadway Books, 1996.
Diamandis, Peter, and Steven Kotler. *Abundance: The Future Is Better Than You Think*. New York: Free Press, 2014.
Duckworth, Angela. *Grit: The Power of Passion and Perseverance*. New York: Scribner, 2016.
De Botton, Alain. *Art as Therapy*. 7th ed. New York: Phaidon, 2019.
DiChristina, Mariette. "Wild Ideas in Science." *Scientific American*, September 17, 2019.
Feireiss, Lukas. *Planetary Echoes*. Leipzig, Germany: Spector Books, 2019.
Fuller, R. Buckminster. *Critical Path*. New York: St. Martin's Press, 1981.
———. *Utopia or Oblivion*. 5th ed. New York: Bantam Books, 1971.
Gawain, Shakti. *Living in the Light*. 2nd ed. London: Eden Grove Editions, 1988.
———. *Creative Visualization*. 3rd ed. Novato, CA: New World Library, 2002.
Glassman, Bernie and Rick Fields. *Instructions to the Cook*. New York: Harmony Books, 1996.
Greenblatt, Stephen. *The Swerve: How the World Became Modern*. New York: Norton, 2011.
Harari, Yuval. *Homo Deus*. London: Penguin, 2015.
———. *Sapiens: A Brief History of Humankind*. New York: HarperCollins, 2015.
Hawken, Paul, ed. *Drawdown: The Most Comprehensive Plan Ever Proposed to Reverse Global Warming*. New York: Penguin Books, 2017.
Hendel, Charles. *David Hume 1711–1776: An Inquiry Concerning the Principles of Morals*. 16th ed. Indianapolis: Bobbs-Merrill, 1981.
Henri, Robert. *The Art Spirit*. 4th ed. Cambridge: Basic Books, 1958.
Hixon, India Radfar. *India Poem*. New York: Pir Press, 2002.
Hixon, Lex. *Coming Home: The Experience of Enlightenment in Sacred Traditions*. 3rd ed. Burdett, NY: Larson, 1995.
Hixon, Lex, and Fariha Al-Jerrahi. *101 Diamonds: From the Oral Tradition of the Glorious Messenger Muhammad*. New York: Pir Press, 2002.
Howard, Dylan. "The United States Space Force." American Media Specialists, New York, April 5, 2019.
Impey, Chris. *Beyond: Our Future in Space*. New York: Norton, 2015.
Kaufman, Marc. *Mars Up Close: Inside the Curiosity Mission*. Washington, DC: National Geographic Society, 2018.
Kelly, Kevin. *The Inevitable: Understanding the 12 Technological Forces That Will Shape the Future*. New York: Penguin Books, 2016.
Kuhn, Thomas. *The Structure of Scientific Revolutions*. 4th ed. Chicago: University of Chicago Press, 2012.
Lama, Dalai, and Desmond Tutu. *The Book of Joy*. New York: Random House, 2016.
MacEachern, Diane. *The Big Green Purse*. New York: Penguin Group, 2008.
Mascaro, Juan, ed. and trans. *The Upanishads*. London: Penguin Books, 1990.
McAffe, Andrew, and Erik Brynjolfsson. *Machine Platform Crowd: Harnessing Our Digital Future*. New York: Norton, 2017.
Mitchell, Edgar. *The Space Less Traveled: Going to the Moon Isn't for Sissies . . . Neither Is Coming Back*. Fayetteville, AR: Pen-L, 2012.
Nasr, Seyyed Hossein. *Ideas and Realities of Islam*. 5th ed. London: HarperCollins, 1988.
Neufeld, Michael J. *Space Flight*. Washington, DC: MIT Press/Smithsonian Institution, 2018.
Nietzsche, Friedrich. *The Birth of Tragedy and the Case of Wagner*. Trans. W. Kaufmann. New York: Vintage Books, 1967.
Nikhilananda, Swami. *The Gospel of Sri Ramakrishna*. Madras, India: Sri Ramakrishna Math.
Niven, David. *100 Simple Secrets of Happy People*. New York: Harper One, 2006.
Noble, Denis. *The Music of Life: Biology Beyond Genes*. Oxford, UK: Oxford University Press, 2006.
O'Neill, Gerard K. *The High Frontier: Human Colonies in Space*. New York: William Morrow and Company, 1977.
———. *2081: A Hopeful View of the Human Future*. New York: Simon & Schuster, 1981.
Petranek, Stephen. *How We'll Live on Mars*. New York: Simon & Schuster, 2015.
Rees, Martin. *On the Future: Prospects for Humanity*. Princeton, NJ: Princeton University Press, 2018.
Reeve, C. D. C. *Aristotle: Politics*. Cambridge, MA: Hackett, 1998.
Sagan, Carl. *Pale Blue Dot: A Vision of the Human Future in Space*. New York: Ballantine Books, 1994.
Starratt, Alfred B. *Your Self, My Self & the Self of the Universe: Living, Knowing, Loving. A Faith of Reason, Science and Religion*. Keene, NH: Stemmer House, 1979.
Suzuki, D. T. *The Awakening of Zen*. Boston: Shambhala Books, 2000.
Swimme, Brian. *The Universe Is a Green Dragon: A Cosmic Creation Story*. Santa Fe, NM: Bear, 1984.
Thurman, Robert. *Inner Revolution: Life, Liberty, and the Pursuit of Real Happiness*. New York: Penguin, 1998.

Taylor, Steve. *Out of the Darkness: From Turmoil to Transformation*. London: Hay House, 2011.
———. *Spiritual Science*. London: Watkins Media, 2018.
———. "Spontaneous Awakening Experiences: Exploring the Phenomenon Beyond Religion and Spirituality." *Journal of Transpersonal Psychology* 44, no. 1 (2012): 73–91.
———. *Waking from Sleep: Why Awakening Experiences Occur and How to Make Them Permanent*. London: Hay House, 2010.
Tyson, Neil DeGrasse. *Astrophysics for People in a Hurry*. New York: Norton, 2017.
Von Braun, Wernher. *The Mars Project*. 3rd ed. Urbana: University of Illinois Press, 1991.
Weinersmith, Kelly, and Zach Weinersmith. *Soonish: The Emerging Technologies That'll Improve and/or Ruin Everything*. New York: Penguin, 2017.
White, Frank. *The Cosma Hypothesis*. Self-published, 2019.
———. *The New Camelot: The Quest for the Overview Effect*. Burlington, Ontario, Canada: Griffin Media, 2016.
———. *The Overview Effect*. Boston: Houghton Mifflin, 1987.
Williamson, Marianne. *A Woman's Worth*. New York: Random House, 1993.
Wilson, Edward O. *Letters to a Young Scientist*. New York: Norton, 2013.
Zubrin, Robert. *The Case for Mars: The Plan to Settle the Red Planet and Why We Must*. New York: Simon & Schuster, 1996.

PHOTO CREDITS

Intergalactic thanks to the many talented photographers who made the art of *Space Nomads* possible.

Cover: Horses in Water, Vadim Petrakov. Mars, NASA/JPL-Caltech. Earth, Nico El Nino, Shutterstock.

Blue Landscape: Crystals, Albert Russ, Shutterstock. Sand dunes, Sunsinger, Shutterstock. Elephants, Cocoparisienne, Pixabay. Woman, Rhyan Stark, Pexels.

Table of Contents: *Space Nomad Superhighway:* White Sand Dune, Oleg Znamenskiy, Shutterstock.

Foreword: *The Great Unity:* Northern Lights, Frans Van Heerden, Pexels. Moons, Angela Harburn, Shutterstock.

Pushing Dragons and Chasing Unicorns: Girl, Alise Ali Nari, Pexels. Building, Alex Azabache, Pexels. Moons, Angela Harburn, Shutterstock.

The Space Nomads Among Us: Unicorn Silhouette, Gordon Johnson, Pixabay.

The Partial View: Rainbow Scene, Fietzfotos, Pixabay.

Onward and Upward: Highway, Markus Spiske, Pexels.

Higher Ground: Woman, Best Stock Photo, Shutterstock. Ship, DM7, Shutterstock. Tulip Field, Travelpixs, Shutterstock. Dome, Worldpics, Shutterstock.

The Anti-Gravity Machine of Higher Knowing: Woman Driving to Mars, Jill Wellington, Pexels. Mars, WikiImages, Pixabay.

Scribes of the Future: Horses, Ventdusud, Shutterstock. Quartz, Sebastian Janicki, Shutterstock. La-goon Nebula, WikiImages for Pixabay.

We Are One: *Marscape R-4:* glitter on canvas, 24" x 36", 2018.

The End of Ignorance: Color Wave Circle, Pyroterra Lightoys, Visual Poi Zone.

Ordinary People Reaching for Mars: *Marscape R-12 J-14:* glitter on wood, 24" x 18", 2018.

Contact: Structure Floating in Sky, Photovision, Pixabay. Castle, Eccles, Shutterstock.

Change Makers: Earth, Adobe Stock by studio023. Tall Rainbow Sound Wave, Marta Ortiz, Getty iStock.

The Bottom Billion: Lotuses, Man Dy, Pexels. Woman, Lucas Pezetes, Pexels. Building, Max Bogaert, FreeImages.com.

Climate Deniers: Iceberg, Paudhillon, Pixabay. Moon, Romain Kamin, Pexels.

The Conscience Cannot Ignore Extinction: Aurora, John A. Davis, Shutterstock. Deer, Petr Simon, Shutterstock.

The Probes of Mars: Prairie Dog Family, Zoltan Taulacz, Shutterstock.

Terraforming: Landscape Nature Photo, Shutterstock.

Tech Turning the Tides: Huangpu Qu, China, Peng LIU, Pexels. Futuristic Train, Andrey_1, Shutterstock.

Artificial Intelligence: Space Time Portal, Vadym Pasichnyk, Shutterstock.

The Speed of Light: White Horse, Sponchia, Pixabay.

Flux: Pink Crystals, Dids, Pexels. Highway, Florian Kurz, Pixabay.

Overview and Breakaway Effects: Sound Wave of Voice, Deposit Photos. Water Surface, Free-Photos, Pixabay.

Virtual Reality: Woman with Headset, Mark Nazh, Shutterstock.

The First Space Nomad: UFO, Peter Lomas, Pixabay. Landscape, Sunyu, Pexels. Unicorn, Mysticartdesign, Pixabay.

The Obstacle Course to Mars: Building with Sign, PC, Pexels. Rocket, Pixabay, Pexels.

The Space Stairway: *Marscape J-12 R-18:* glitter on wood, 18" x 14", 2018.

Floating Space Habitats: 300ad, Shutterstock.

Mother Earth Provides: Glitter Unicorns on Wood, 72" x 72". Backyard of Clover Hill Farm, Lyme, CT, photo courtesy of Pola Esther, 2012.

Our Furry Friends: Sun, Menno van der Haven, Shutterstock. Scottish Highlanders, Defotoberg, Shutterstock. Time-Lapse Photograph of Stars at Night, InstaWalli, Pexels.

Recovering from Materialism: Garden, Tama66, Pixabay. Statue, Baptist, Shutterstock. Moon, Dariusz Grosa, Pexels.

Women: The Key to the Future: Redhead, Gabriel Baretto. Satellite, Pixabay, Pexels.

The Texture of the Future: Inverloch Sand Dune House, Victoria, AU, courtesy of Rhiannon Slater, Google, labeled for reuse. Moons, Angela Harburn, Shutterstock.

Art Calibrates Humanity: Venus, Sandro Botticelli.

The Future Is Now: Four Divers, Vibrant Image Studio. Woman in Foreground, Prostock Studio, Shutterstock.

A Portable Rainbow: *Neon Glitter Yes:* glitter on canvas, 40" x 30", 2015.

True Desires of Body and Mind: Cat, Natasha Semenkona, Pexels. Pink Clouds, Mont Photographs, Pexels.

Integrity: A Prerequisite: Waterfall, James Wheeler, Pexels.

Baking the Space Cake: Red Velvet Cake, New Africa, Adobe Stock.

The Society of Our Dreams: Surfers, One Inch Punch, Shutterstock.

Enlightenment Education for Space Nomads: Asian Couple, Alice Bitencourt, Pixabay. Windows, Areck Socha, Pixabay. Earth, PIRO, Pixabay.

Confluence of Art and Science: Background, Oleg Gamulinskiy, Pixabay. Escalator, Michael Gaida, Pixabay.

Shifting Sands: Habitat, Pavel Chagochkin, Shutterstock. Deserted Terrestrial Planet, Esfera, Shutterstock. Cybertruck, Wikimedia, free and relabeled to use.

Open Future: *Infinite Possibility:* Glitter and mica on canvas, 36" x 48", 2017.

Whole Earth: Silhouette, Public Domain Vectors. Earth, Jay Mantri, Pexels.

Evolution Keeps Evolving: Clouds, StockWarehouse. Sea, Asad Photo Maldives, Pexels.

The Visible Spectrum: Red-Haired Girl, Pedro Sandrini, Pexels.
Waves of Spirit Awakening: 3 motional, Pexels.
Inner Knowing: Unicorn Stampede art installation for Lyman Allen Museum of Art, New London, CT, 2012, photo courtesy of Pola Esther.
Castle Building: Silhouette, Ballerina, Ava Carter, photo courtesy of Vella Carter. Mushrooms, Adege, Pixabay.
Visualizing the Colony: Jonathan Borba, Pexels.
Optimism Turns the Wheel: Ship, Alvov, Shutterstock.
The Circle of Belief: Purple Jacarandas, Milleflore Images, Australia, Shutterstock.
The Tap of Infinite Possibility: *From the Center of the Universe:* glitter and spray paint on canvas, 24" x 36", 2014.
Love: The Religion beyond Religion: Moon Man, NASA.
Union: Photo of Swans courtesy of Michael Huggan. Waterfall, Kasabubu, Pixabay.
Great Love, Great Miracles: Sand Dunes, Sunsinger, Shutterstock.
Human Happiness: Woman in Bed, Roberto Nickson, Pexels. Mars, NASA/JPL-Caltech.
Galactic Unity: Earth, Jay Mantri, Pexels. Meditator, Activedia, Pixabay.
Governing Bodies: *Open Future:* glitter on canvas, 36" x 48", 2017.
Unified Stardust: Swimming Pool, Belle Co., Pexels.
The Universal Over-Mother: Couple, Tristan Le, Pexels. Starship, Sdecoret, NASA, Shutterstock.
The Greatest Adventure: *Love from Mars:* glitter and paint on canvas, 48" x 48", 2012.
About the Author: Spaceship Interior, Sdecoret, Shutterstock.

ABOUT THE AUTHOR

New York City visual artist **Camomile Hixon** chases the unicorns of infinite possibility to build new worlds. She is reaching for shifts in awareness through space-travel experiences to transform life on Earth.

Hixon communicates this message through various art forms, including music. Her glitter paintings have been exhibited at Tokyo's Shibuya Subway Terminal and New York City's Oculus Transportation Hub at the World Trade Center, and in shows at the 57th and 58th Venice Biennales. Her *Love from Mars* painting was exhibited on 130 digital kiosks across New York City. Camomile's virtual, interactive worldwide *Search for the Missing Unicorn* has included millions of people and been covered by major media outlets, including MSNBC, the BBC, and the CBC, among others. Museum shows include the American Textile History Museum, Cornell Art Museum, and the Lyman Allyn Art Museum. Hixon's works are held in public and private collections worldwide.

Visit her on Instagram @camomilehixon

www.camomile.com